Maria ...
Thankyou for
your support !
Enjoy the MOVE !
James Hurt

MOVE

pH powerHouse Books Brooklyn, NY

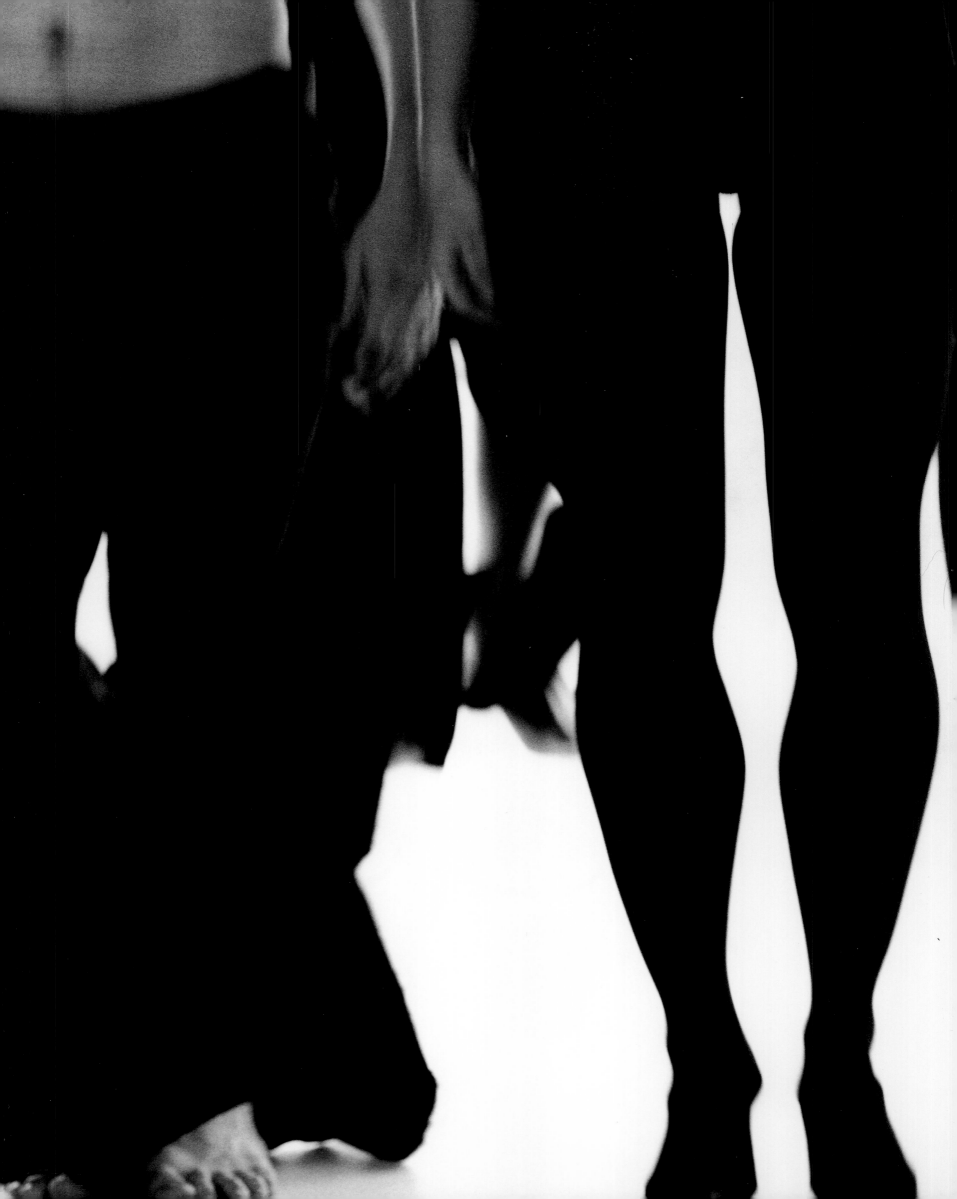

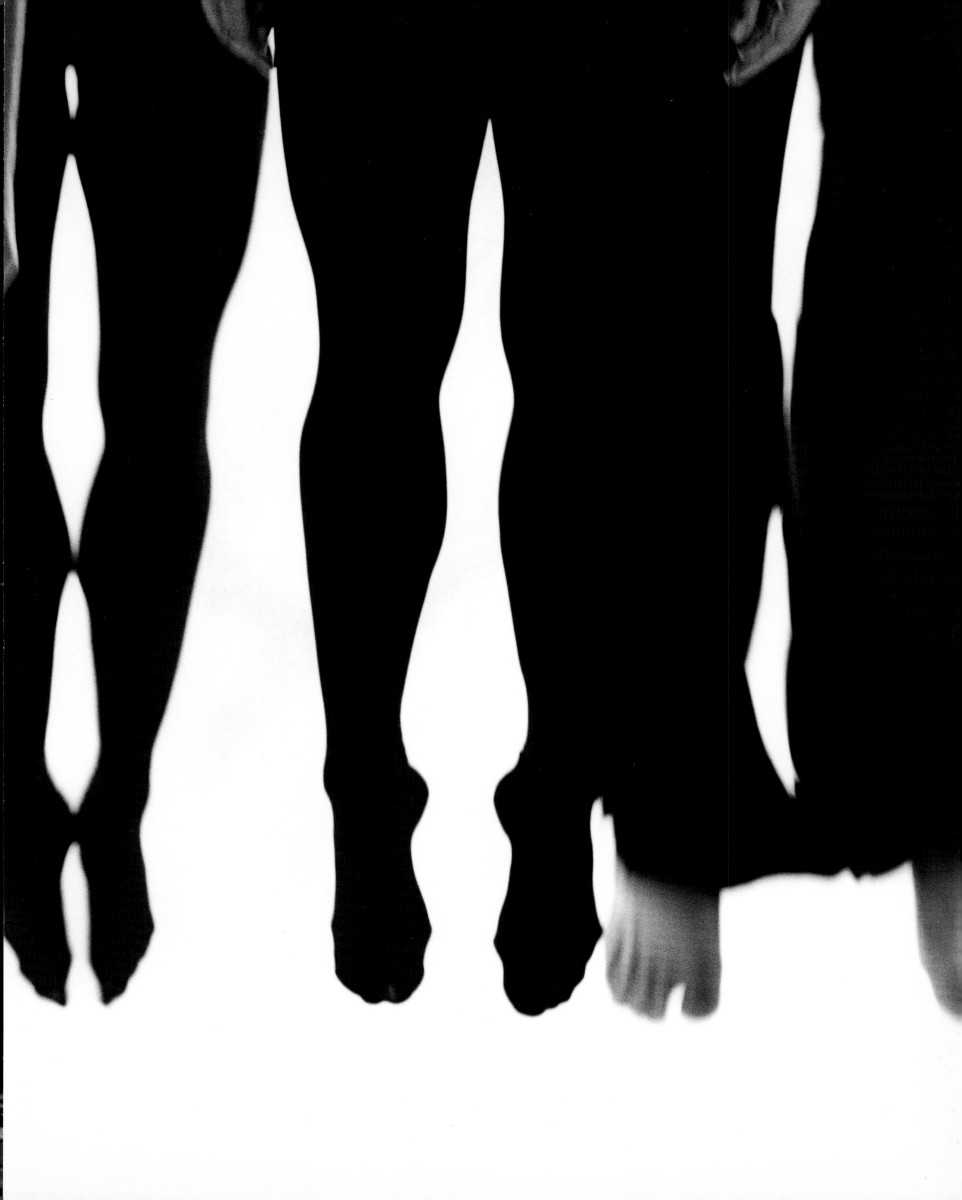

Published in the United States by powerHouse Books,
a division of powerHouse Cultural Entertainment, Inc.
37 Main Street, Brooklyn, NY 11201-1201
telephone 212 604 9074, fax 212 366 5247
e-mail: info@powerHouseBooks.com
website: www.powerHouseBooks.com

First edition, 2006

Library of Congress Control Number: 2006927726

Hardcover ISBN 1-57687-332-3

Book design and direction by Anthony Battaglia, produced by Catie Dyce
Box Communications PTY LTD [BoxTM] www.boxtm.com

Separations, printing, and binding by Oceanic Graphic Printing, Inc., China

A complete catalog of powerHouse Books and Limited Editions
is available upon request; please call, write, or move to our website.

10 9 8 7 6 5 4 3 2 1

Printed and bound in China

AS A CHILD, AND INDEED RIGHT THROUGH TO EARLY ADULTHOOD, MY SIGHTS AND DREAMS WERE ALL
FOCUSED ON ENGLAND. MY FAMILY, SINCE I WAS LITTLE, WAS SPLIT BETWEEN AUSTRALIA AND ENGLAND.
BY THE TIME I BECAME A PROFESSIONAL ACTOR AT THE AGE OF 26, I HAD SPENT A LONG TIME IN ENGLAND
WHILST NEVER SETTING FOOT IN THE US, LET ALONE DREAMING OF HOLLYWOOD AND BROADWAY.

FOR

The year I spent on Broadway with *The Boy from Oz* was the most rewarding (and probably the most exhausting) year of my professional life! Nothing could have prepared me for the warmth and vibrancy of the Broadway community and then there's the audience! Wow, you are never in doubt about how they are feeling. The energy that rushes onto the stage from the audience is like nothing else in the world! Life brings you many wonderful experiences if you are willing to go along for the ride and I feel honored that it has brought me to the **MOVE FOR AIDS** Project with James Houston.

I was a little shocked to find out that James had had some trying times when he first moved to New York, because my recollection is that for years I had tried to work with James, only to find him unavailable! But finally I got my wish earlier this year...and it was worth the wait. Not only is James one of the nicest, most warm-hearted people I have met, he is also incredibly talented. James is an artist first, dedicated to capturing that "moment," that slice of "magic." His preparation is second to none and yet when he starts working it all seems completely spontaneous. Oh by the way did I say perfectionist? I now know with great certainty the exact position for my fingers to be in, at all times!

It is no surprise that an artist with this much passion would be drawn to another artistic discipline of equal passion and dedication. As you know, there is nothing passive about the Broadway community. Their commitment to training, rehearsals, and the performances themselves are like nothing you can imagine. The broader involvement of the Broadway community in many charitable causes is just an extension of that passion and commitment. In particular, the efforts of Broadway Cares/Equity Fights AIDS, and its fundraising program—Dancers Responding to AIDS—are extraordinary. Through after-show auctions and other events, over 1 million dollars was raised by *The Boy from Oz* alone!

AIDS, as we all know, has had a devastating effect on the arts community, but I was shocked to discover that 40 million people currently have AIDS, and more people continue to get it everyday. It is still very much a crisis situation. I applaud, whole heartedly, what James is venturing to do with this book. His use of performers and their images to display beauty and tell the story of their expressive challenges, all to benefit the worldwide fight against AIDS, is a tremendous effort. I don't mean to steal from the title, but the images in this book moved me tremendously. I am constantly amazed at how the human form can express such depth of emotion, and James seems to relish every angle, every nuance, every deep-seated dream...yearning...frustration of his subjects. And James' generosity is as inspiring as his talents. He is graciously donating the author royalties for the book sales to Dancers Responding to AIDS so they can continue to battle this nondiscriminatory epidemic.

James, let me be the first to congratulate you on the beauty and excellence of the book. And let me be one of many to applaud your humanity and generosity! I am honoured to be contributing to this project.

Oh and I need you next month for a shoot! Cool?

WORD

HUGH JACKMAN

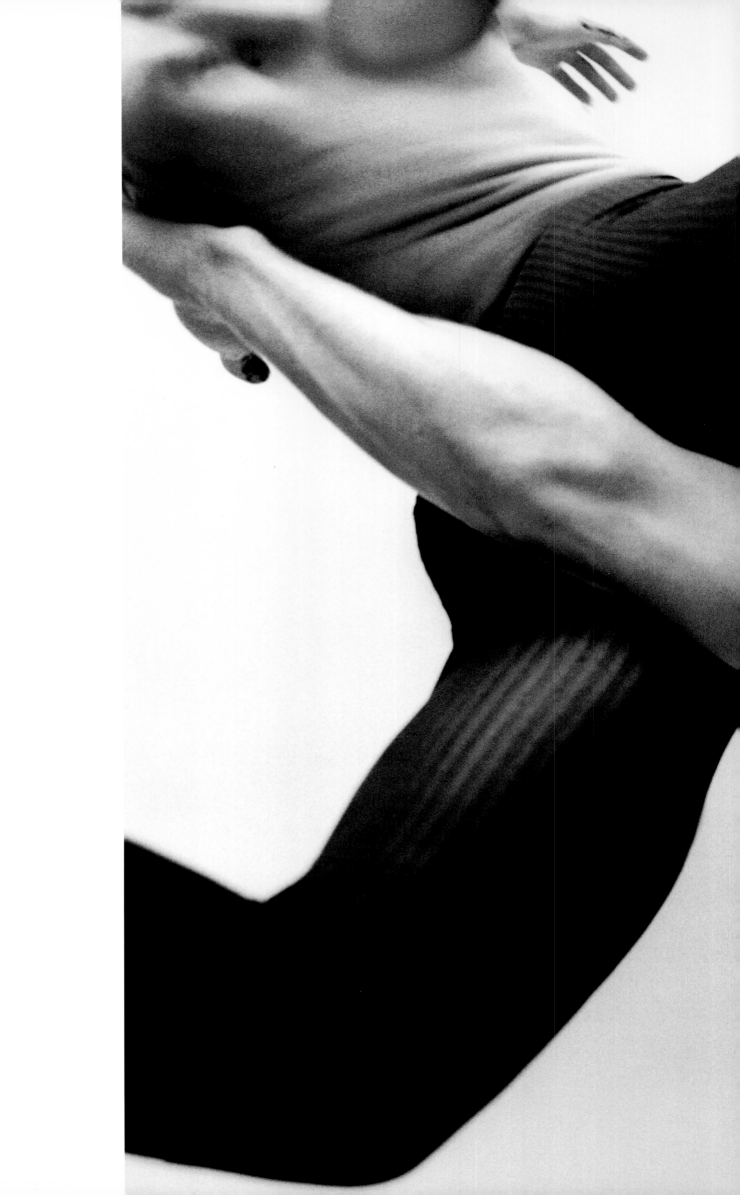

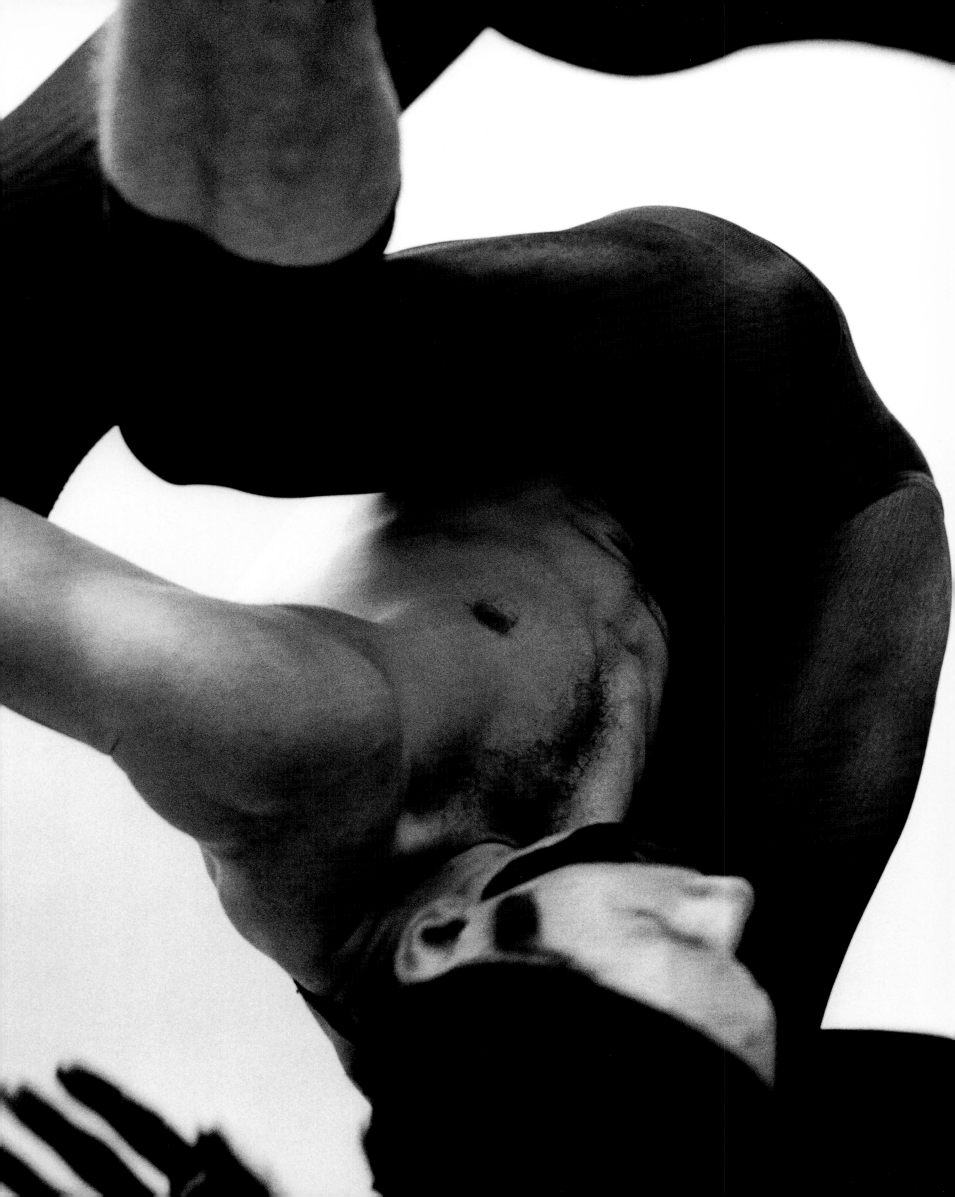

MOVE TO CHANGE IN POSITION FROM ONE POINT TO ANOTHER.
TO ALTER POSTURE…TO STIR THE EMOTIONS….

INTROD

I moved to New York from Sydney, Australia, in March 2000, in a tectonic shift that involved all of the above definitions of the word "**MOVE**" and so much more. Had I known the challenges that lay ahead, I might have reconsidered. New York is a hard nut to crack, perhaps the hardest. I left behind a thriving photography career in Sydney, one I had spent 10 years building, to essentially start anew. But that's New York. Its gravitational pull, its silver spires, its commercial promise make you take a leap of faith.

In the beginning I faced lukewarm reactions, dubious agents, months of unemployment, and dwindling funds. I literally wore out a pair of shoes walking the Manhattan streets on appointments, often catching myself standing in a snowstorm with two huge portfolio bags to keep me grounded, and seriously maxed out a few credit cards along the way. A year later, from my tiny East Village studio, I watched, horrified, as the Twin Towers fell. That episode, combined with a lack of opportunity, drove me to Los Angeles in search of work. The city of angels didn't offer much solace either. Truth be told I spent most days watching *E! True Hollywood Story*, which, strangely enough, I found inspiring. Here were people who had been through much tougher times than I.

In the spring of 2002, lured by the promise of work, I moved back to New York and things began to gradually fall into place. During this experience I relied heavily on the support of my close friends and confidantes and I can't thank these people enough for their support (especially Richard LeMay and Fred Jones in New York and Justin Melvey in Los Angeles). Not surprisingly the themes in this book—darkness, fear, sexuality, hope, joy and enlightenment— reflect my own personal journey. The book could be viewed as a follow-up to an earlier work, **RAWMOVES**, published in Australia. That tome spotlighted dancers from three leading companies, Sydney Dance Company, Bangarra Dance Theatre, and the National Ballet.

It was here that I first explored my passion for the human form, for juxtaposing bodies in motion to create arresting new shapes. An erstwhile sculptor, I am fascinated by the human body and its limitless possibilities, its sinuous grace. **MOVE** was inspired by the annual New York show *Broadway Bares*, in which dancers from leading theatrical productions and New York companies band together for Broadway Cares/Equity Fights AIDS, the United State's leading industry-based organization raising funds for the care and comfort of those living with HIV/AIDS. All my author royalties from **MOVE** will go to DRA (Dancers Responding to AIDS), the dance world's ongoing response to the AIDS crisis.

The book was shot in two installments. The first in late 2001; the second in late 2003. The project was self-funded, and I depended on the generous contributions of photo assistants, hair stylists, makeup artists, fashion editors, and friends. Though I often spend weeks before a shoot sketching ideas, I tend to work from instincts once in the studio. My chief stipulation was that the shots **MOVE** the reader with the same energy invoked to produce them. I also looked to the dancers for ideas, encouraging them to add layers to the ideas and visions I had.

Dancers at this level are uninhibited, innovative, fearless. More than a well-oiled machine, their bodies are their livelihood and an outlet for artistic expression. The dancers in this book came from different companies, shows, and backgrounds, and gave me so much of themselves. There is a lot of nudity in this book but I don't consider it gratuitous. It's a chance to witness the human form working in its rawest and most sublime state. I hope you enjoy the book as much as we enjoyed creating it.

JAMES HOUSTON

MOVE FOR AIDS SPONSORED BY HUGO BOSS WWW.HUGOBOSS.COM

H U G O B O S S

ALL AUTHOR ROYALTIES FROM **MOVE** WILL BE DONATED TO DANCERS RESPONDING TO AIDS WWW.DRADANCE.ORG

IN MEMORY OF PETER CHUCK, MAY 1959–MAY 2000

THIS BOOK IS DEDICATED TO PETER CHUCK, WHO I KNEW THROUGH THE MODELLING WORLD IN AUSTRALIA. PETER WAS A REAL CHARACTER AND LOVED LIFE. PETER WAS ALSO THE FIRST PERSON I HAD KNOWN PERSONALLY THAT WAS DIAGNOSED WITH HIV/AIDS. OVER THE YEARS MY GOOD FRIEND LOUISE PATRICK AND I WOULD GO TO HIS APARTMENT IN DARLINGHURST TO SPEND TIME WITH HIM OR ATTEND SOME OF THE MANY COCKTAIL PARTIES HE HOSTED. PETER'S PARTNER AND FRIENDS SUPPORTED HIM WITH SO MUCH LOVE RIGHT UP UNTIL HE PASSED AWAY. FOR ME IT WAS A VERY SURREAL EXPERIENCE AND ONE THAT DEFINITELY BROUGHT AIDS A LOT CLOSER TO HOME.

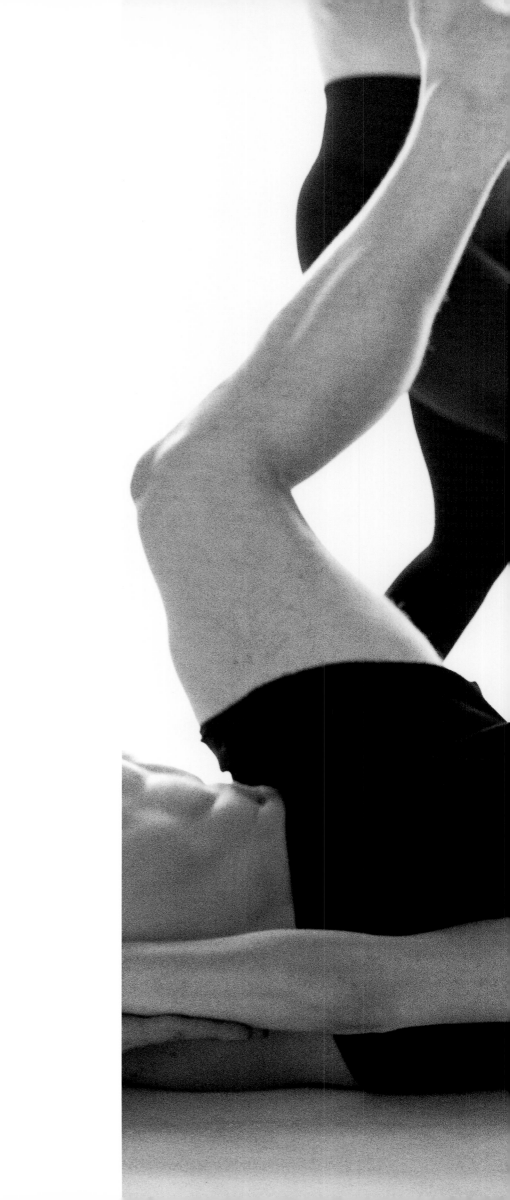

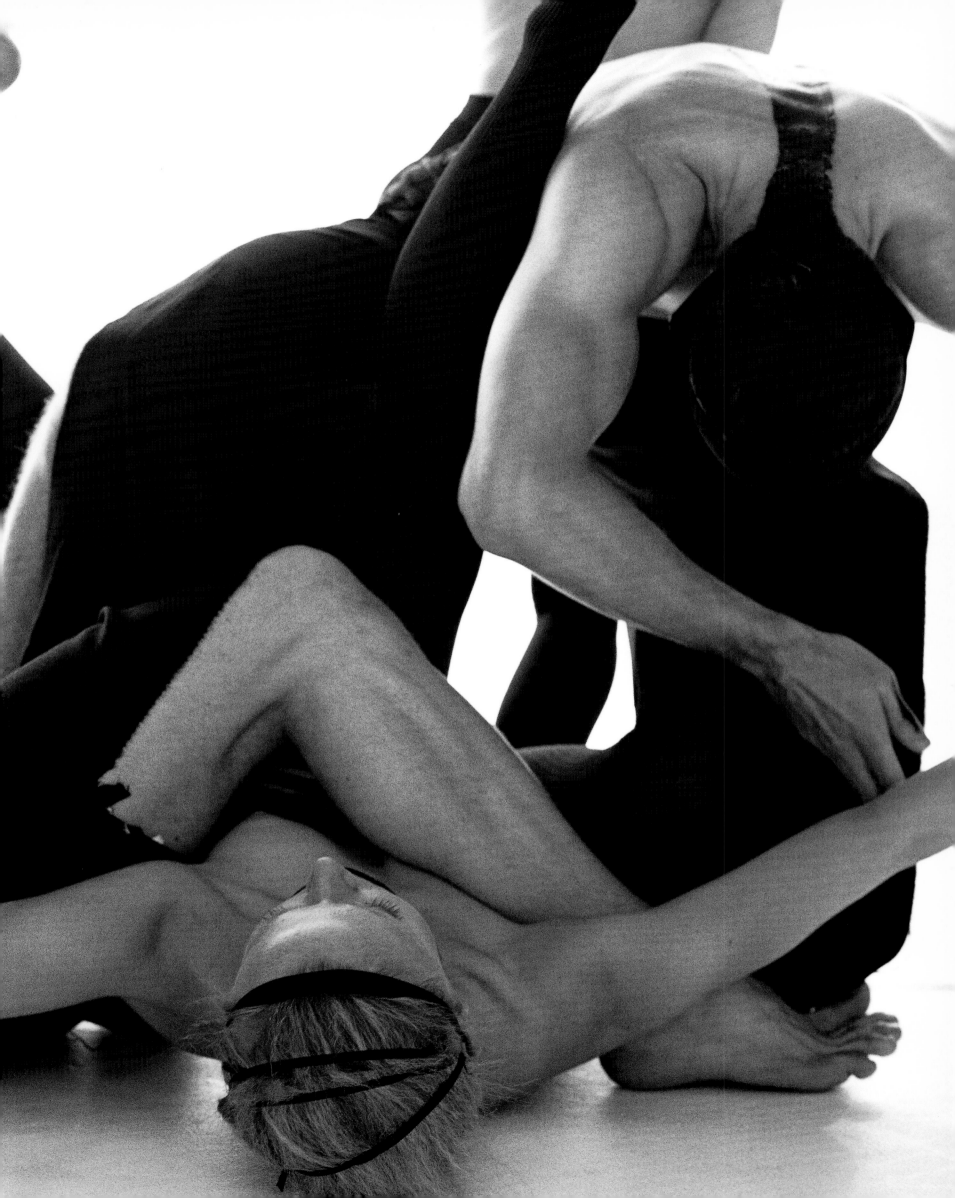

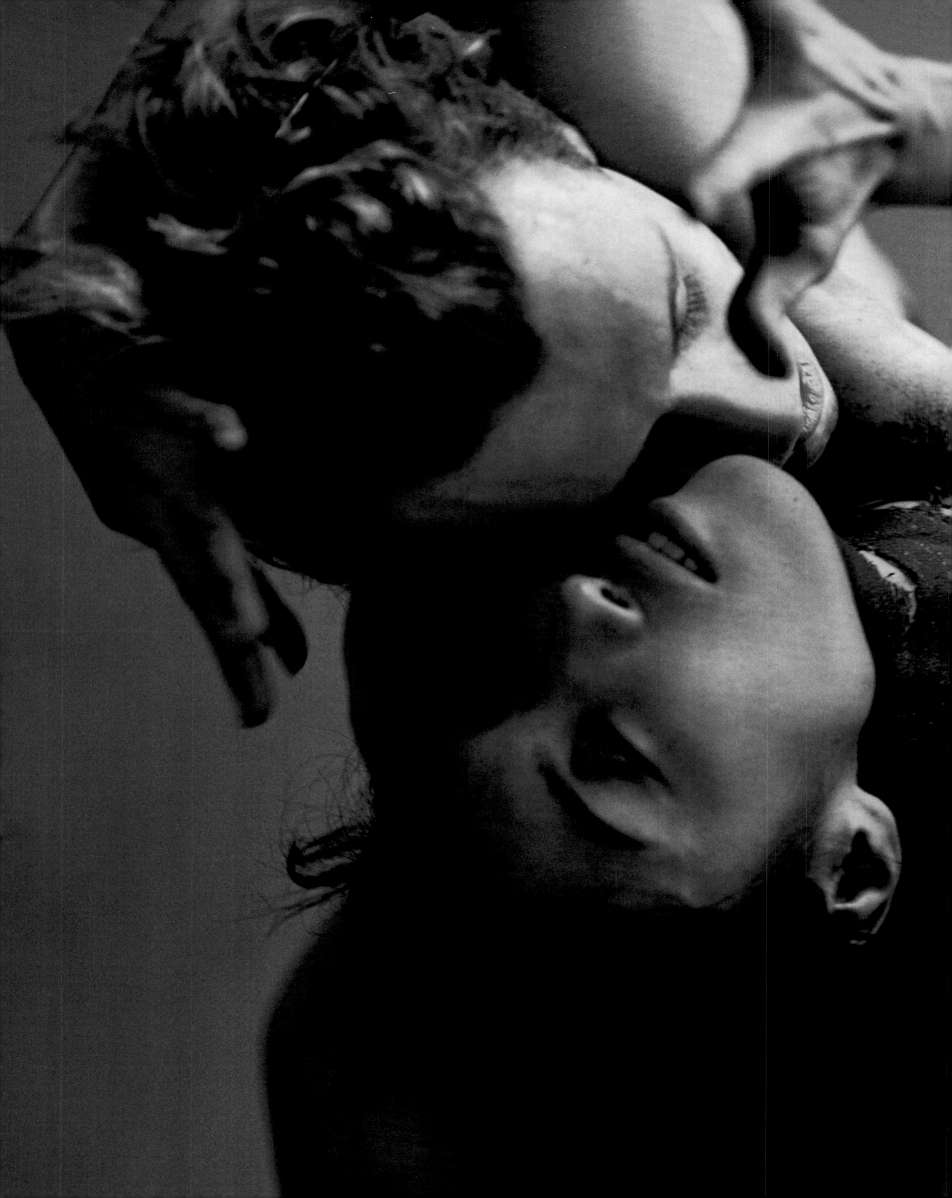

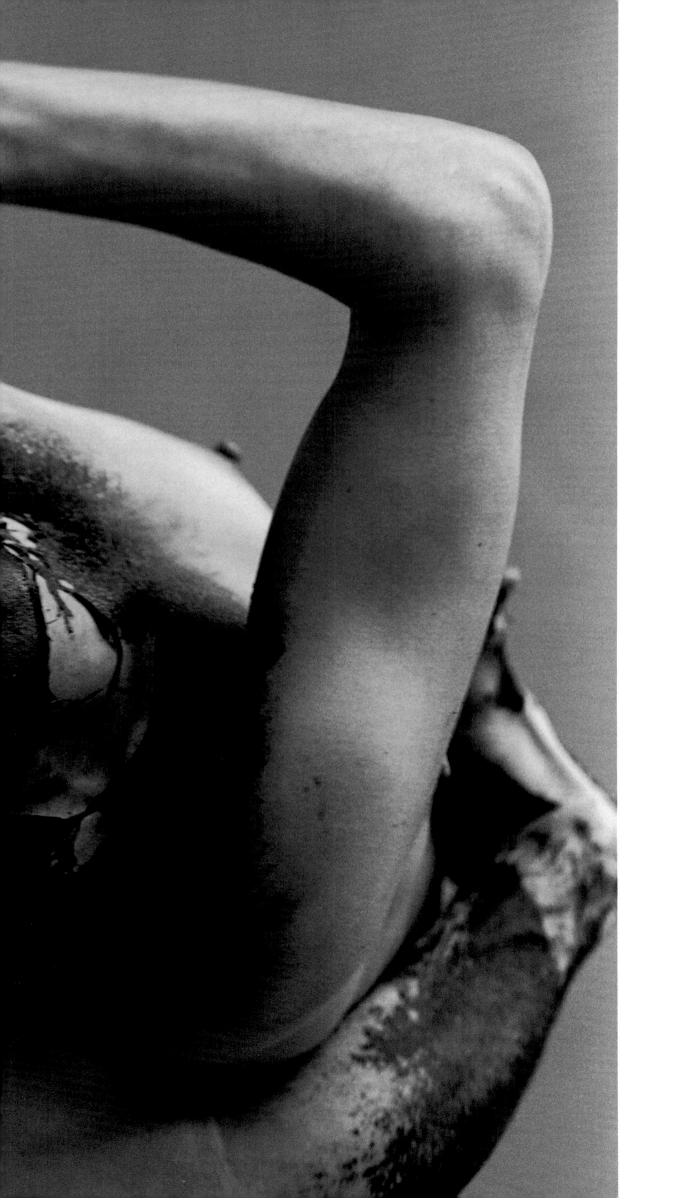

06

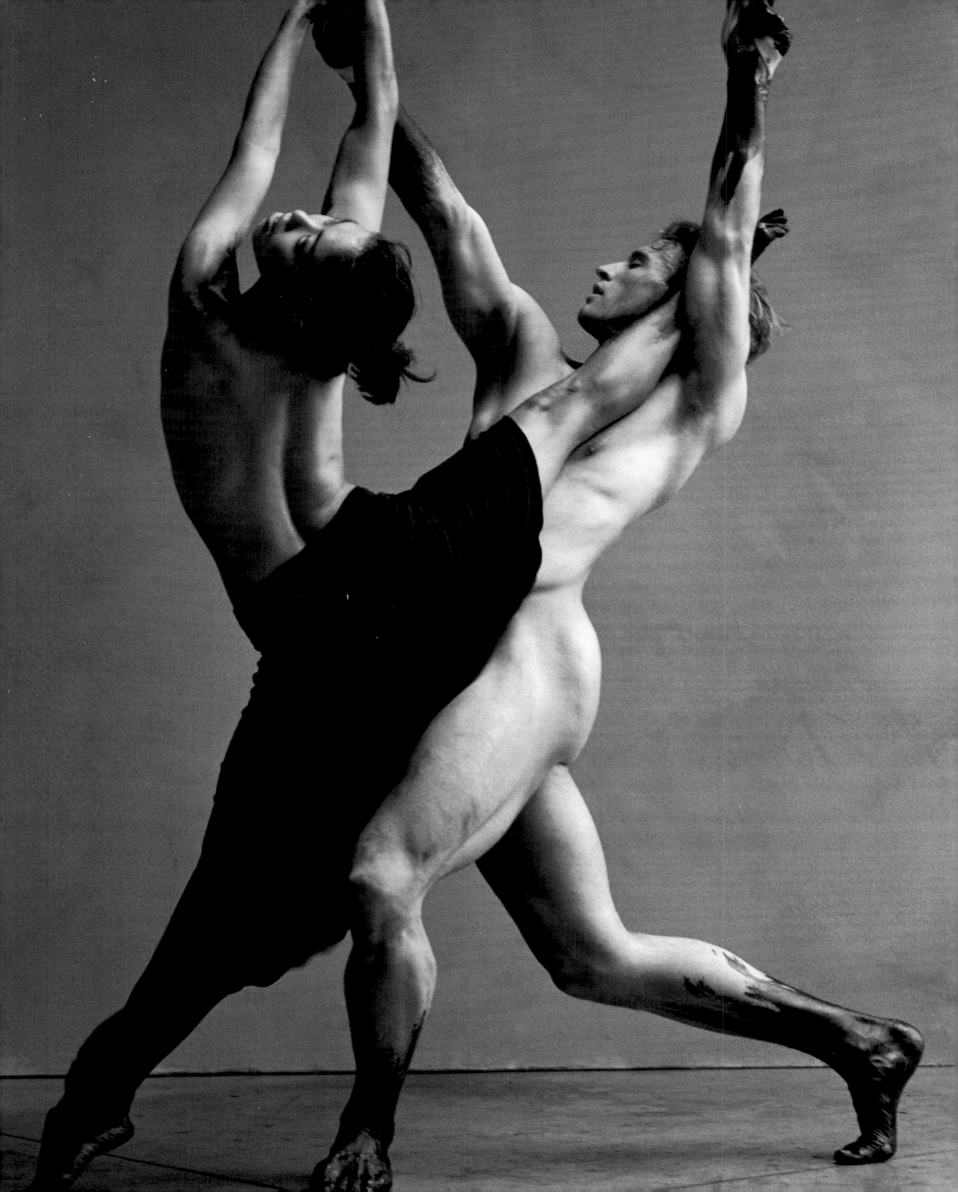

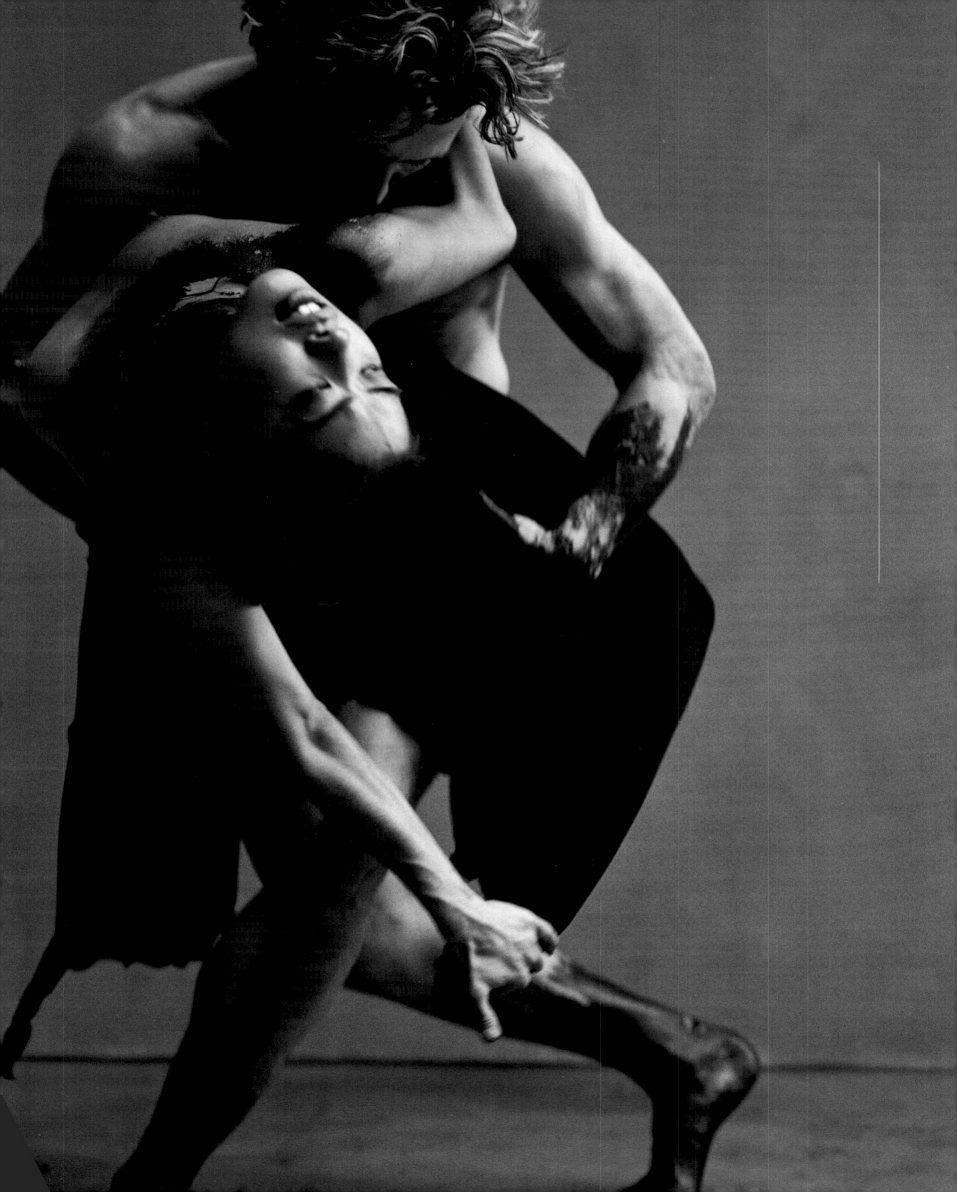

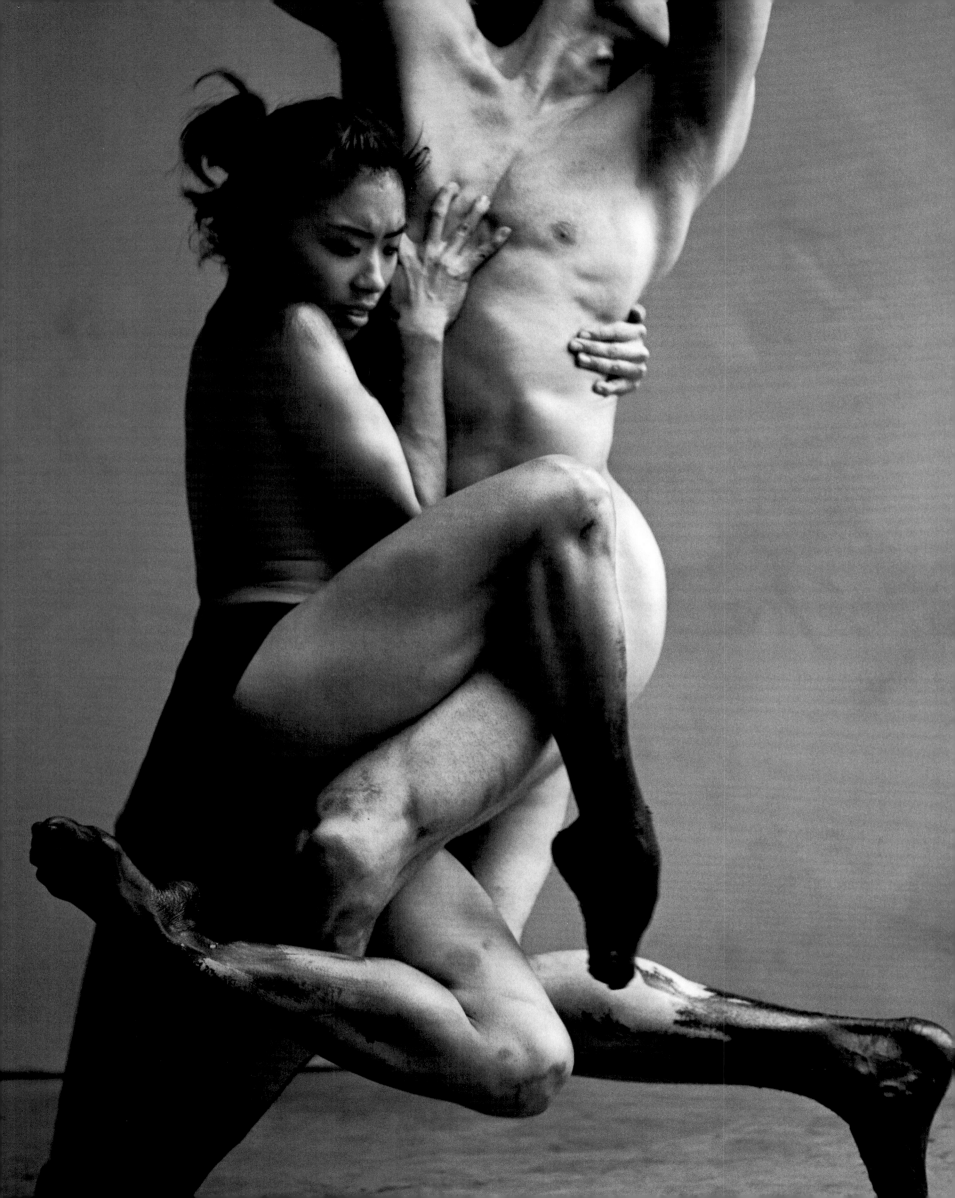

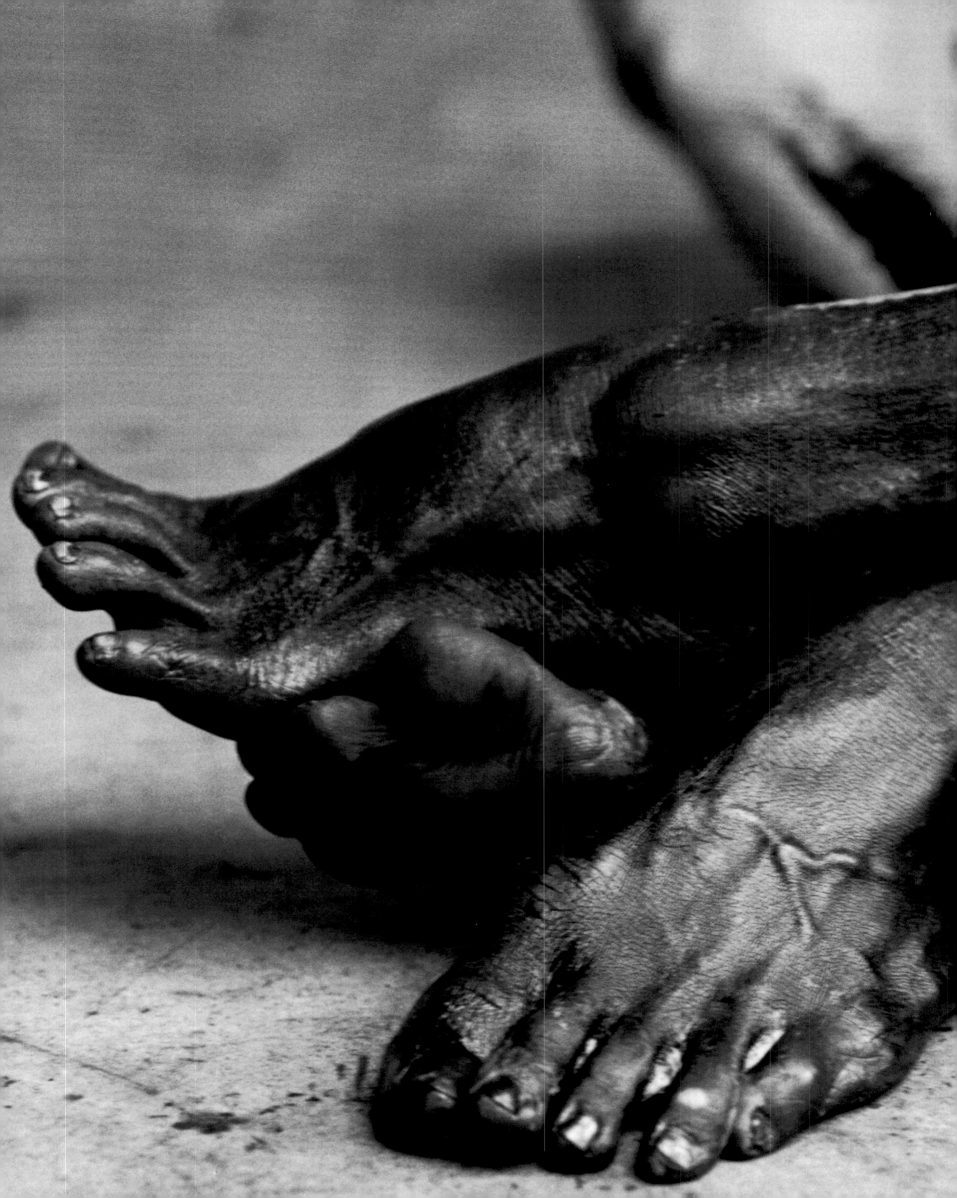

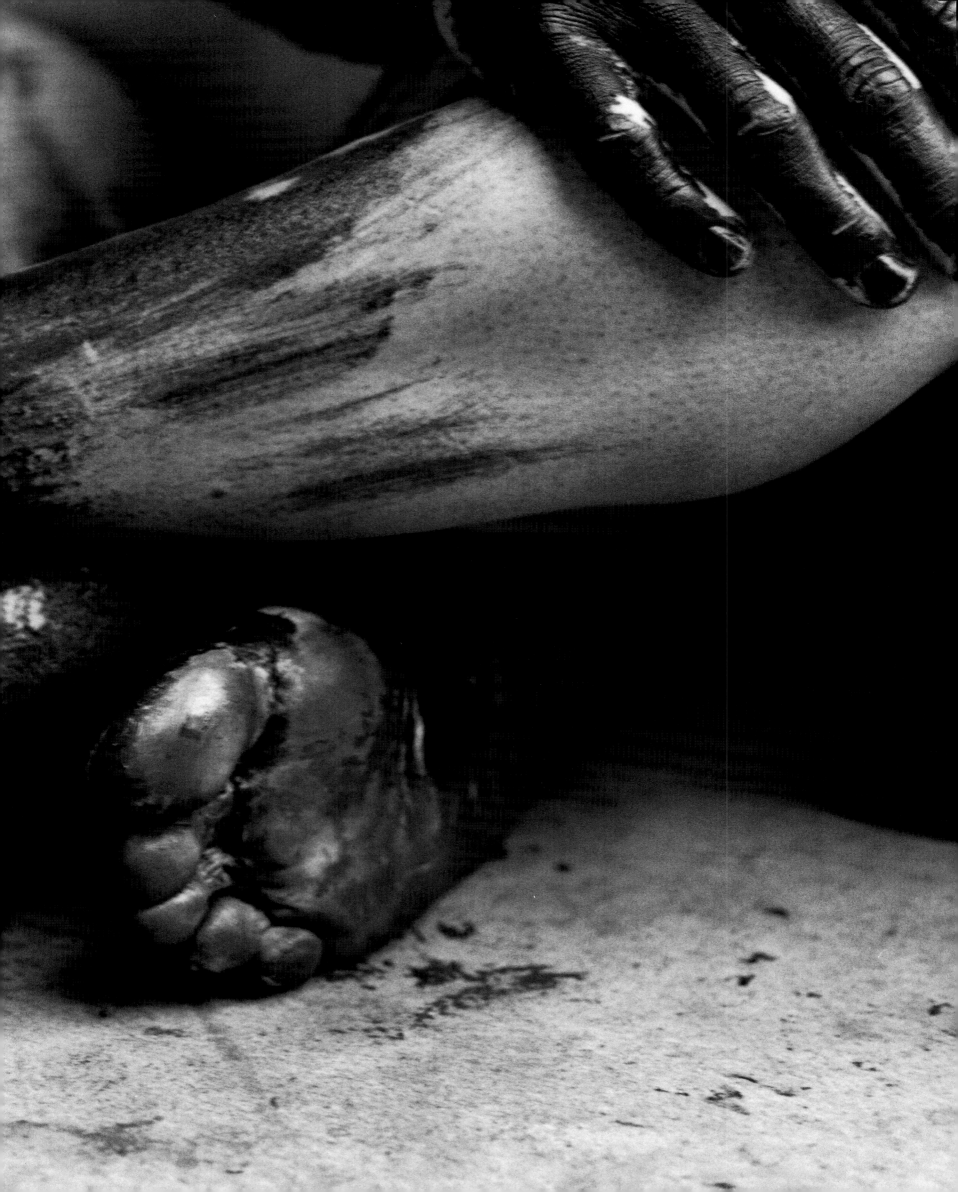

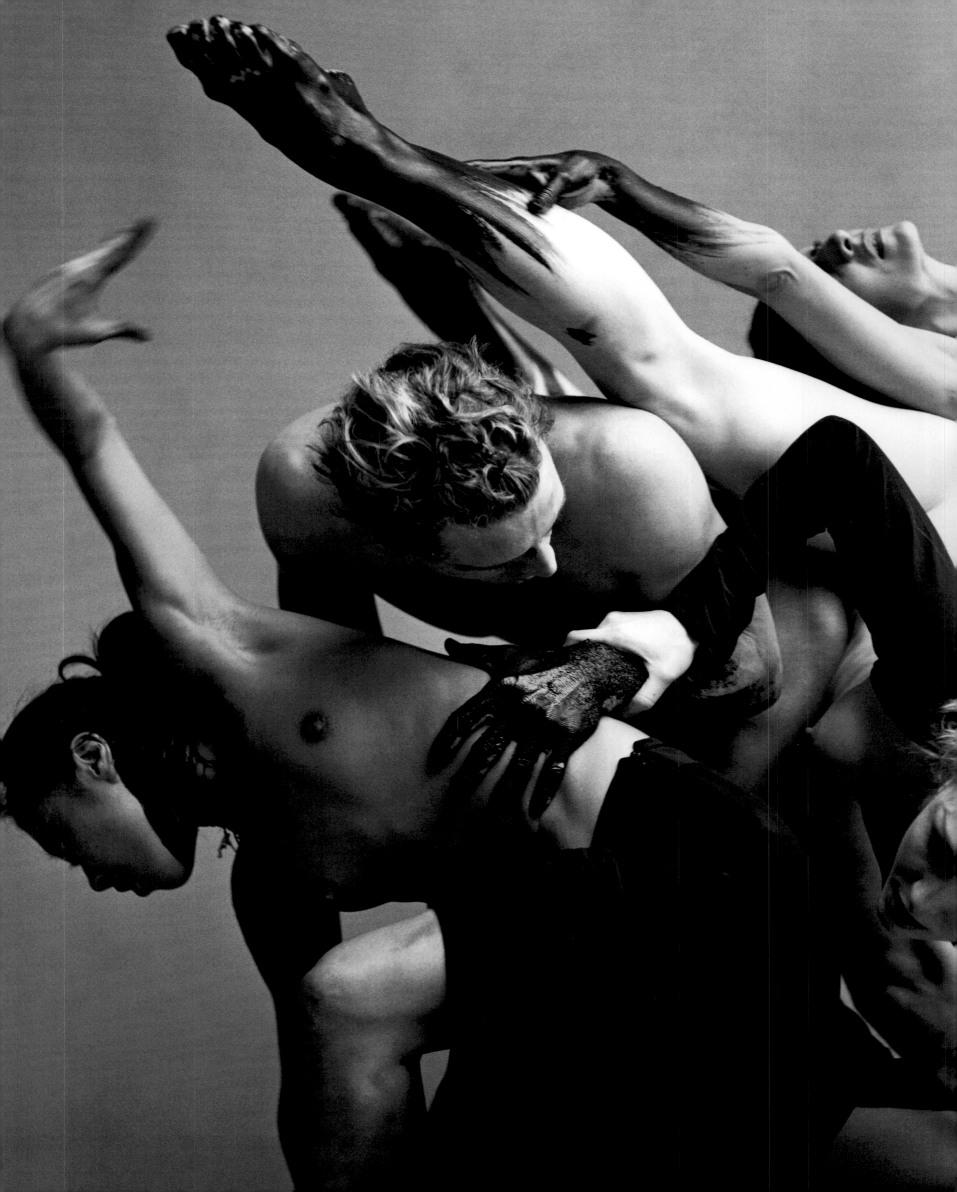

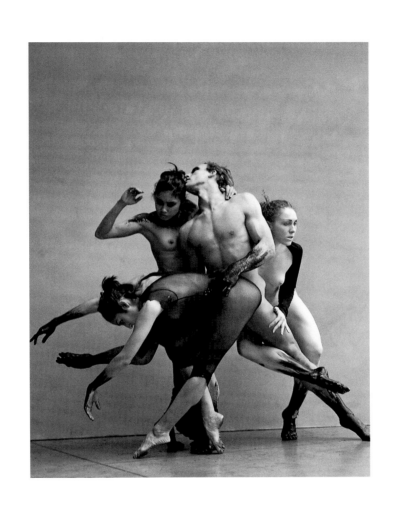

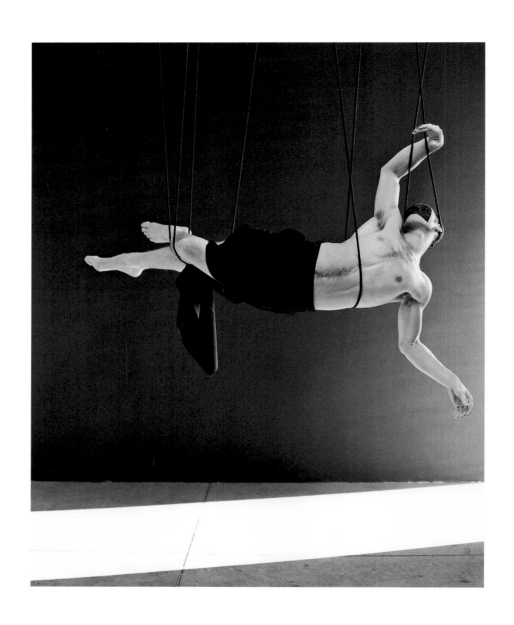

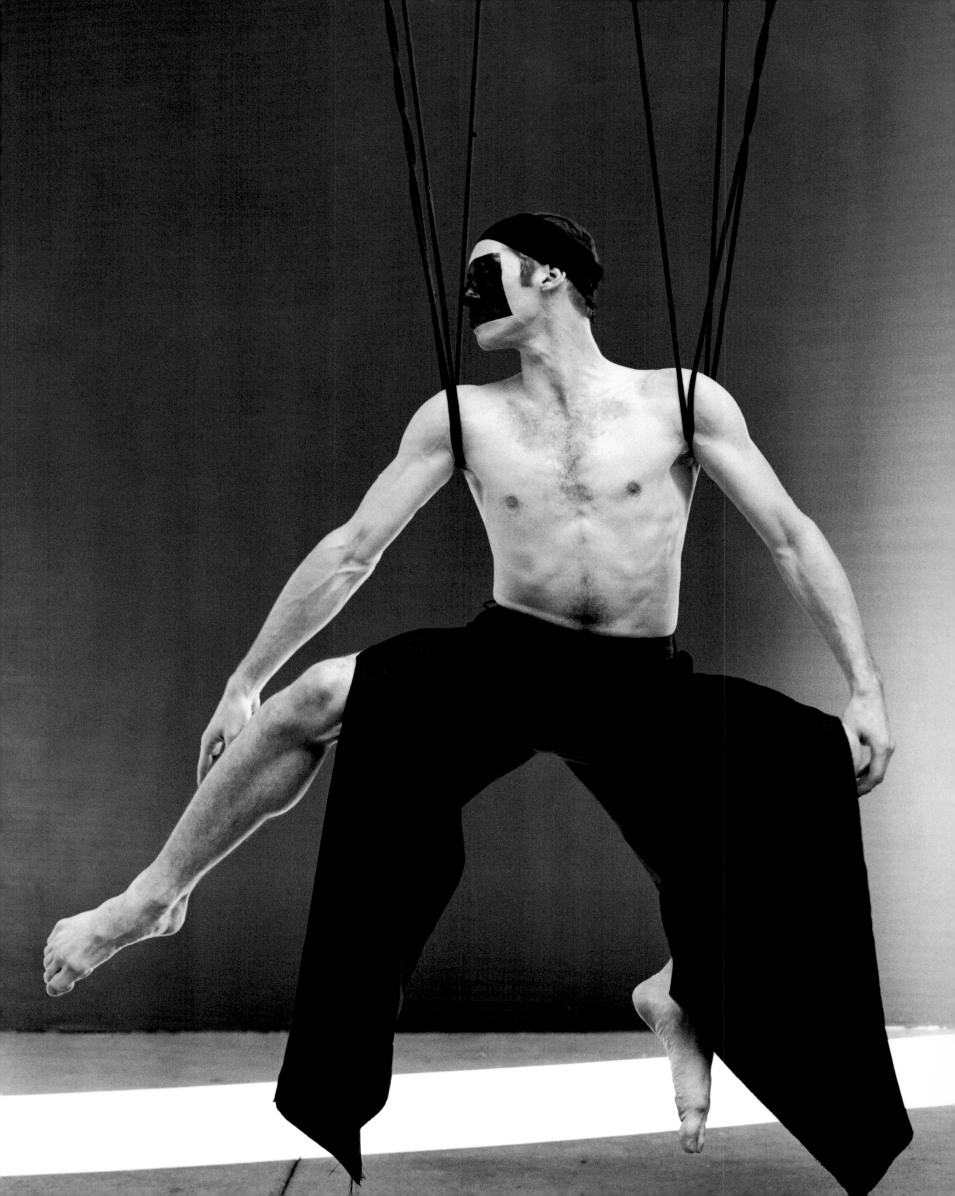

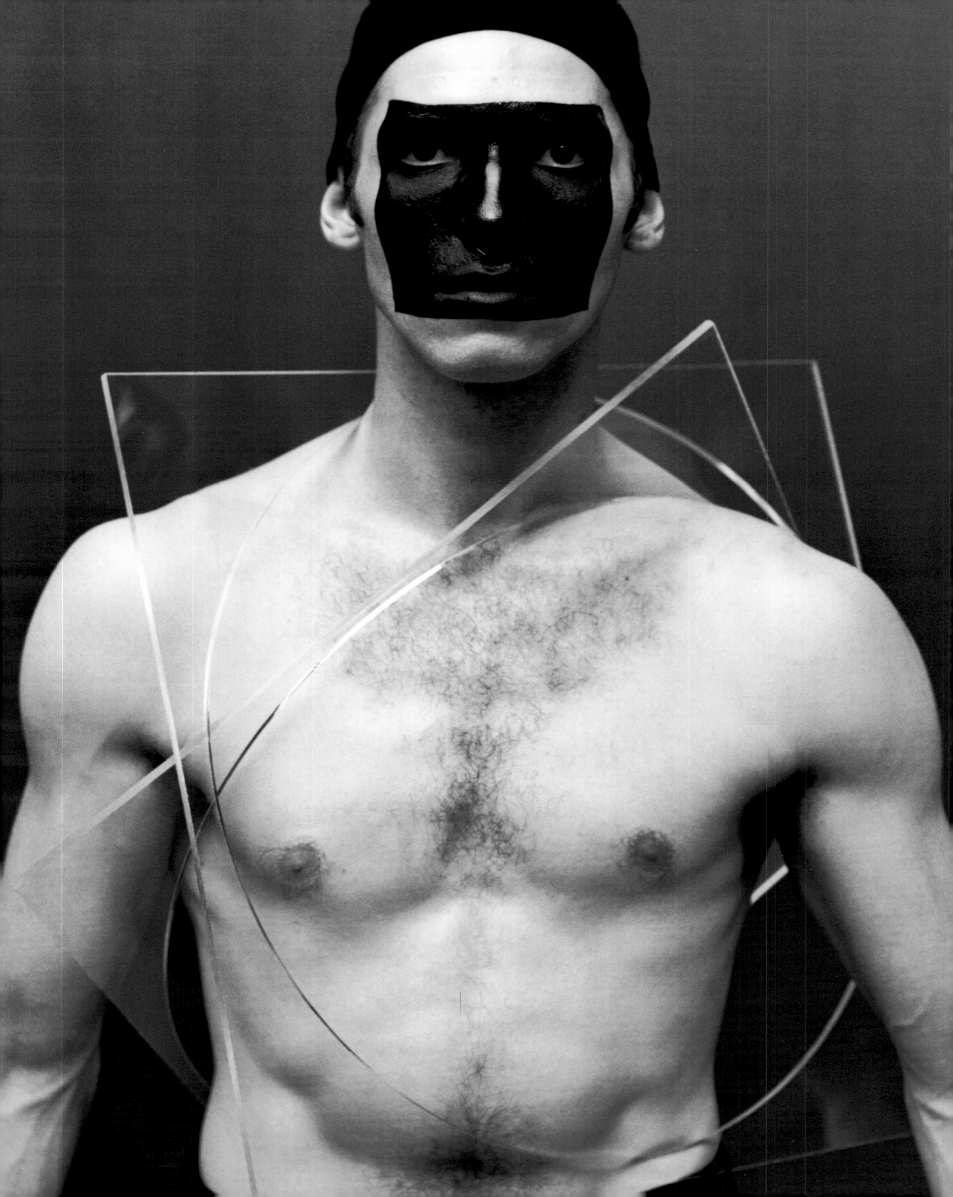

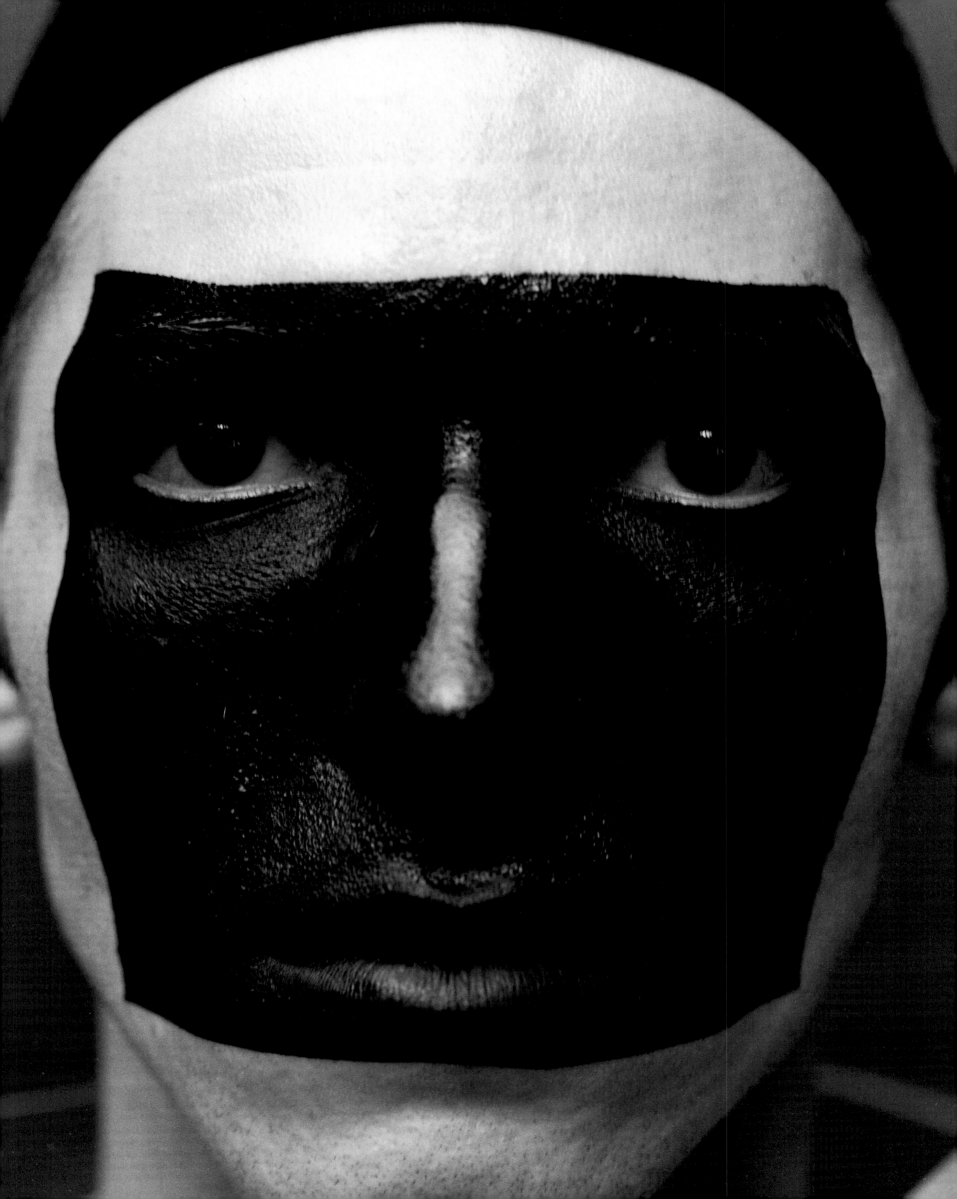

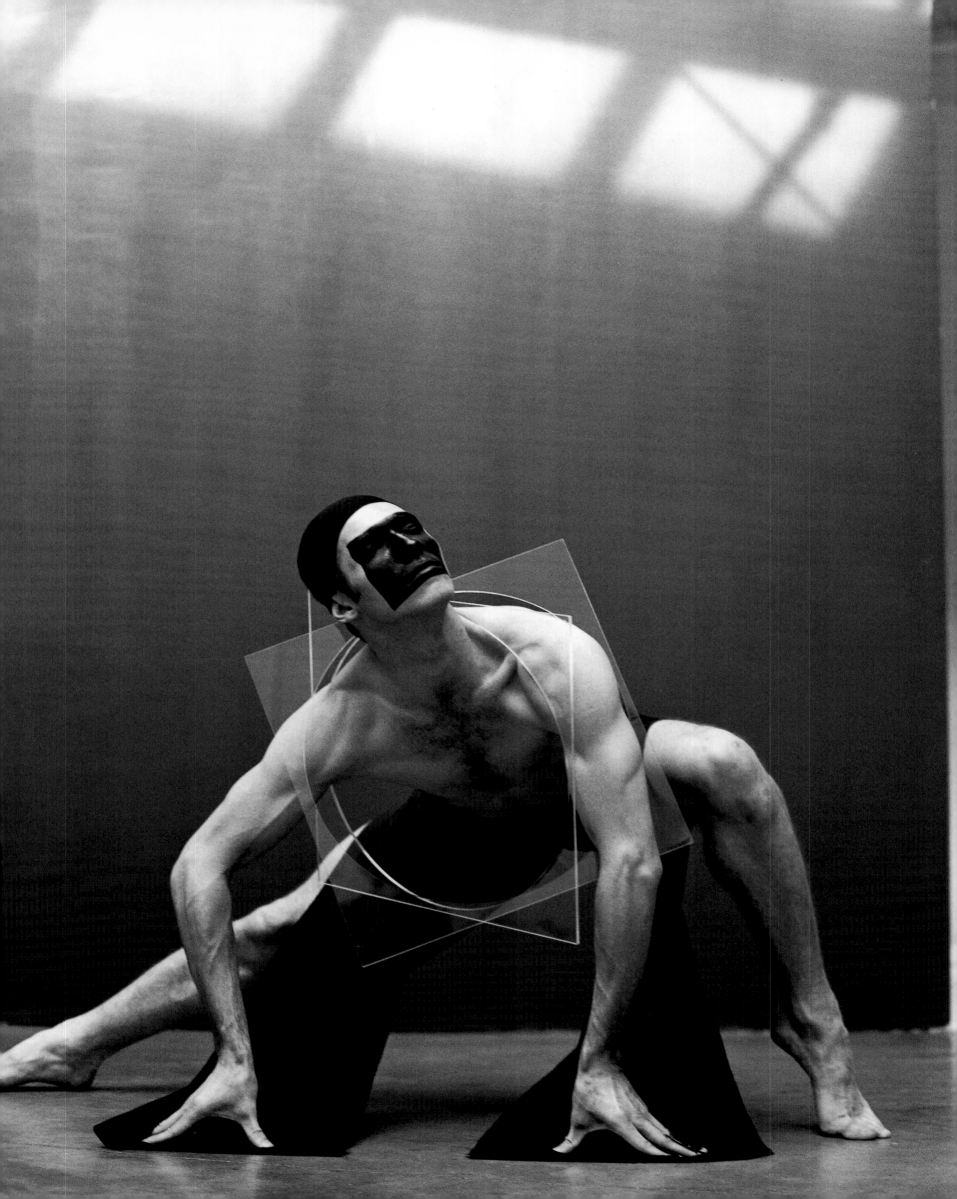

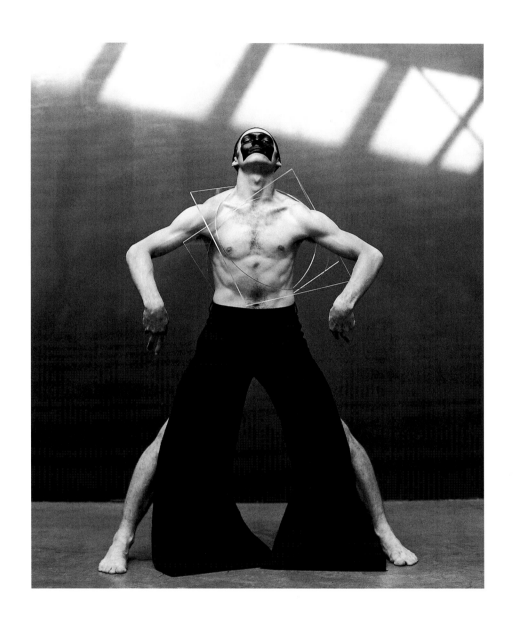

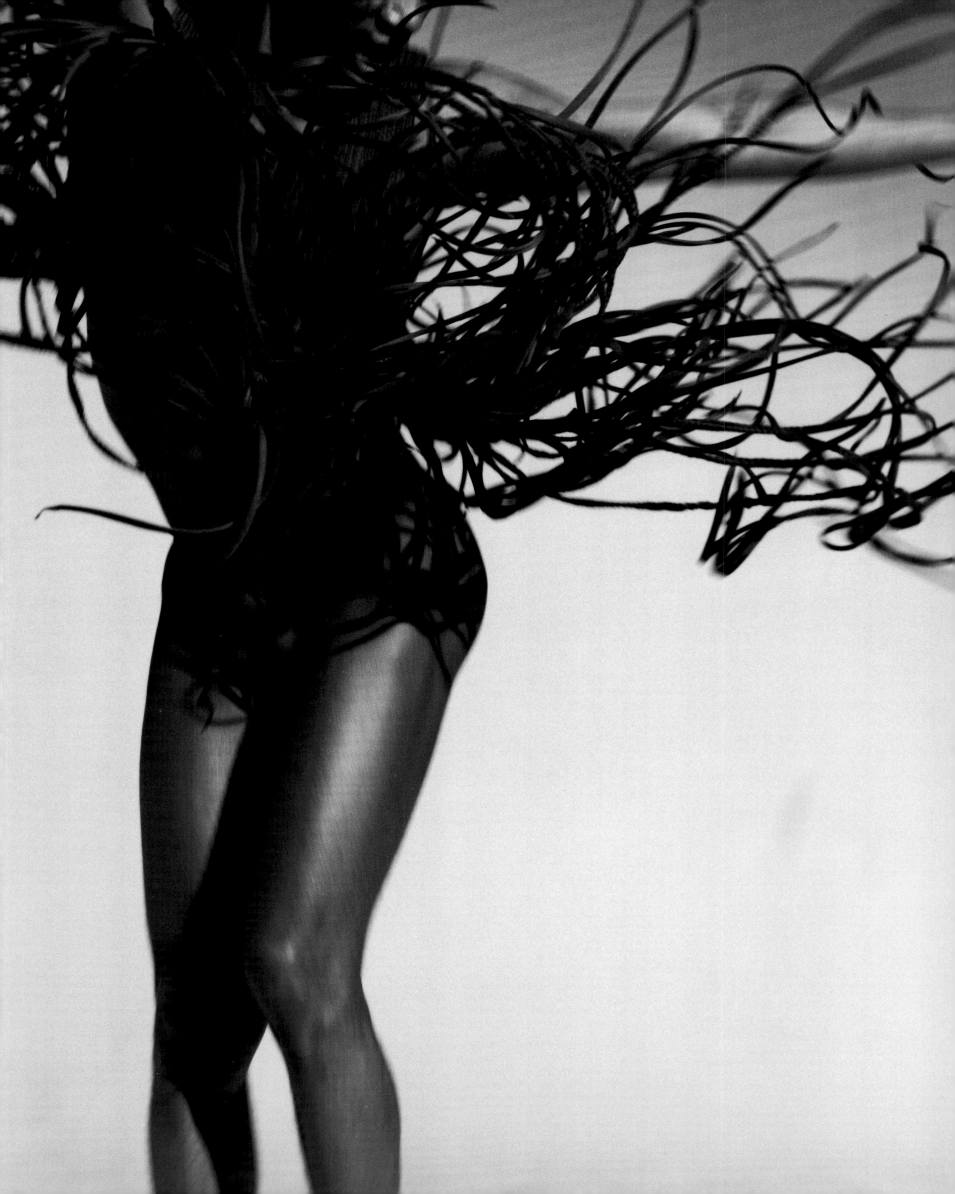

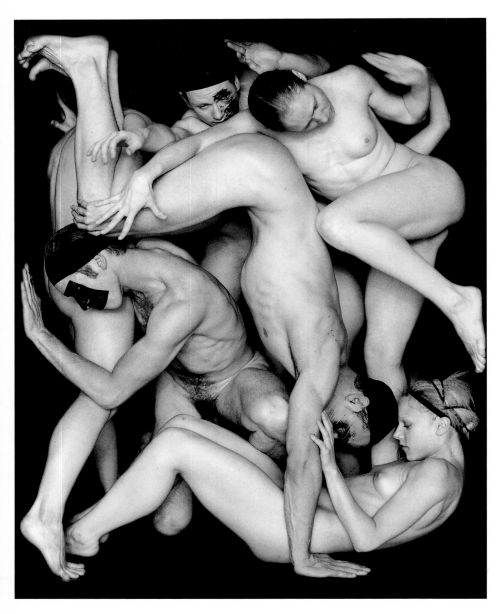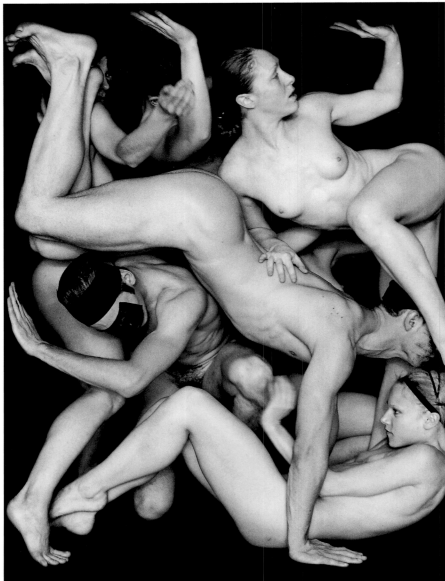

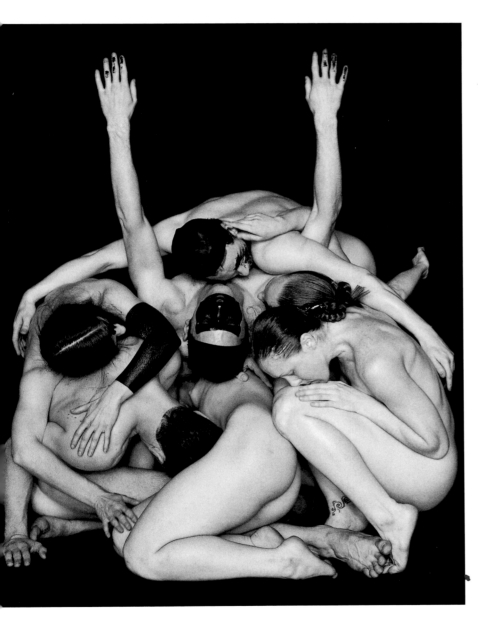
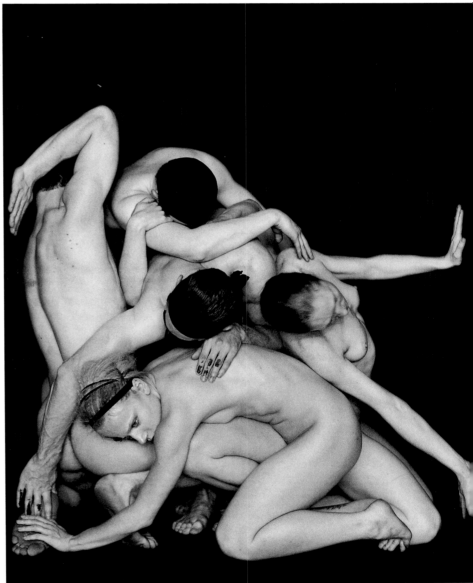

24

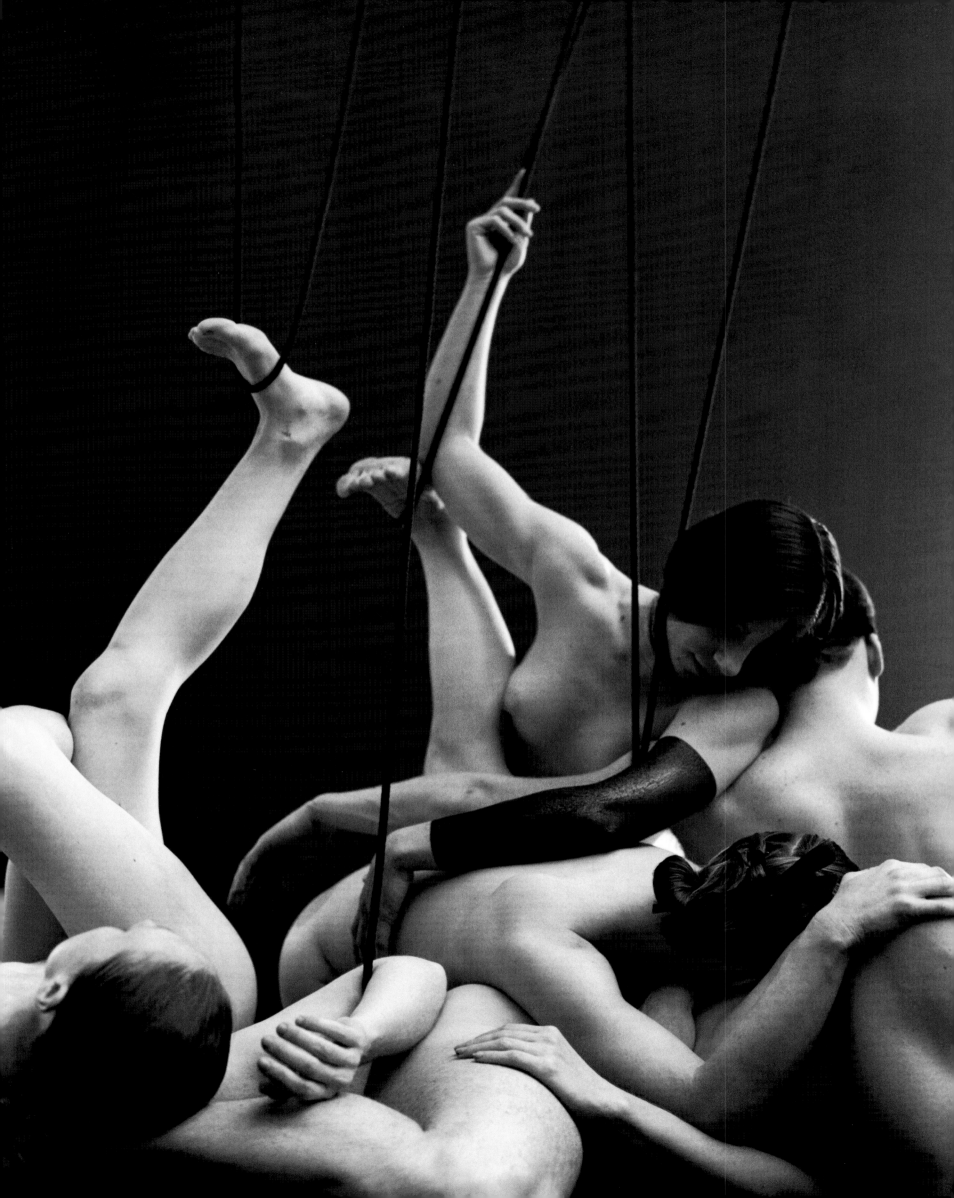

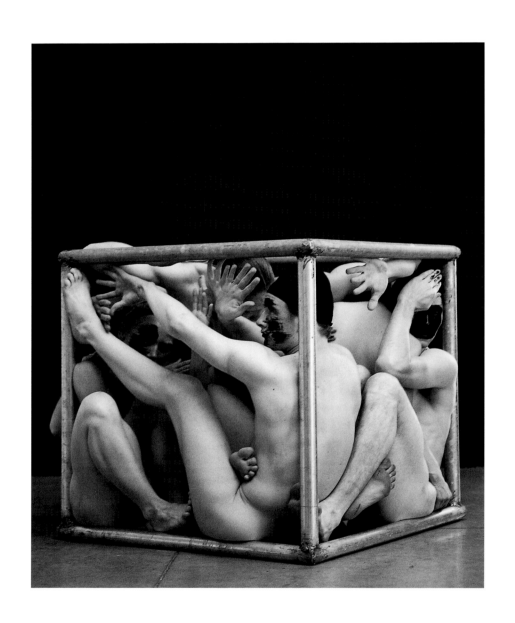

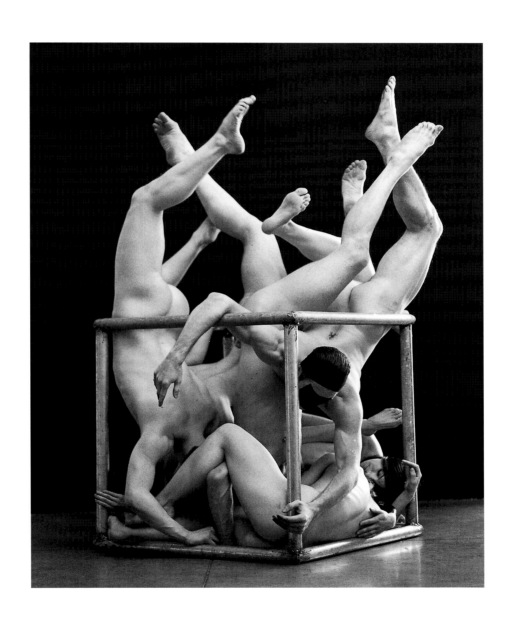

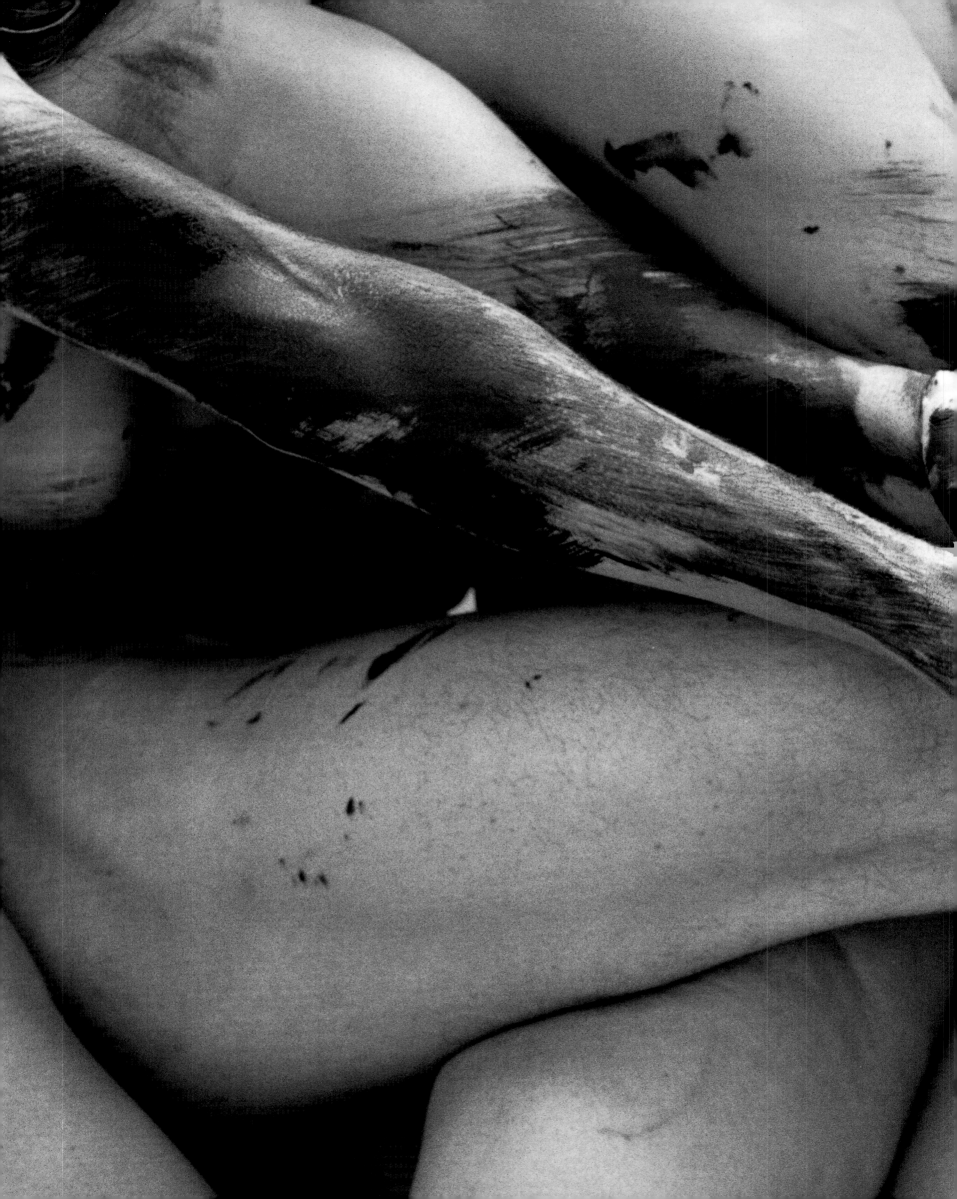

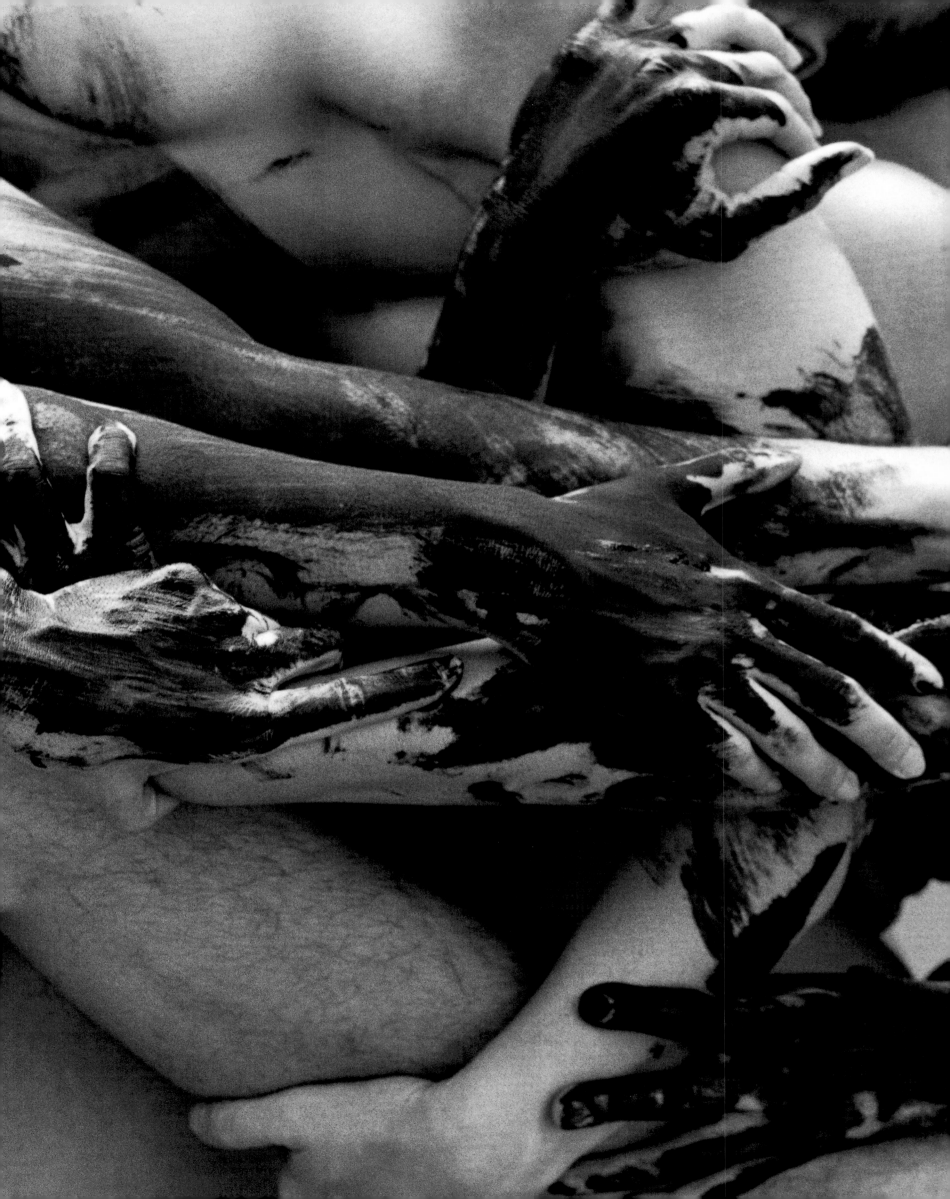

30

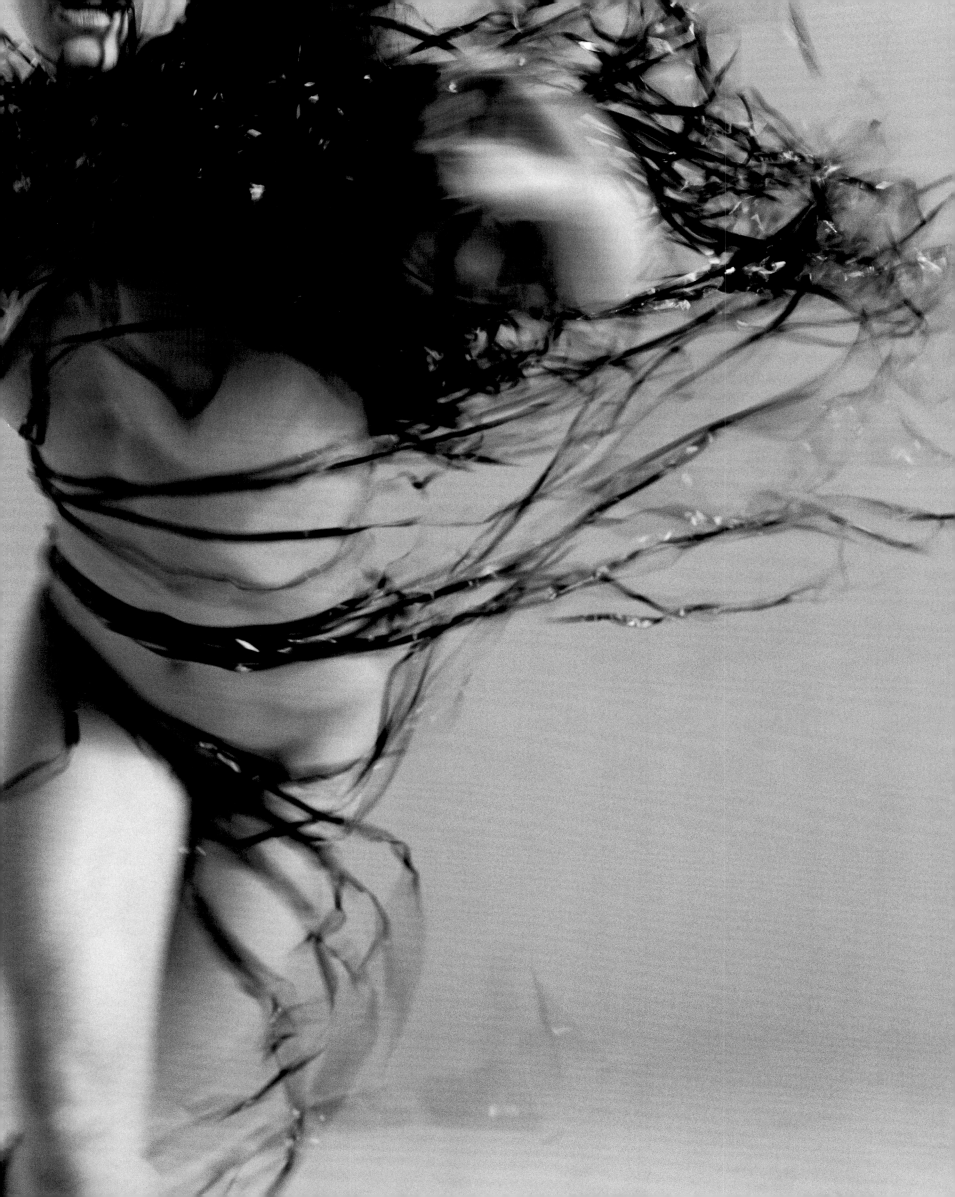

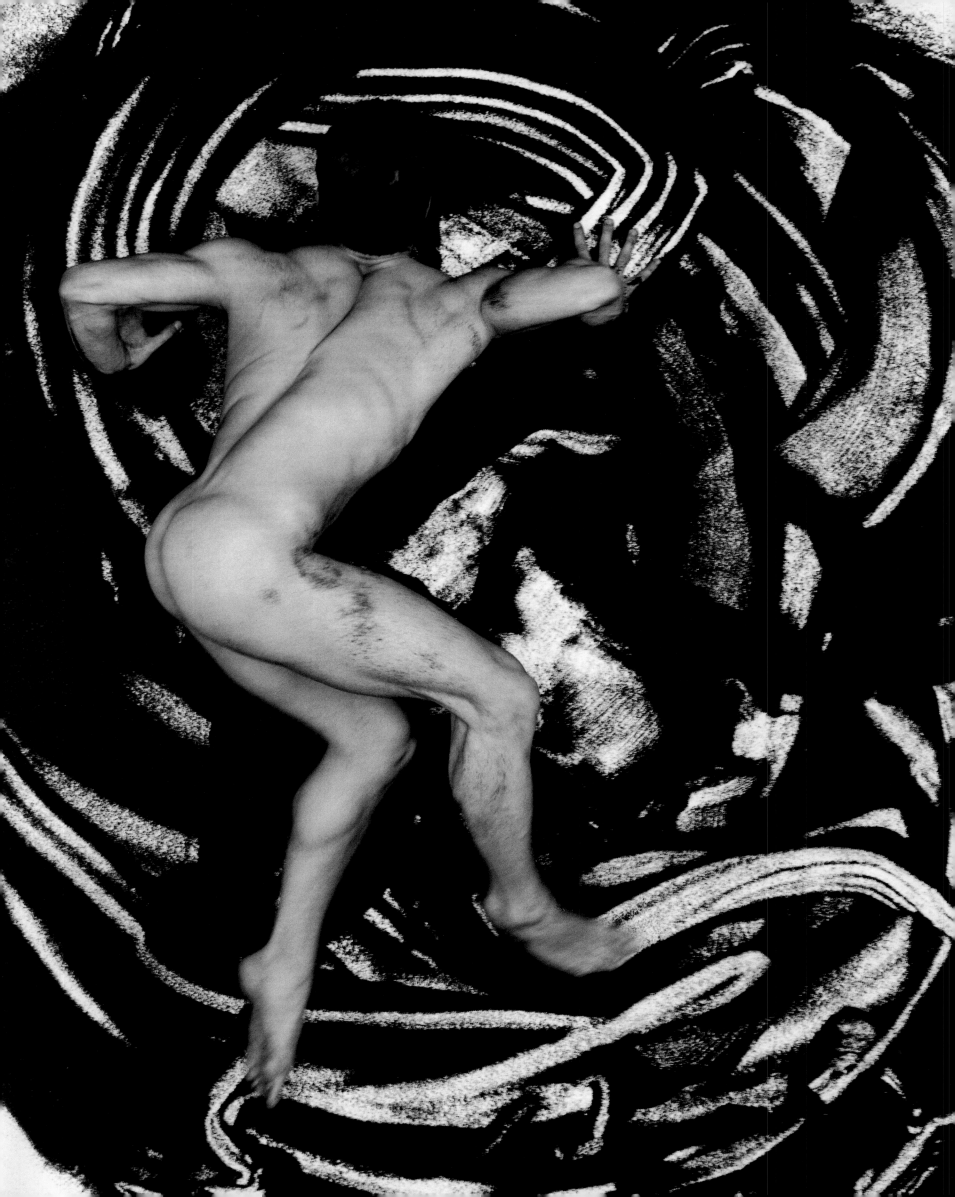

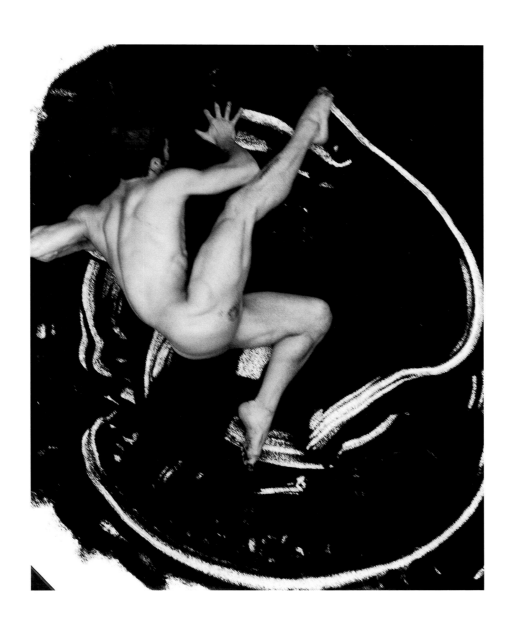

34

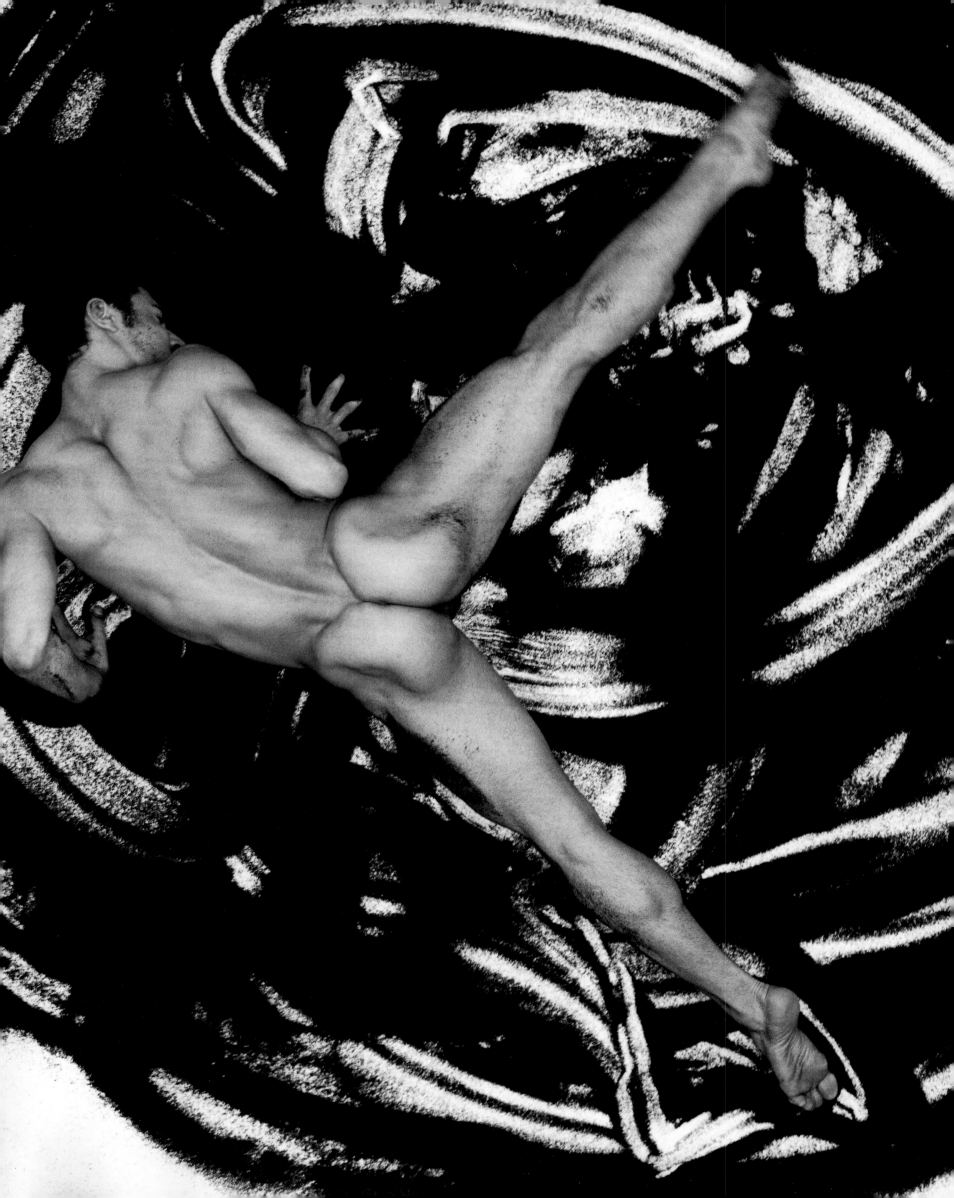

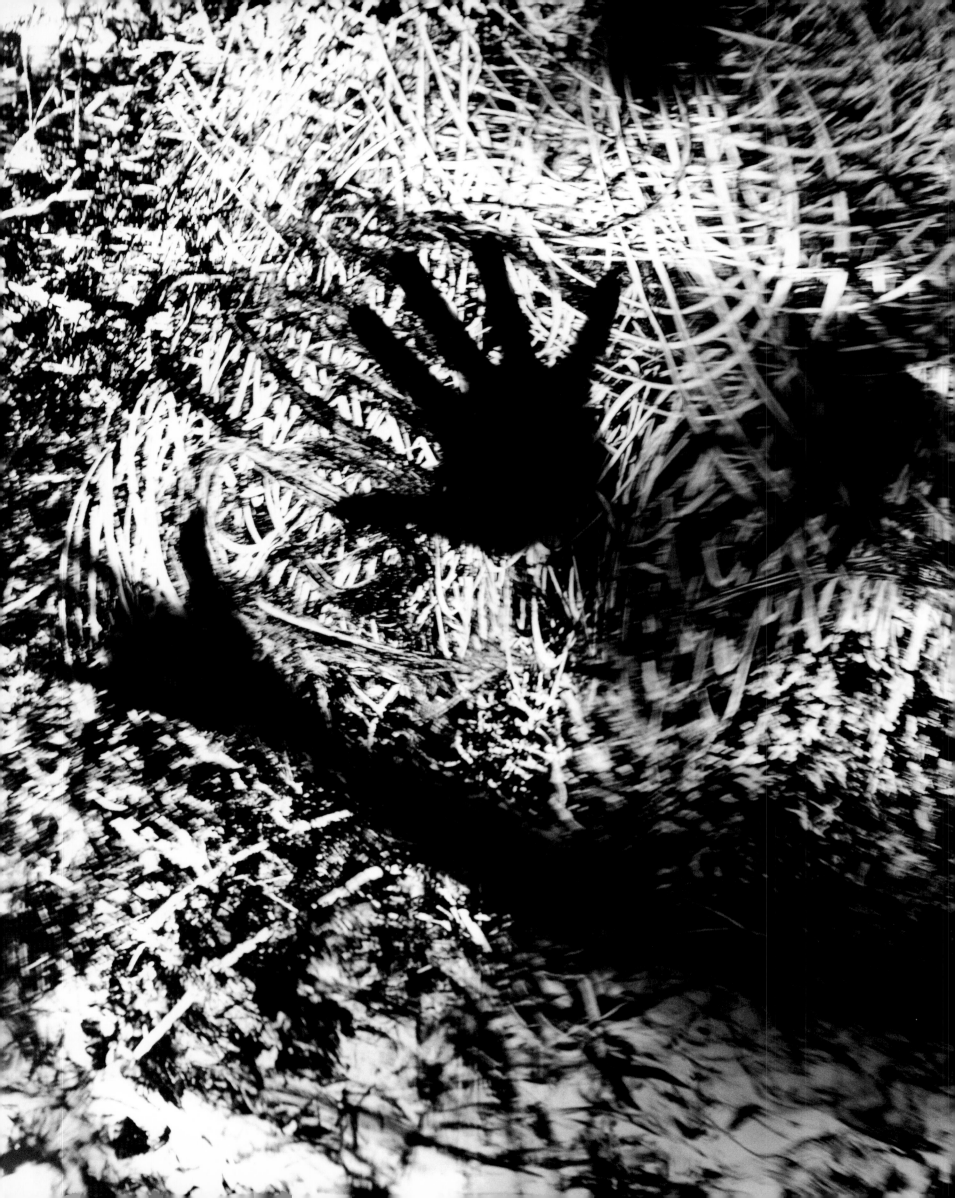

37

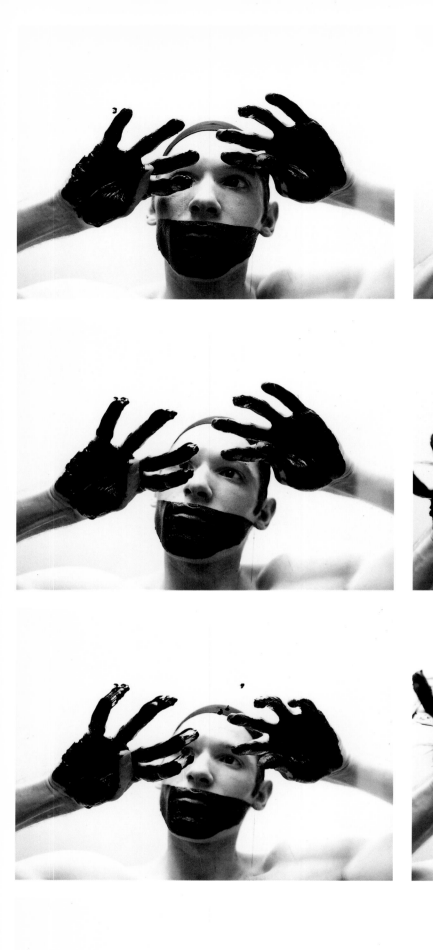
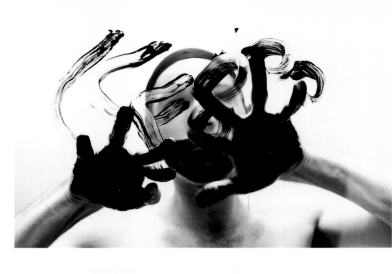

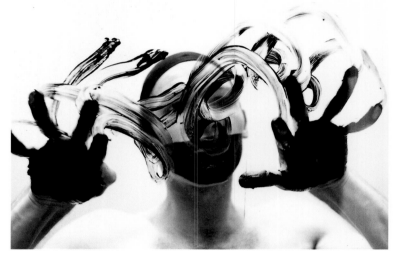

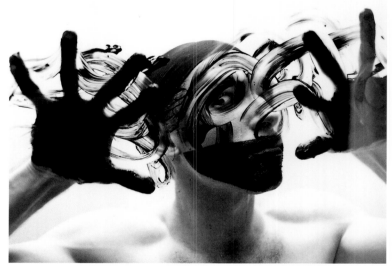
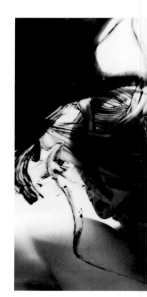
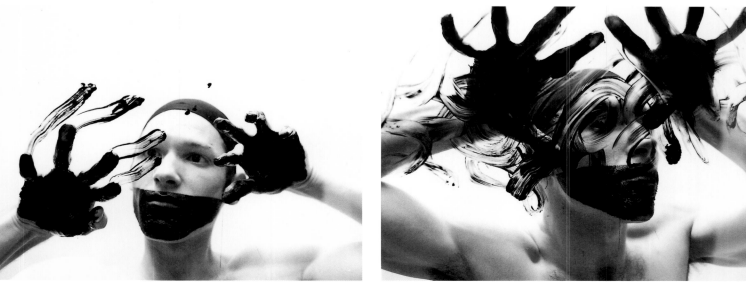
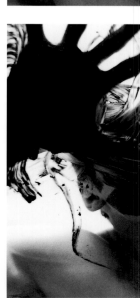

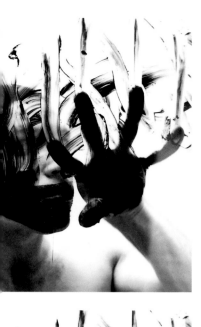
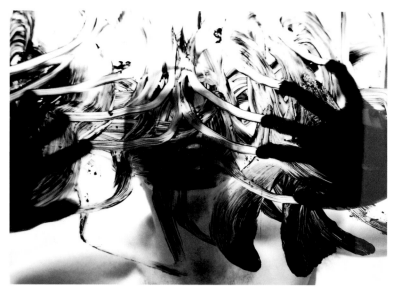
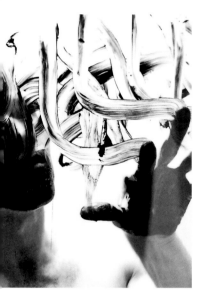
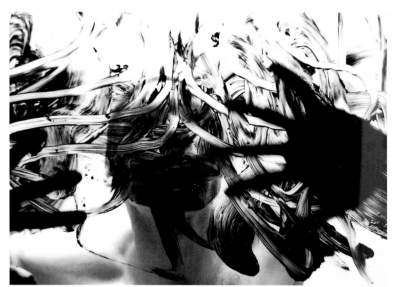
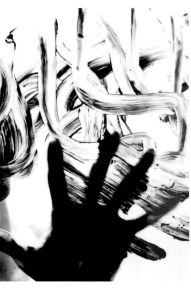
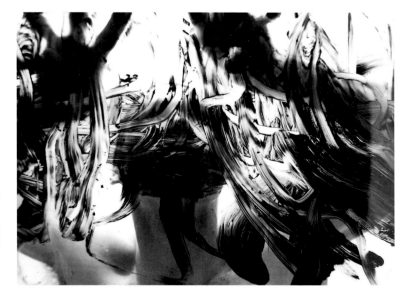
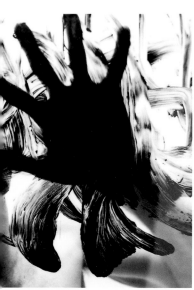
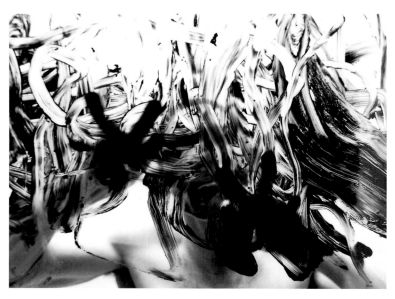

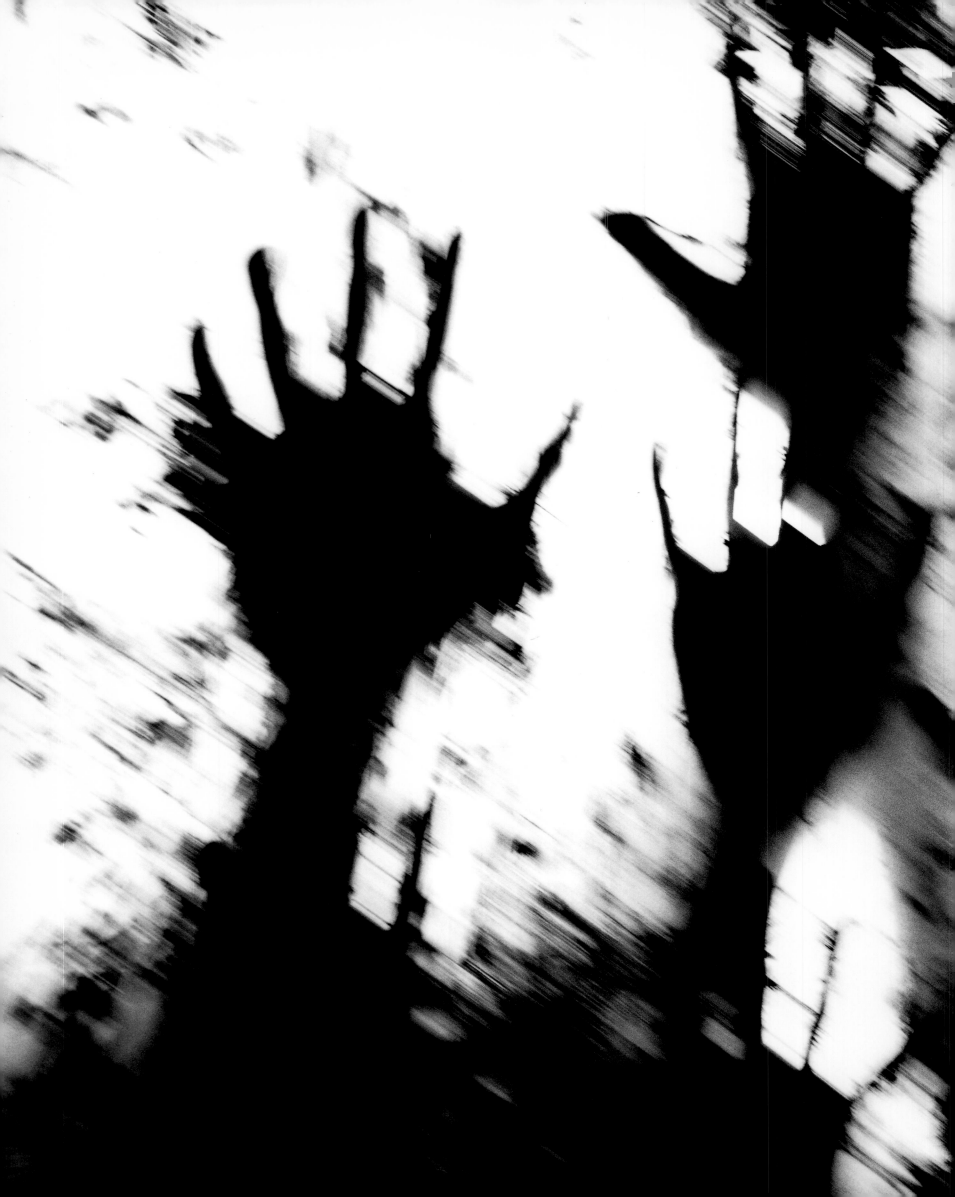

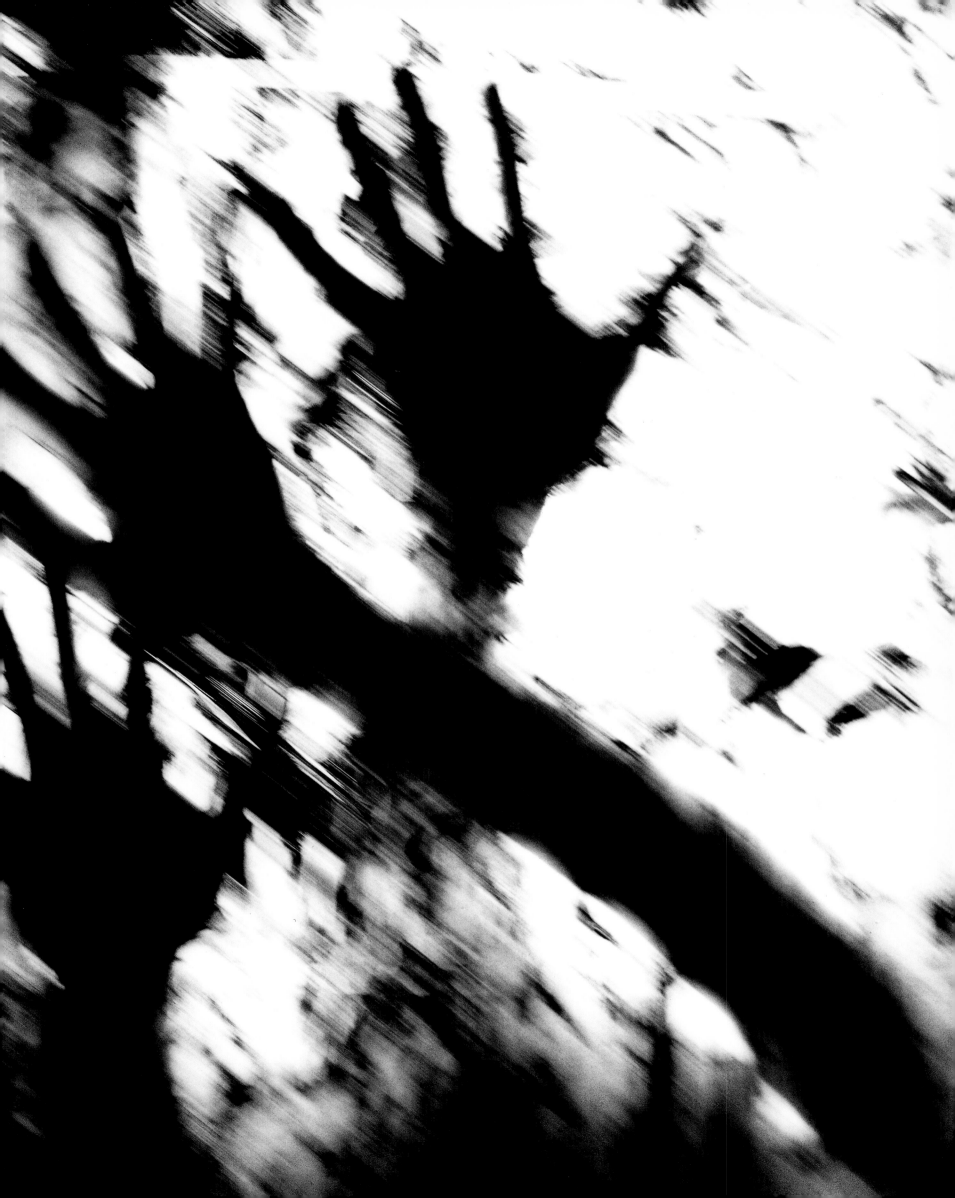

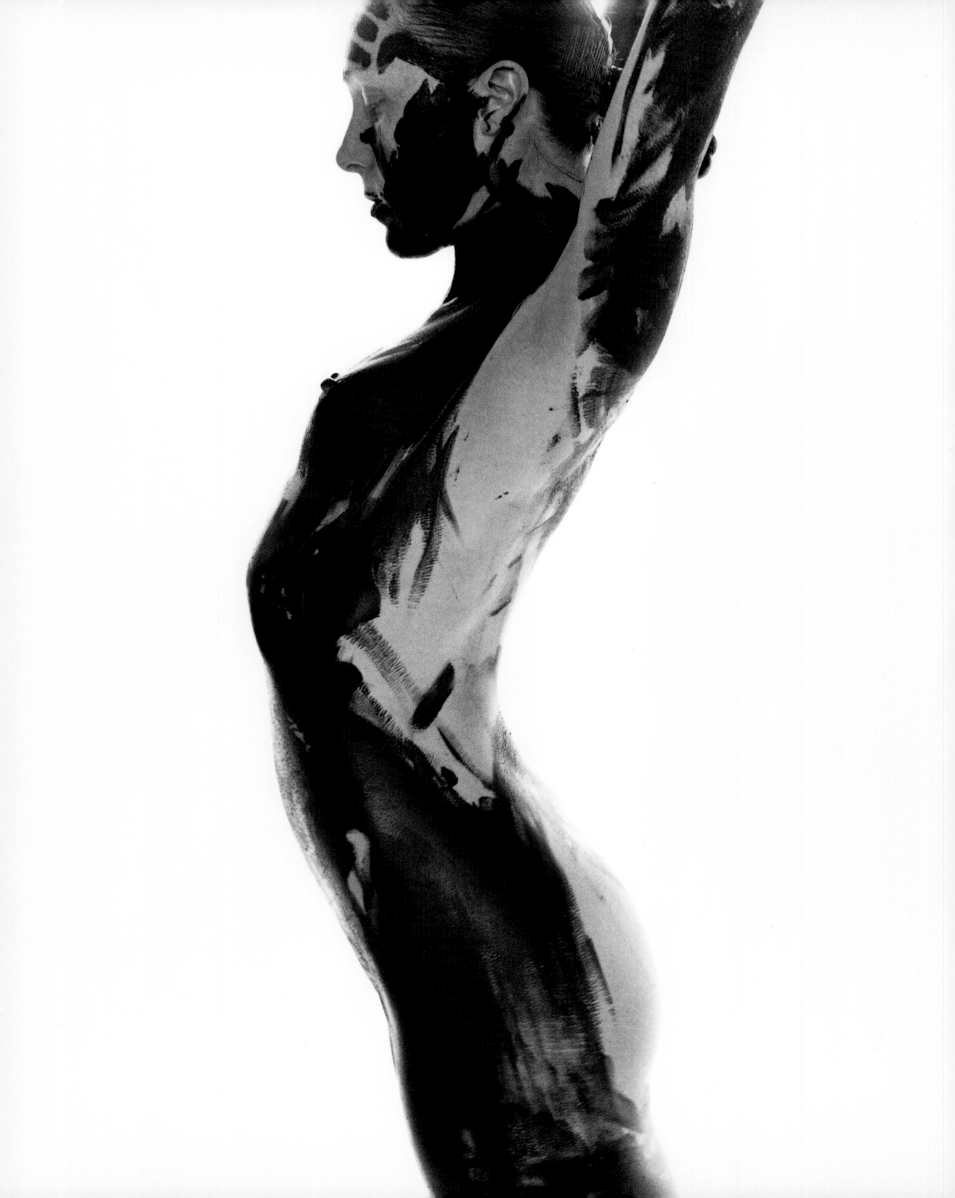

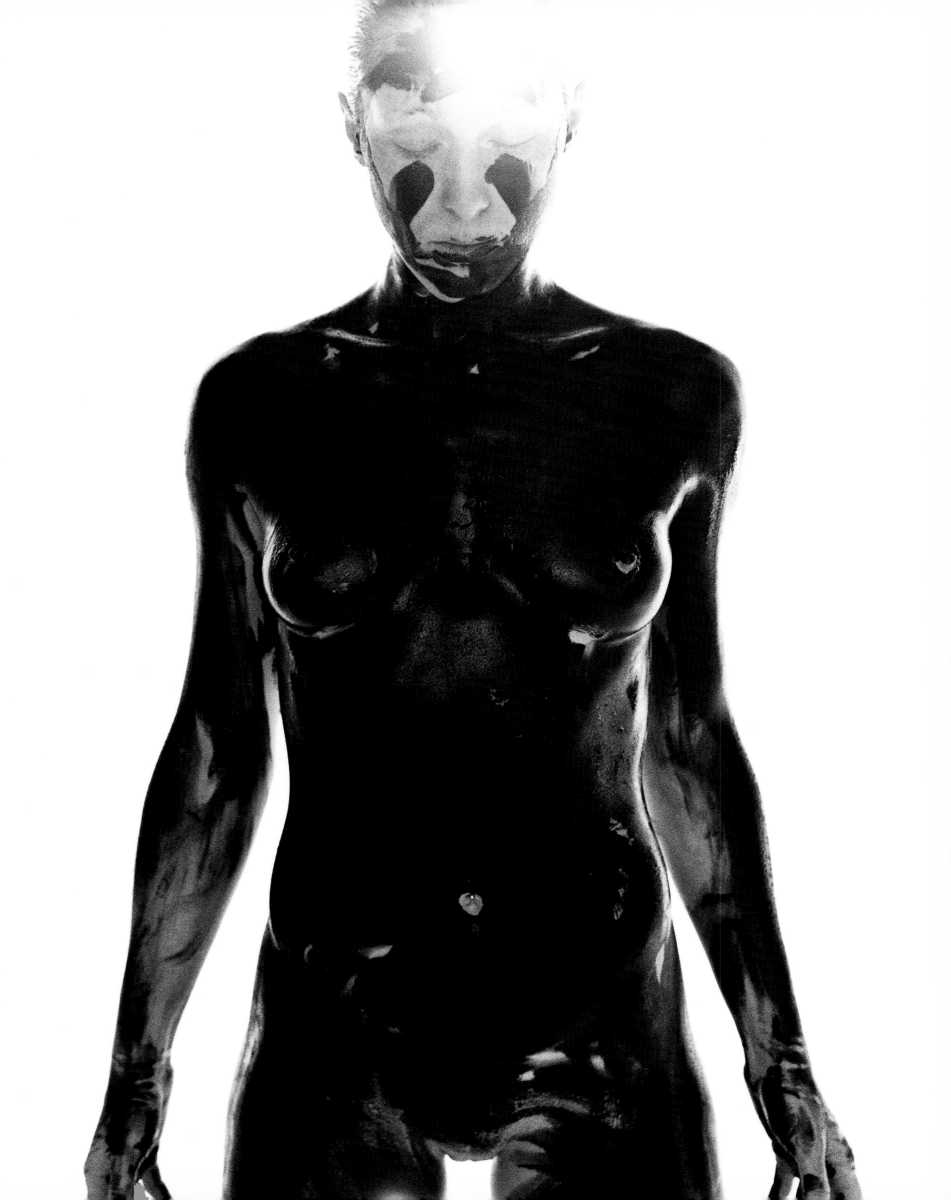

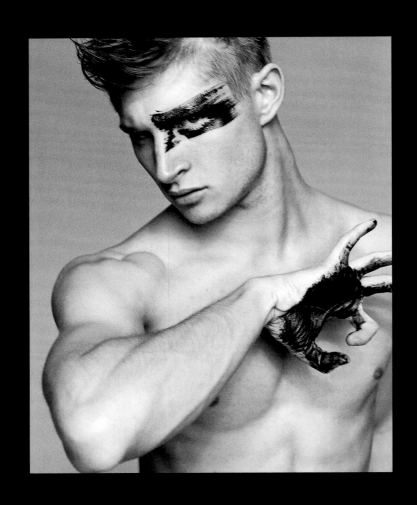

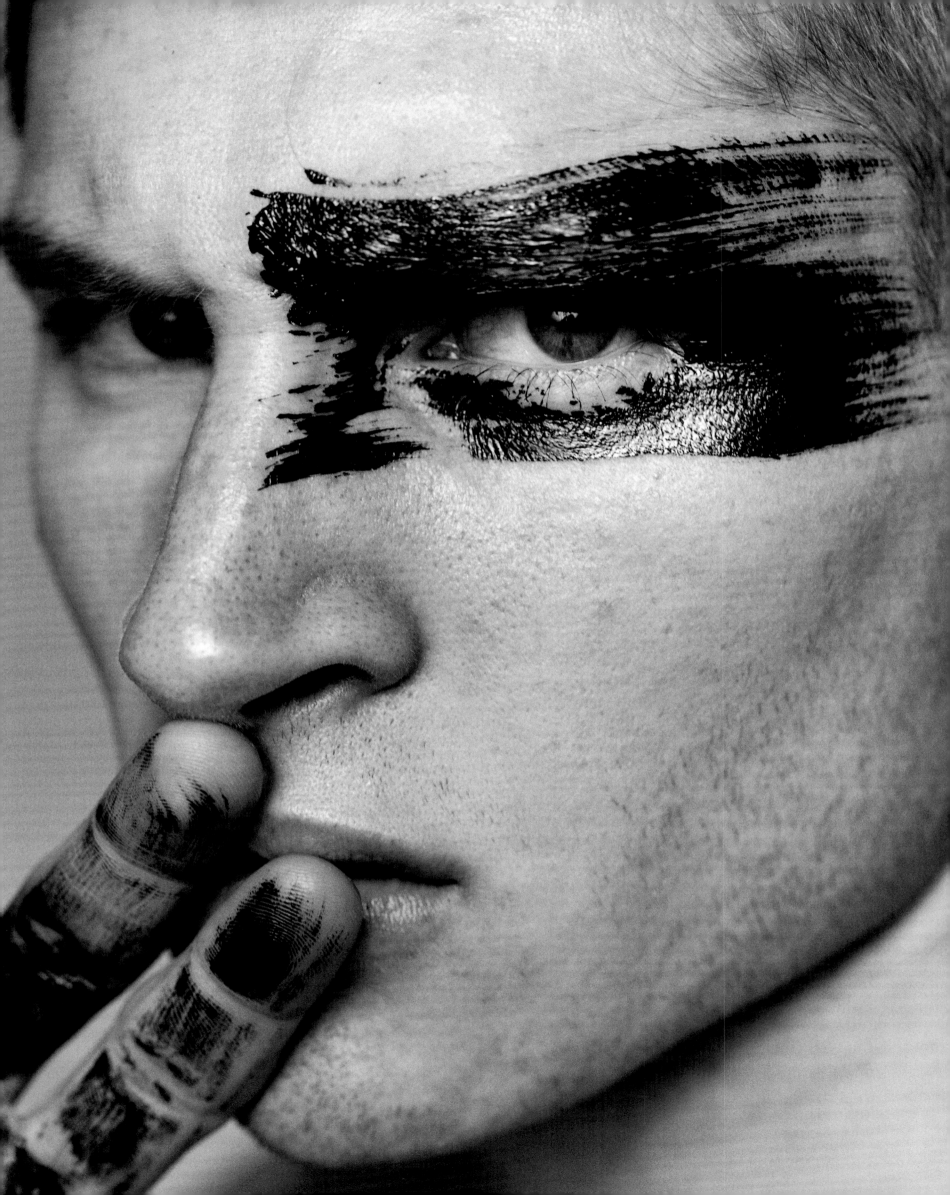

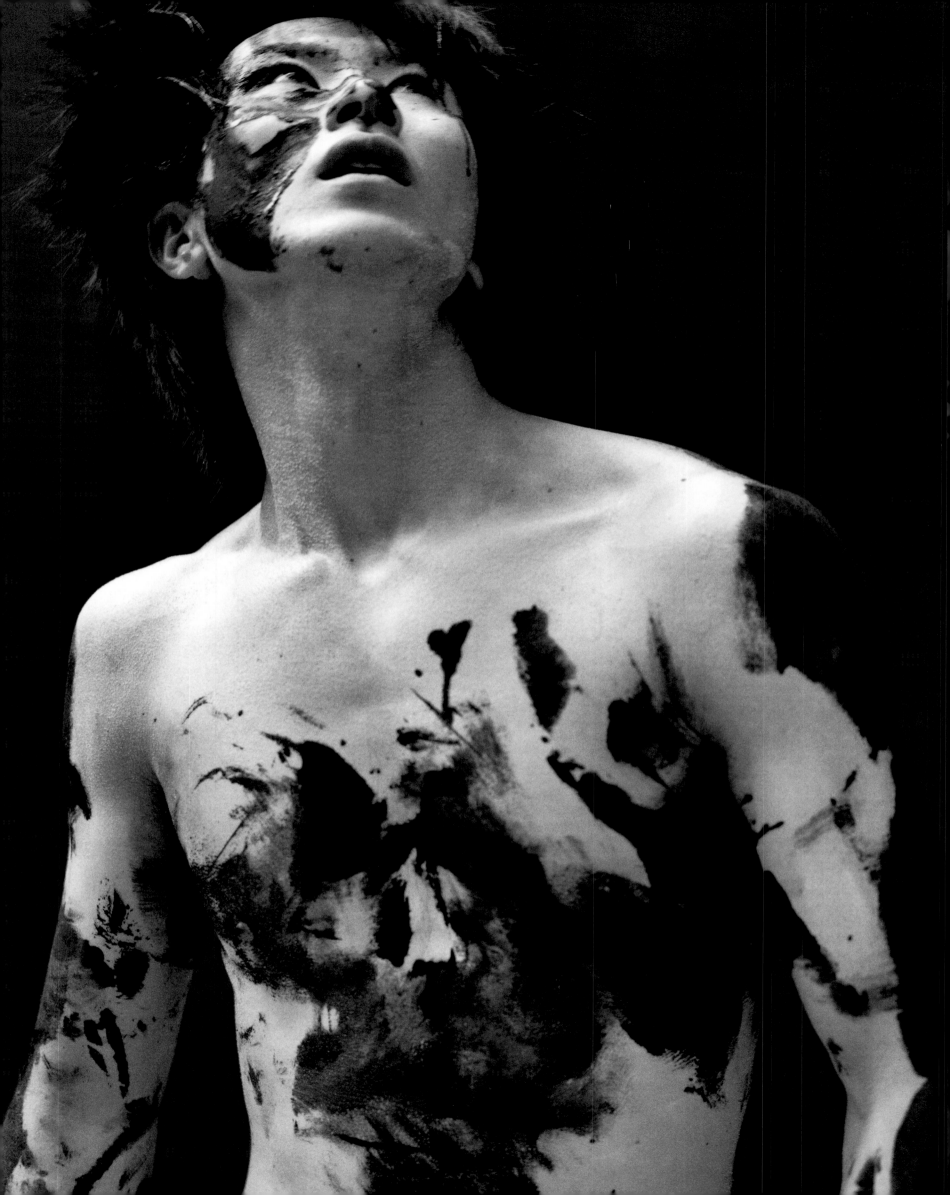

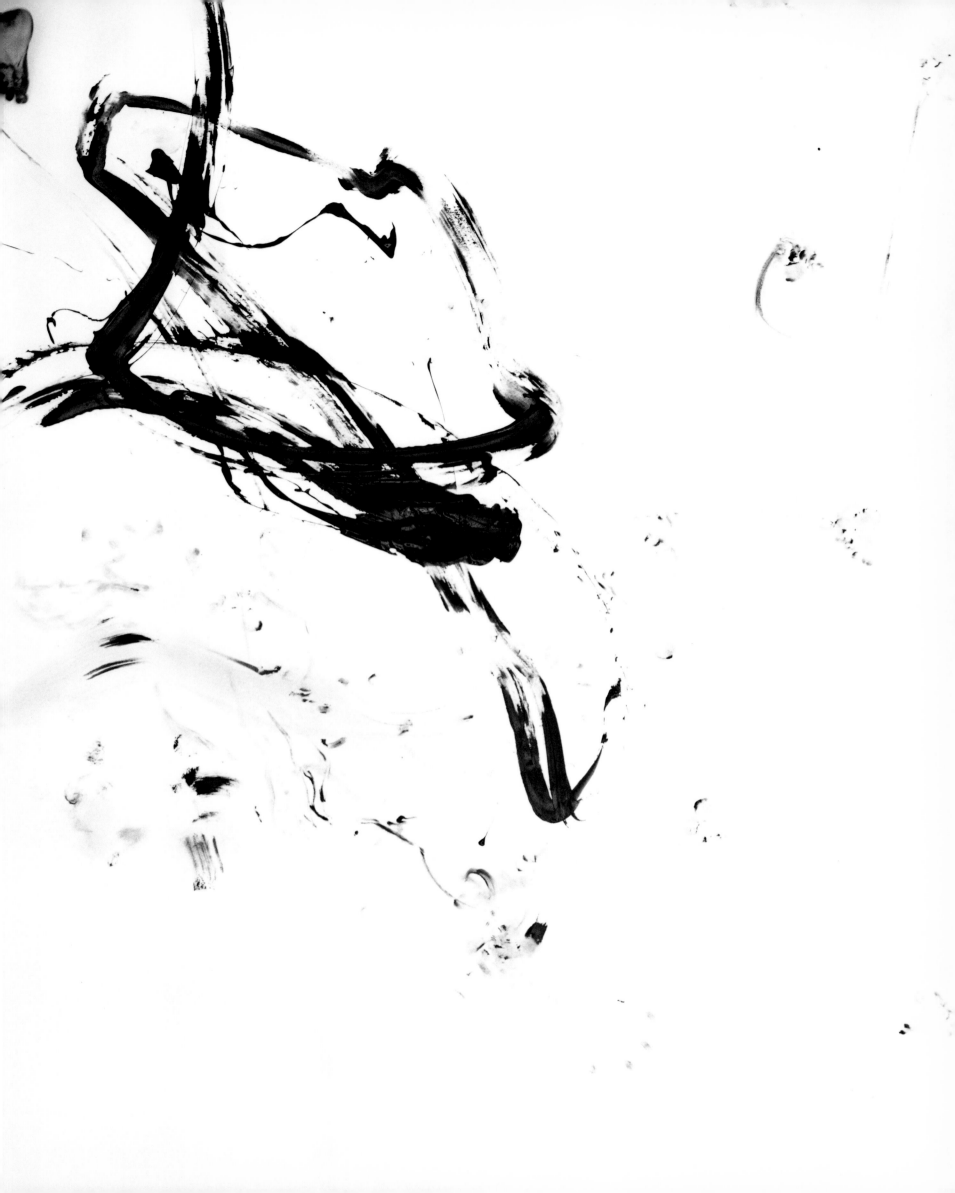

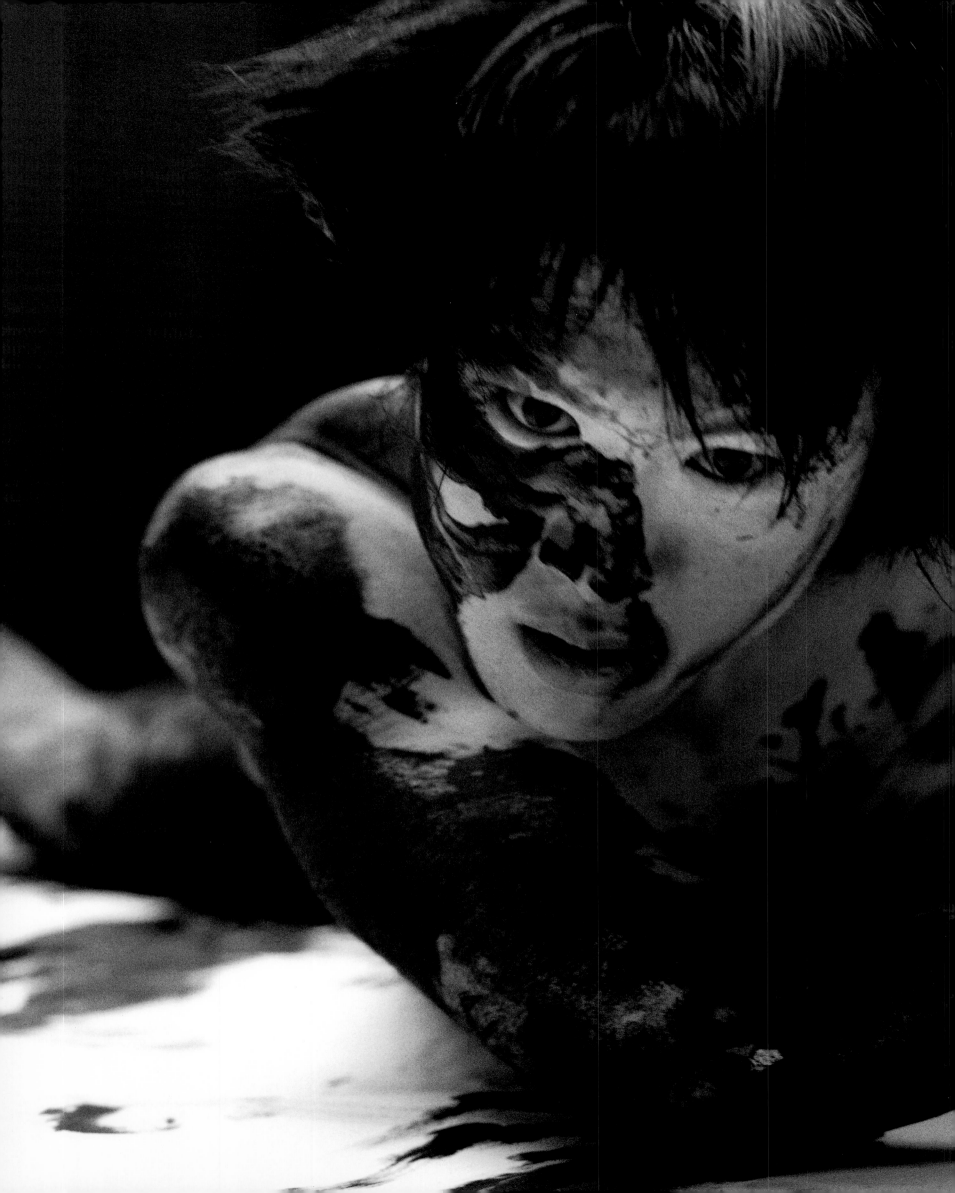

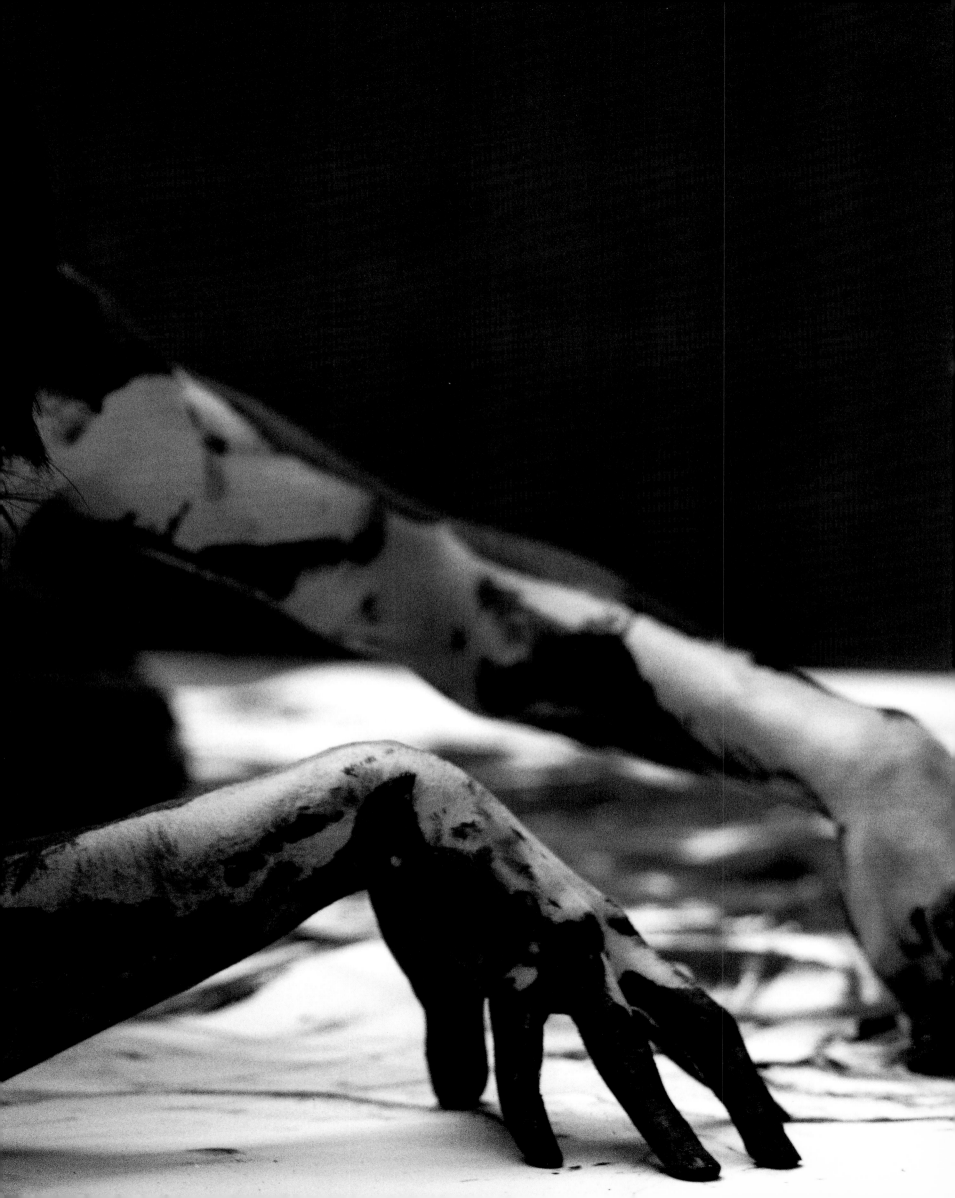

52

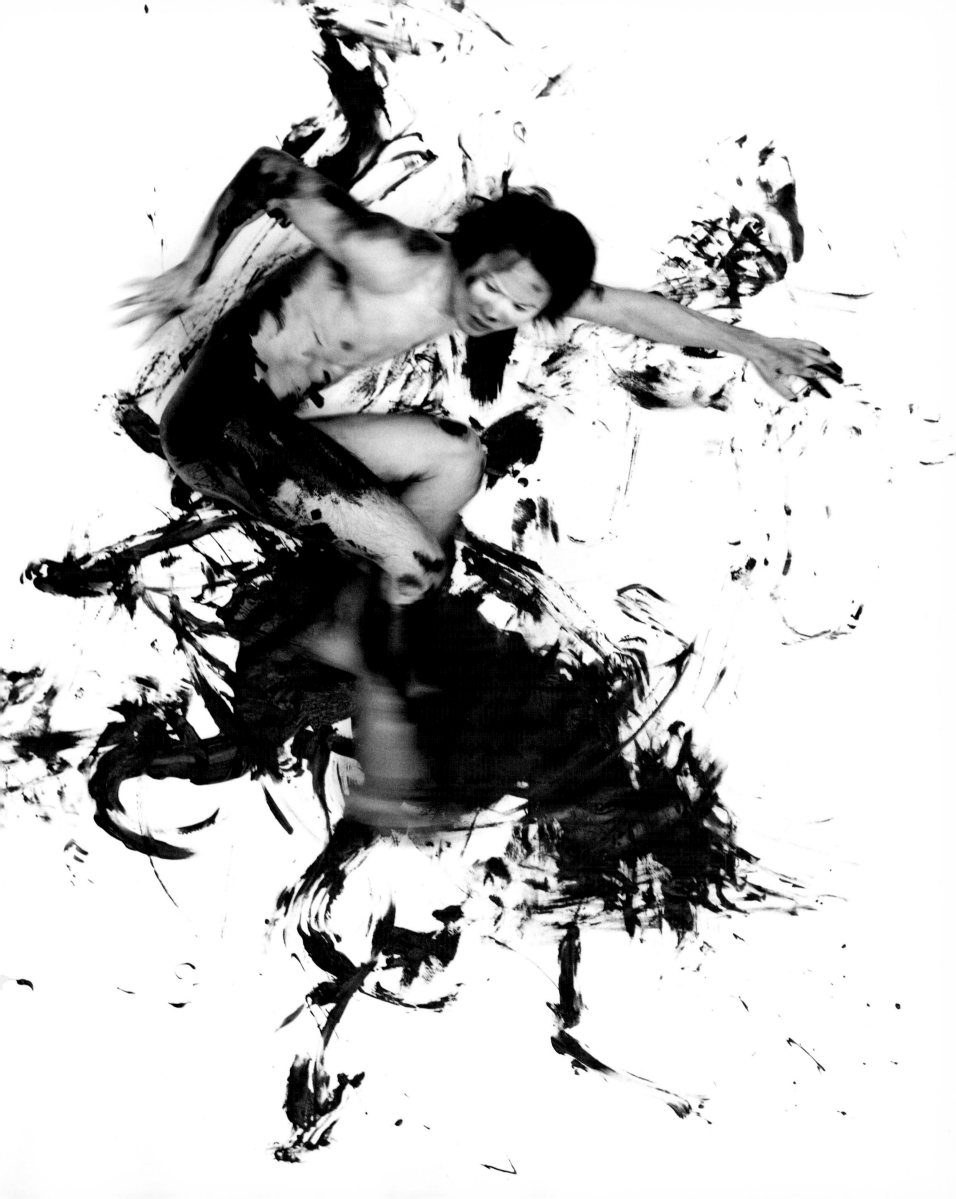

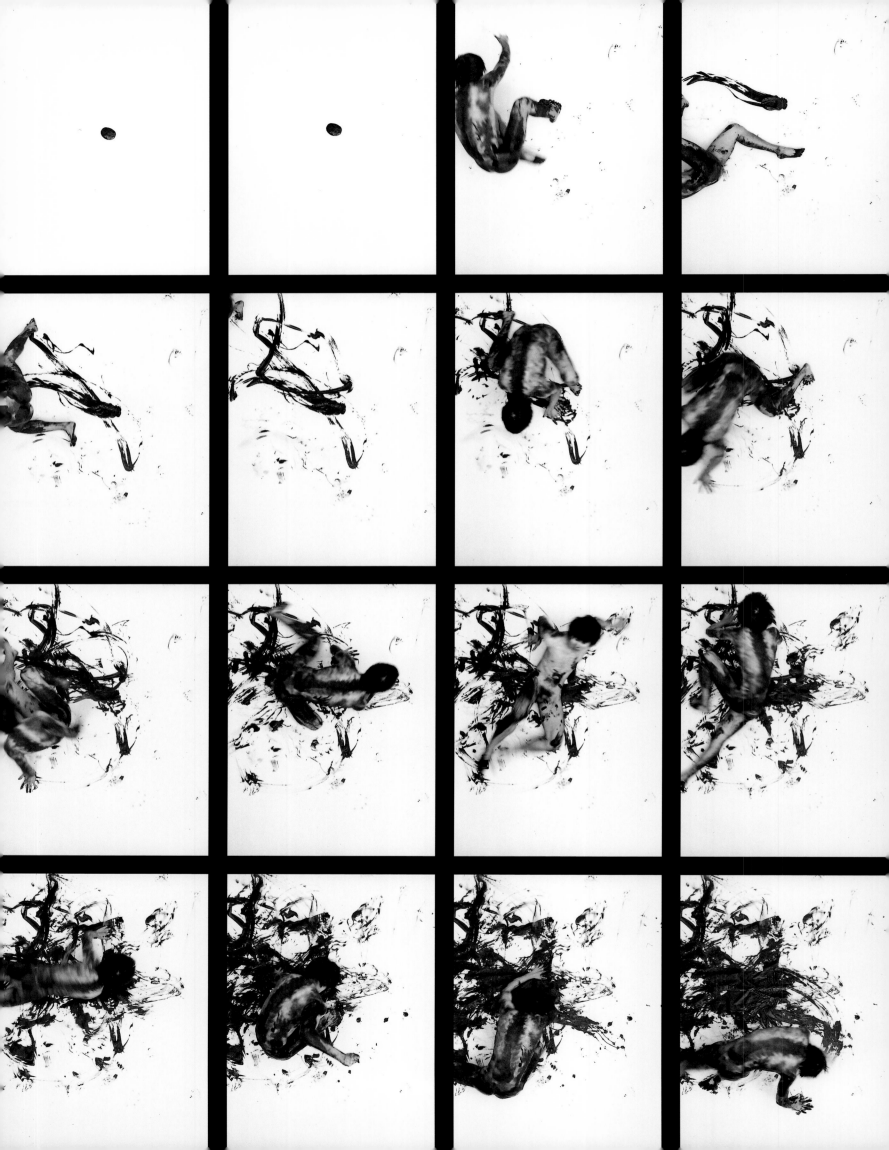

55

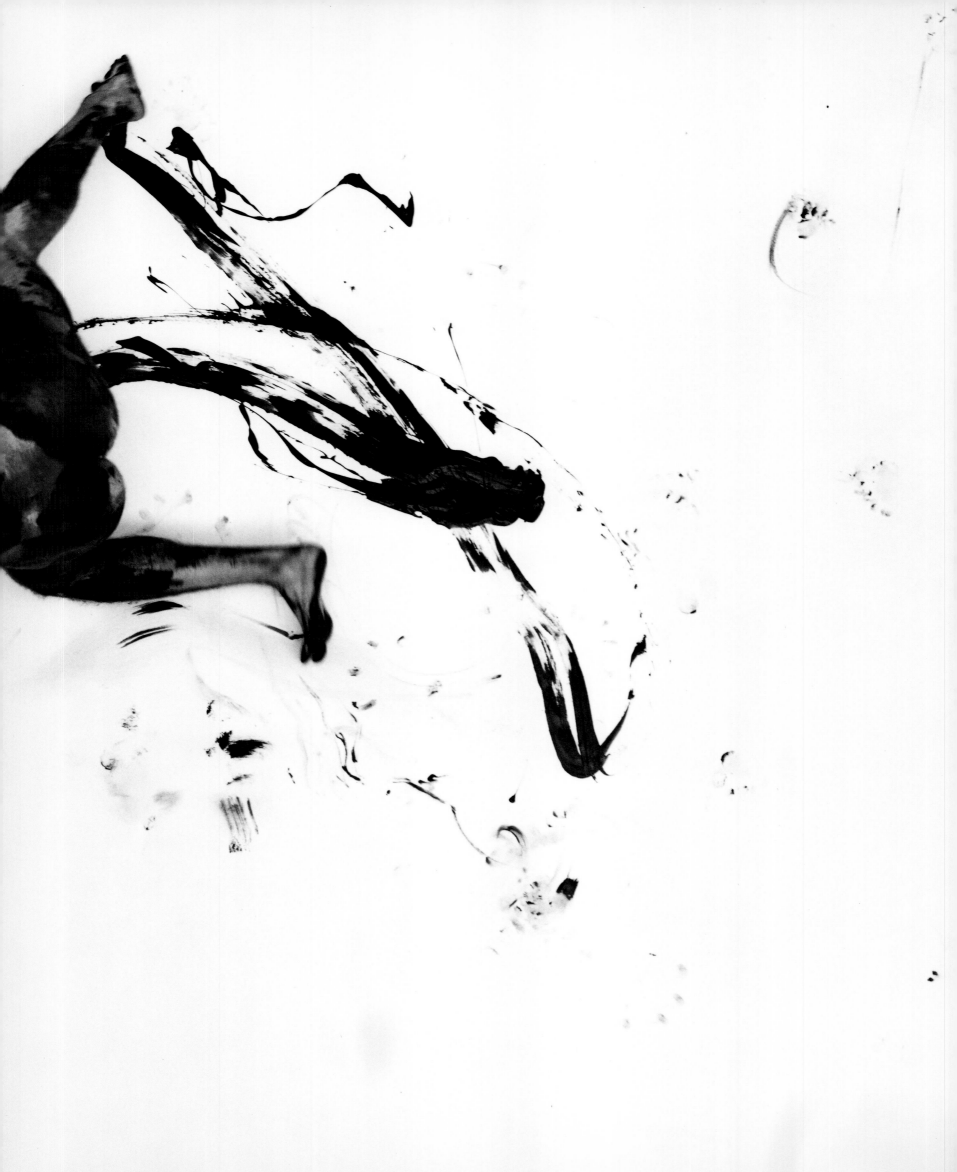

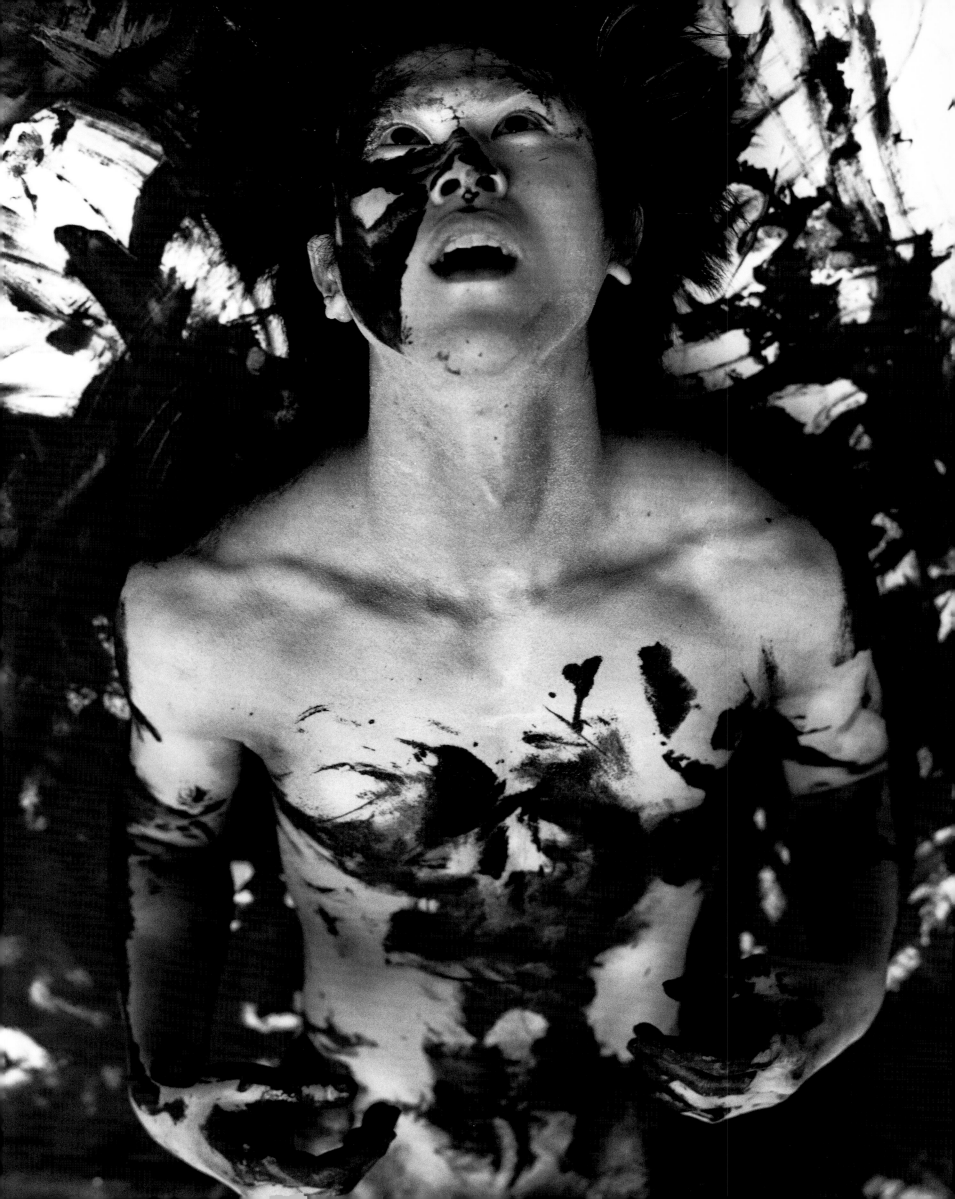

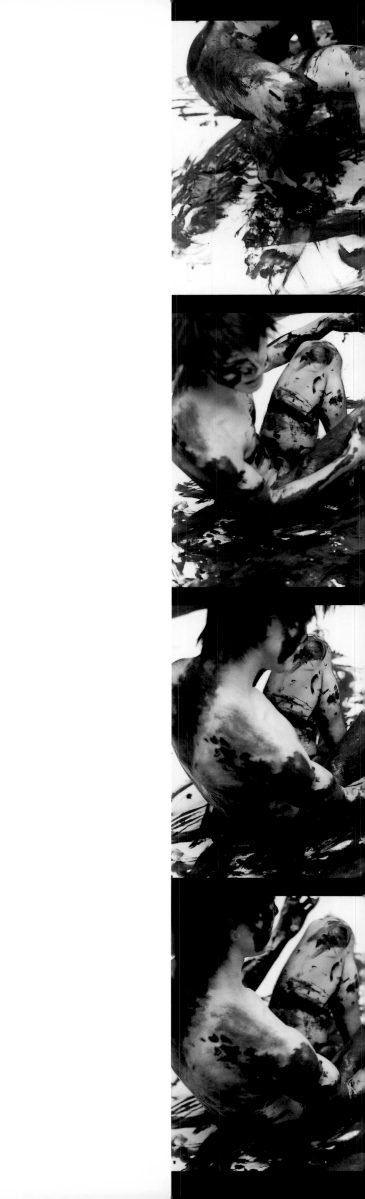

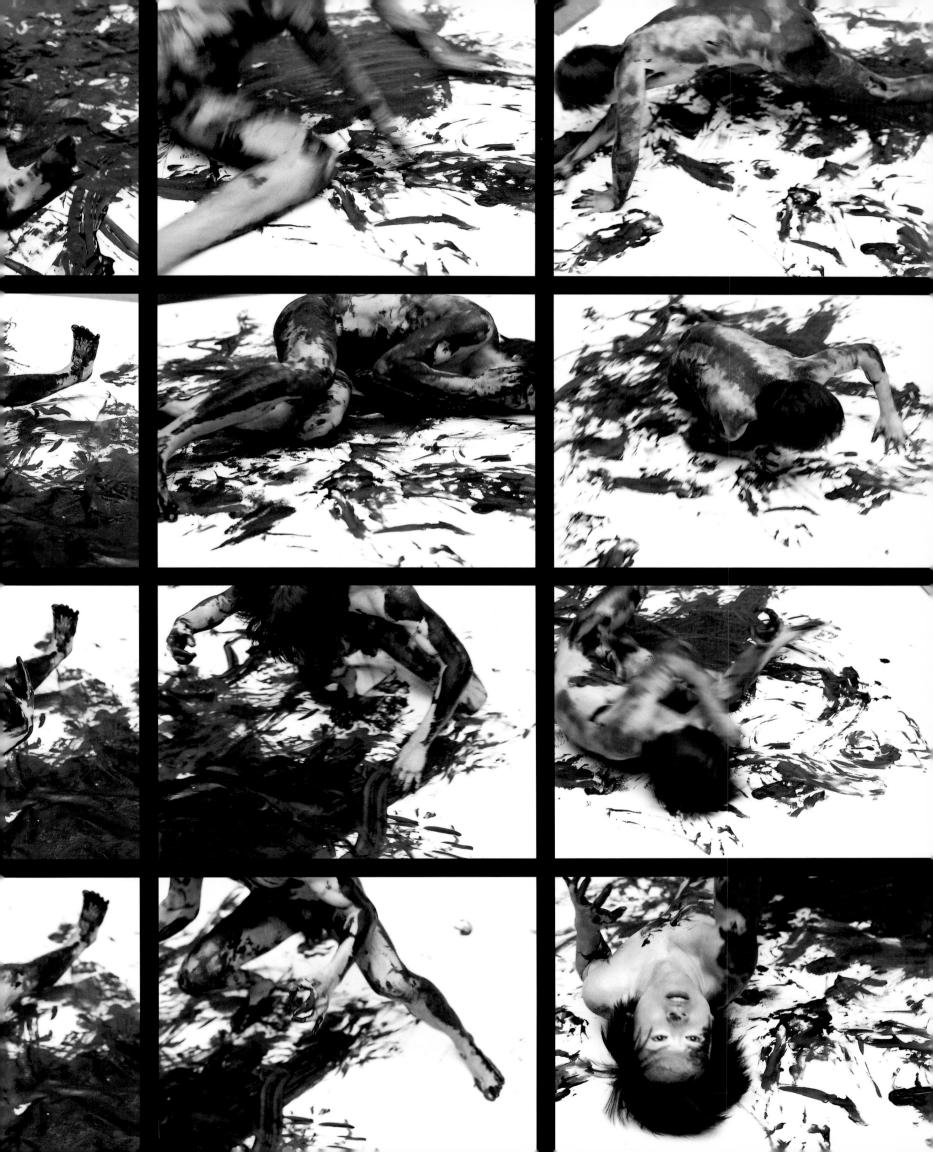

60

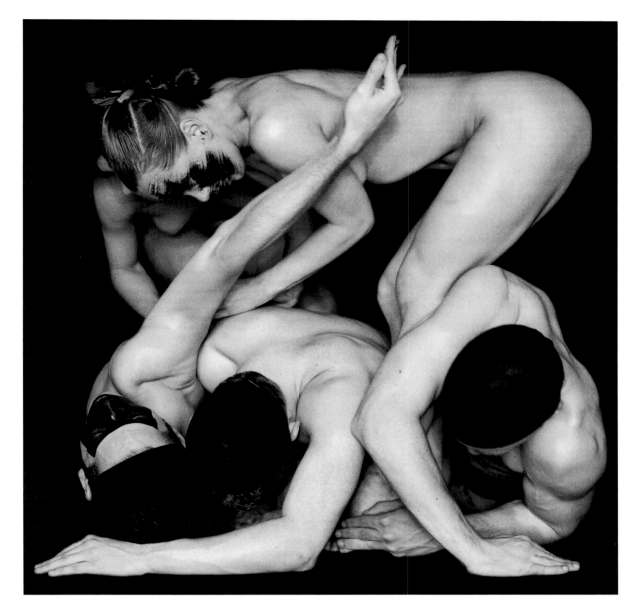
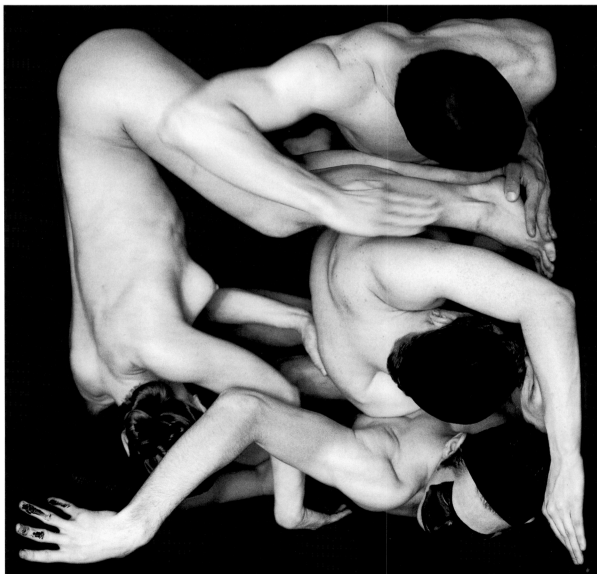

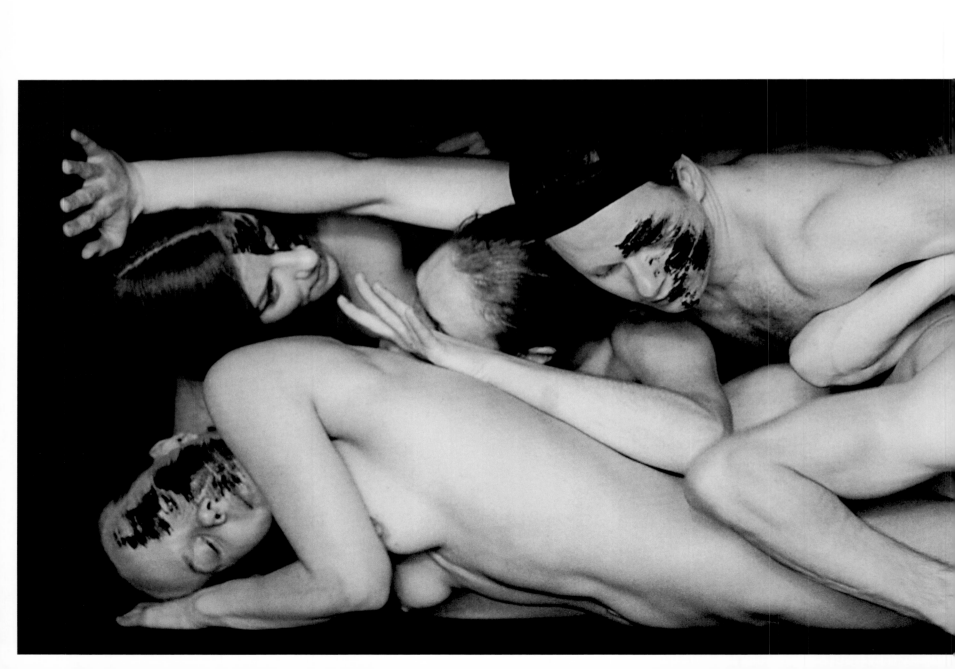

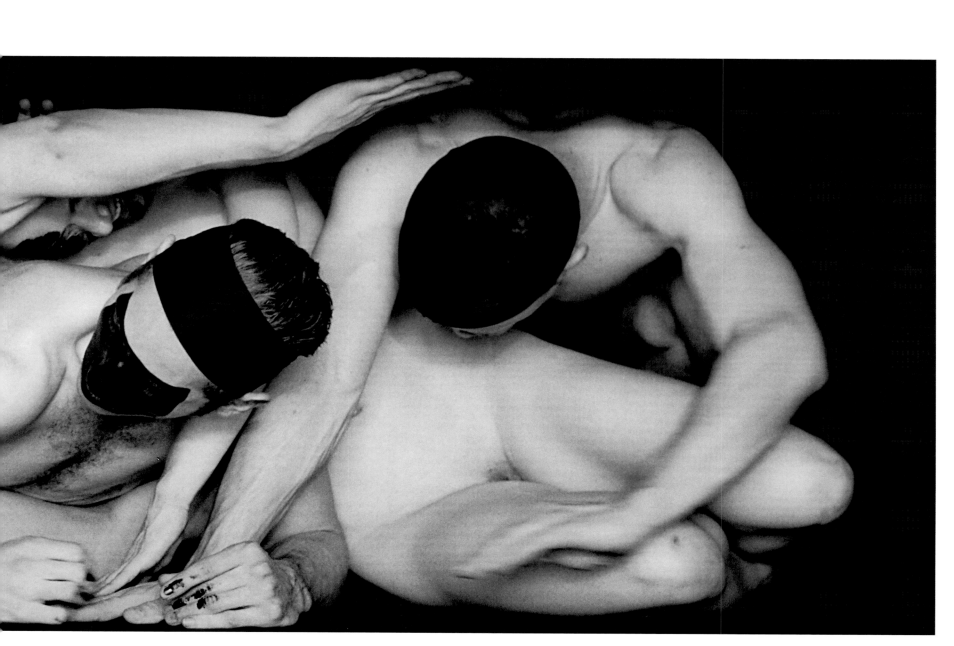

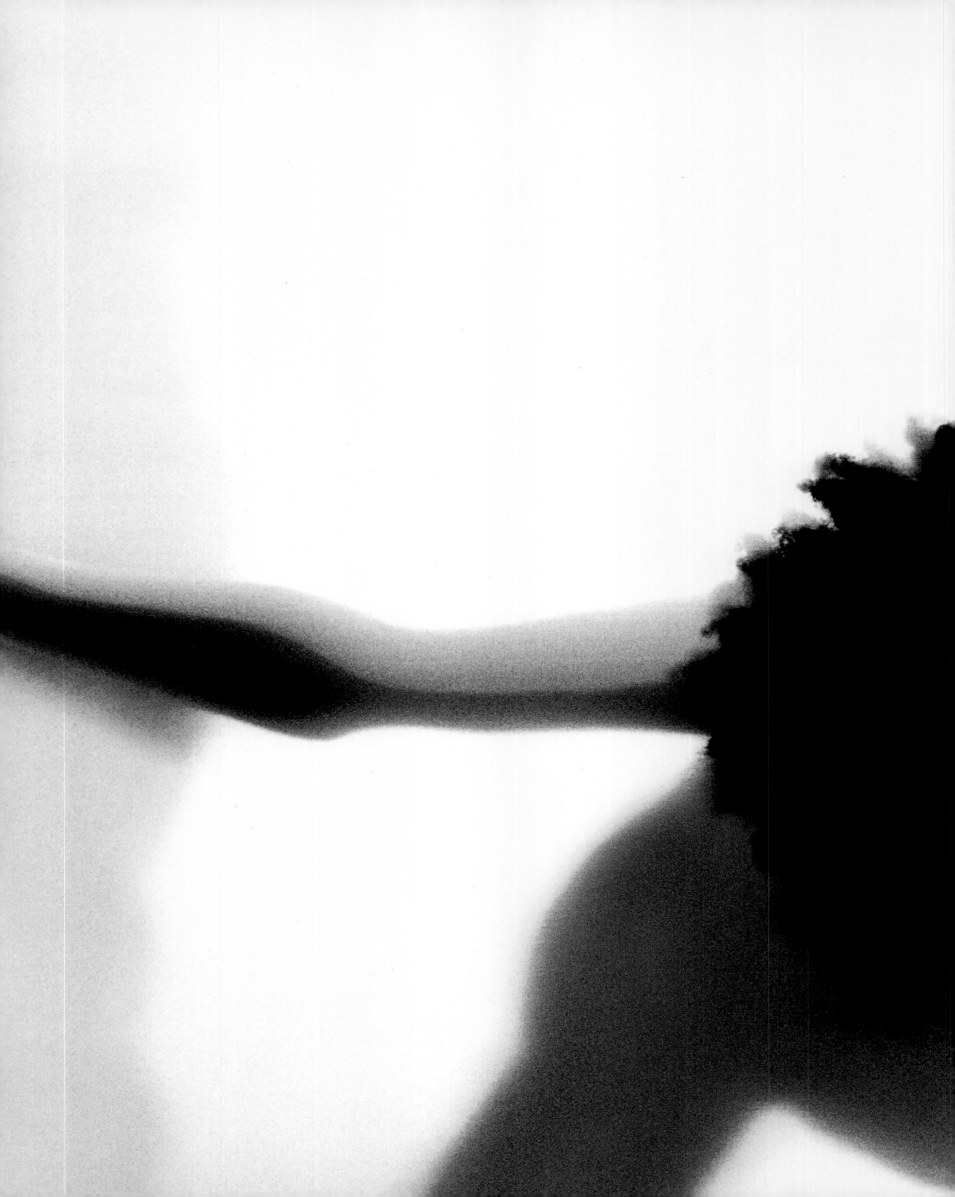

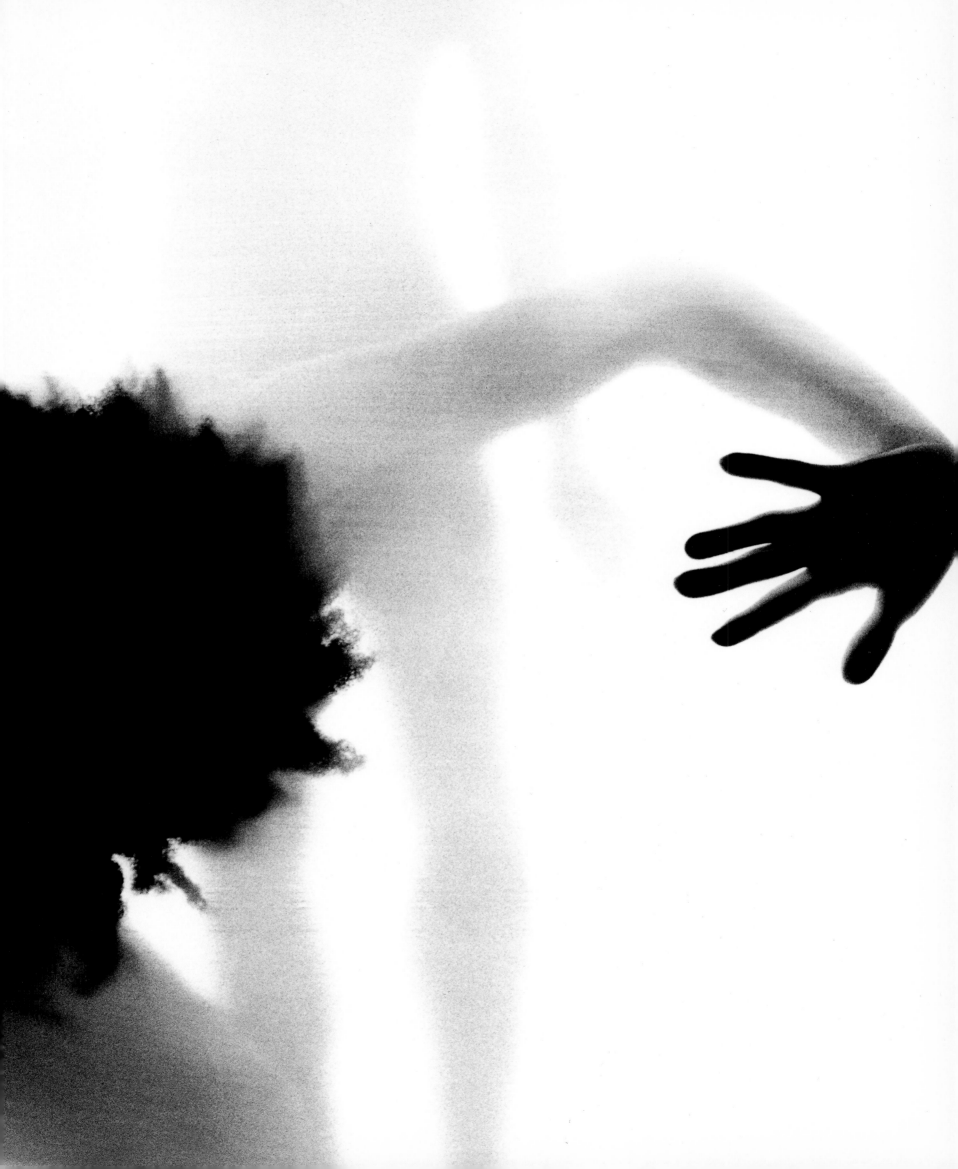

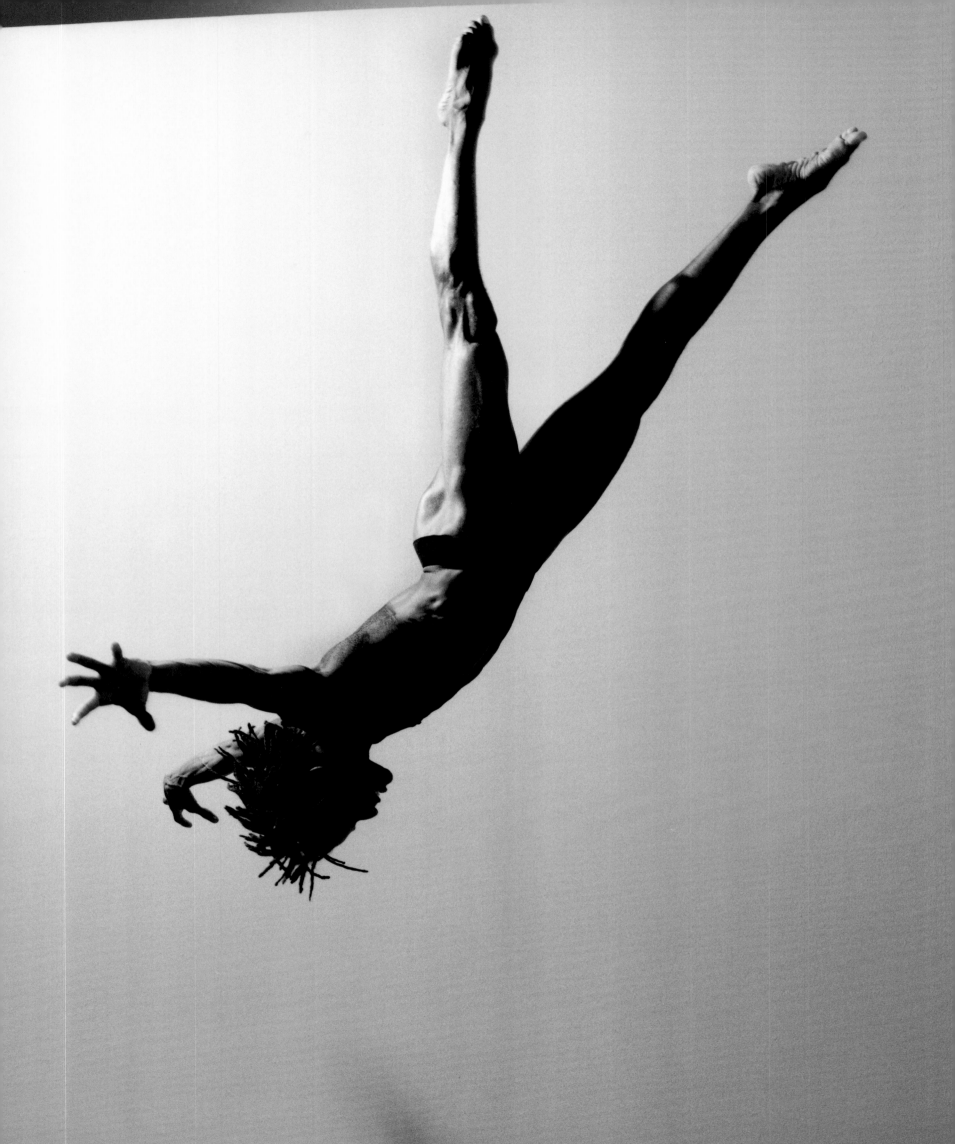

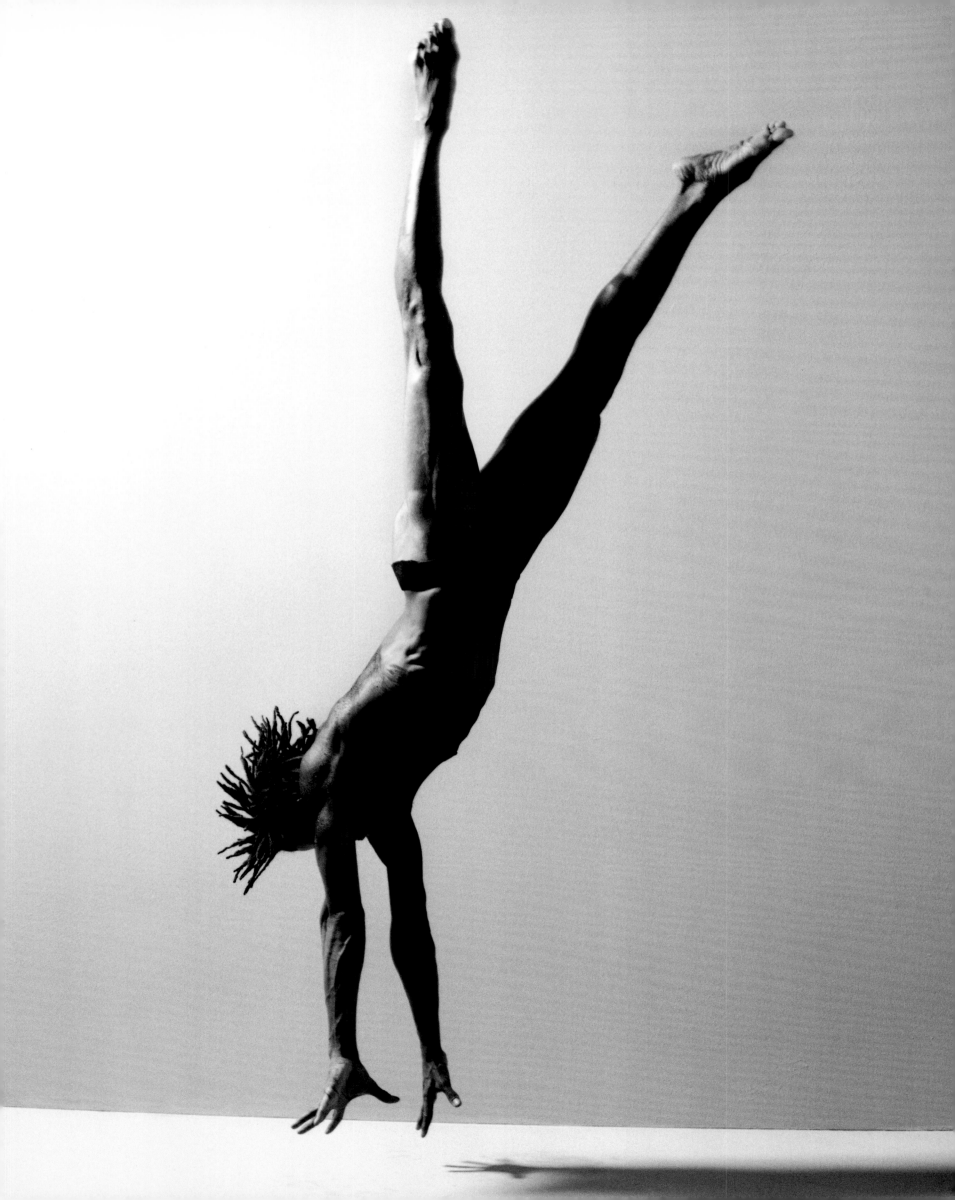

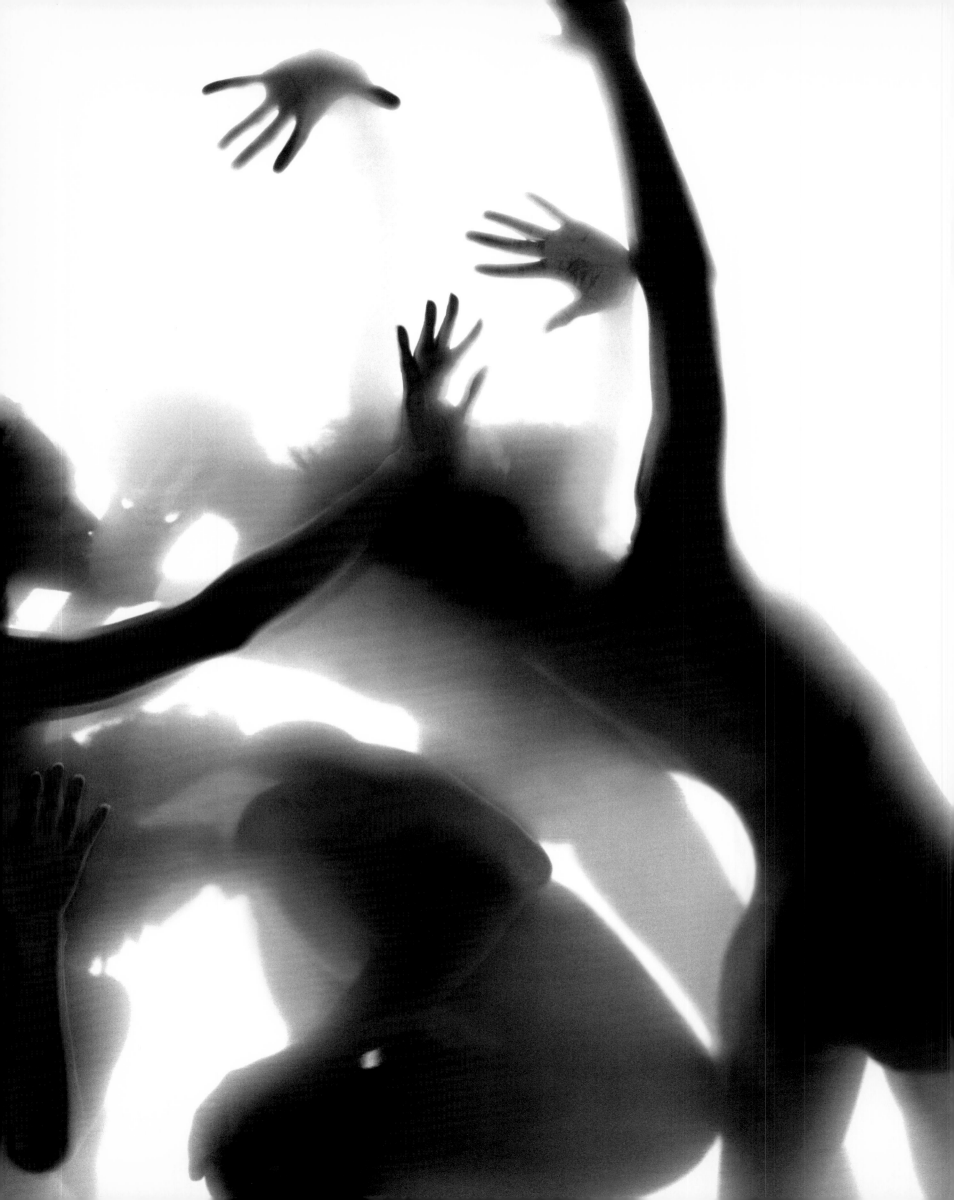

69

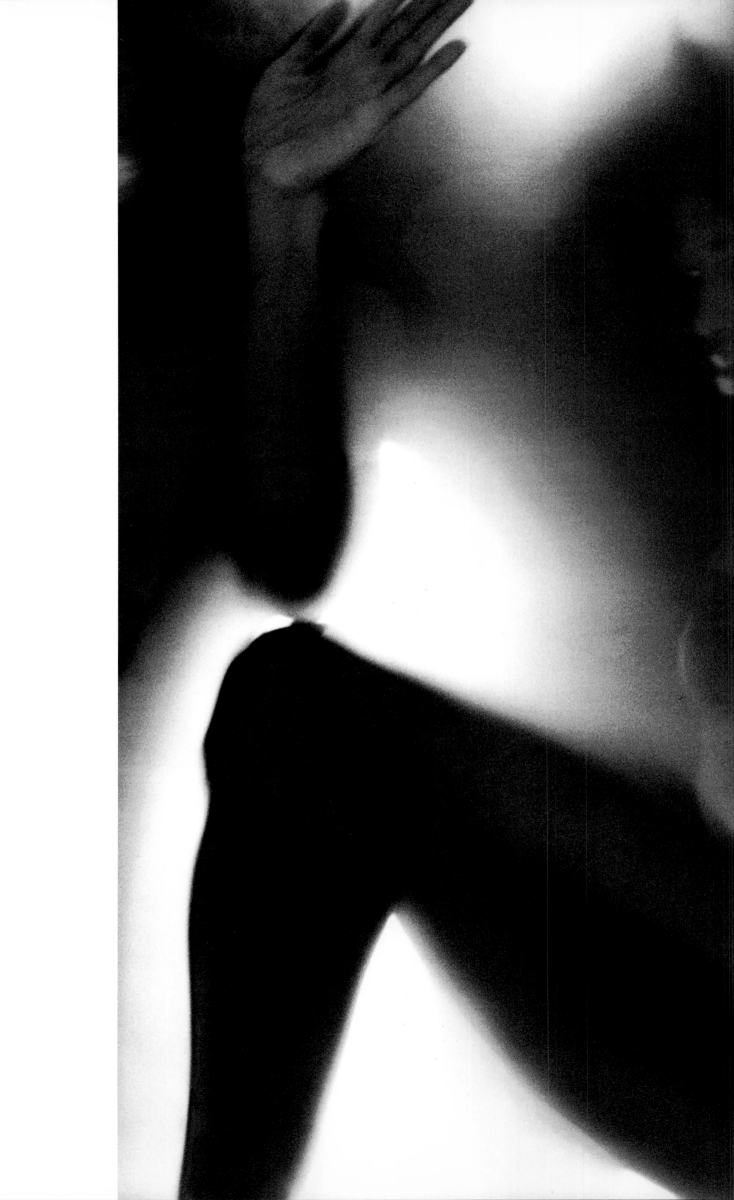

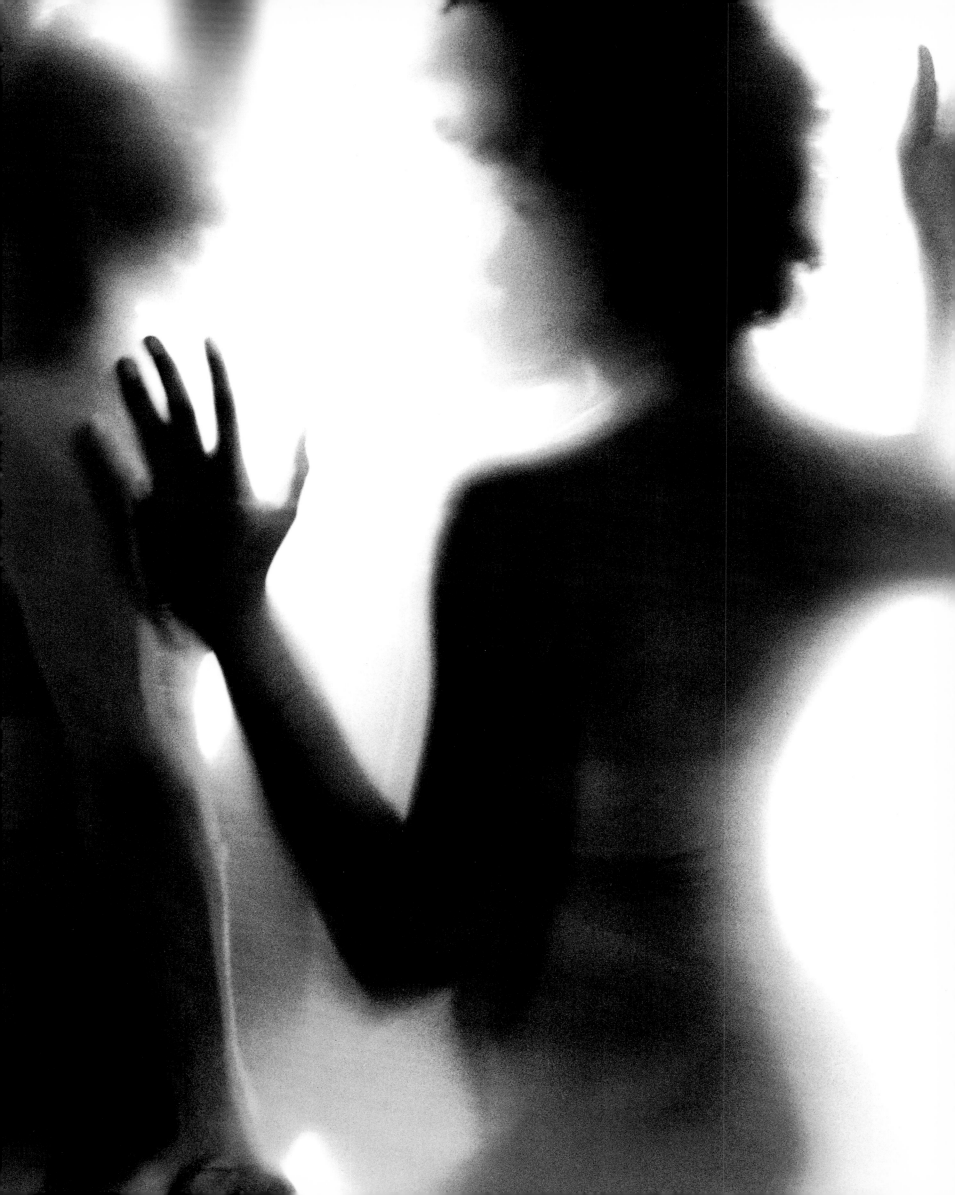

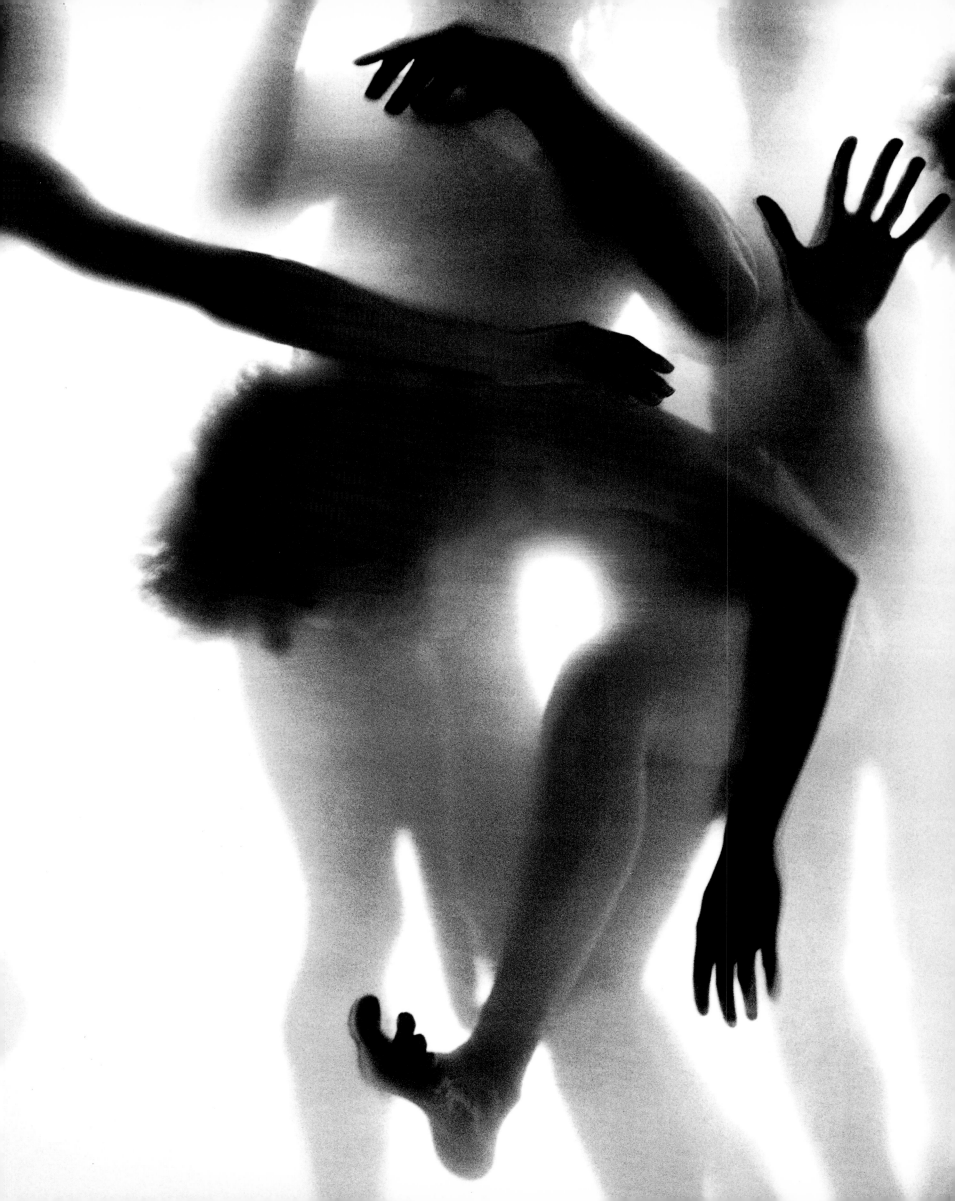

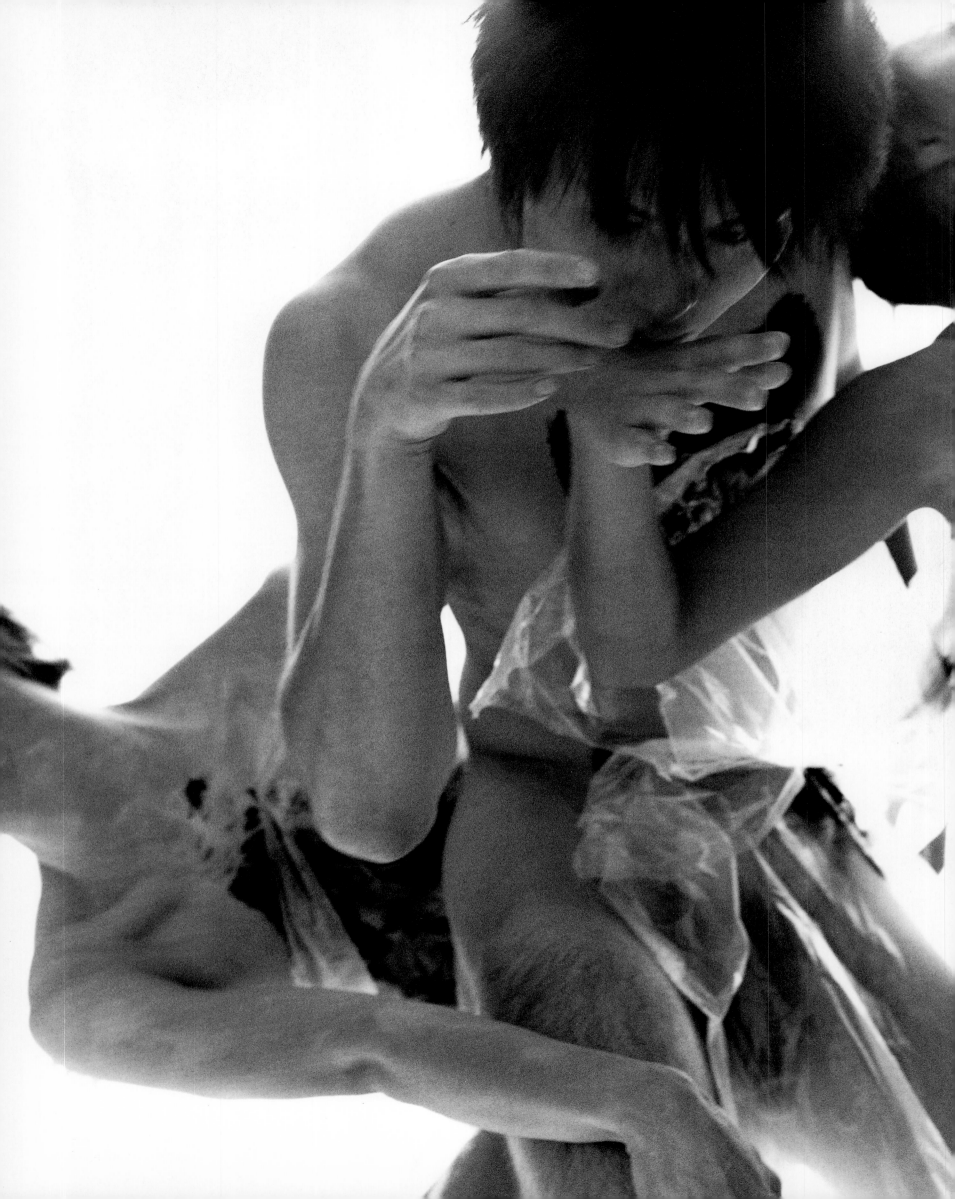

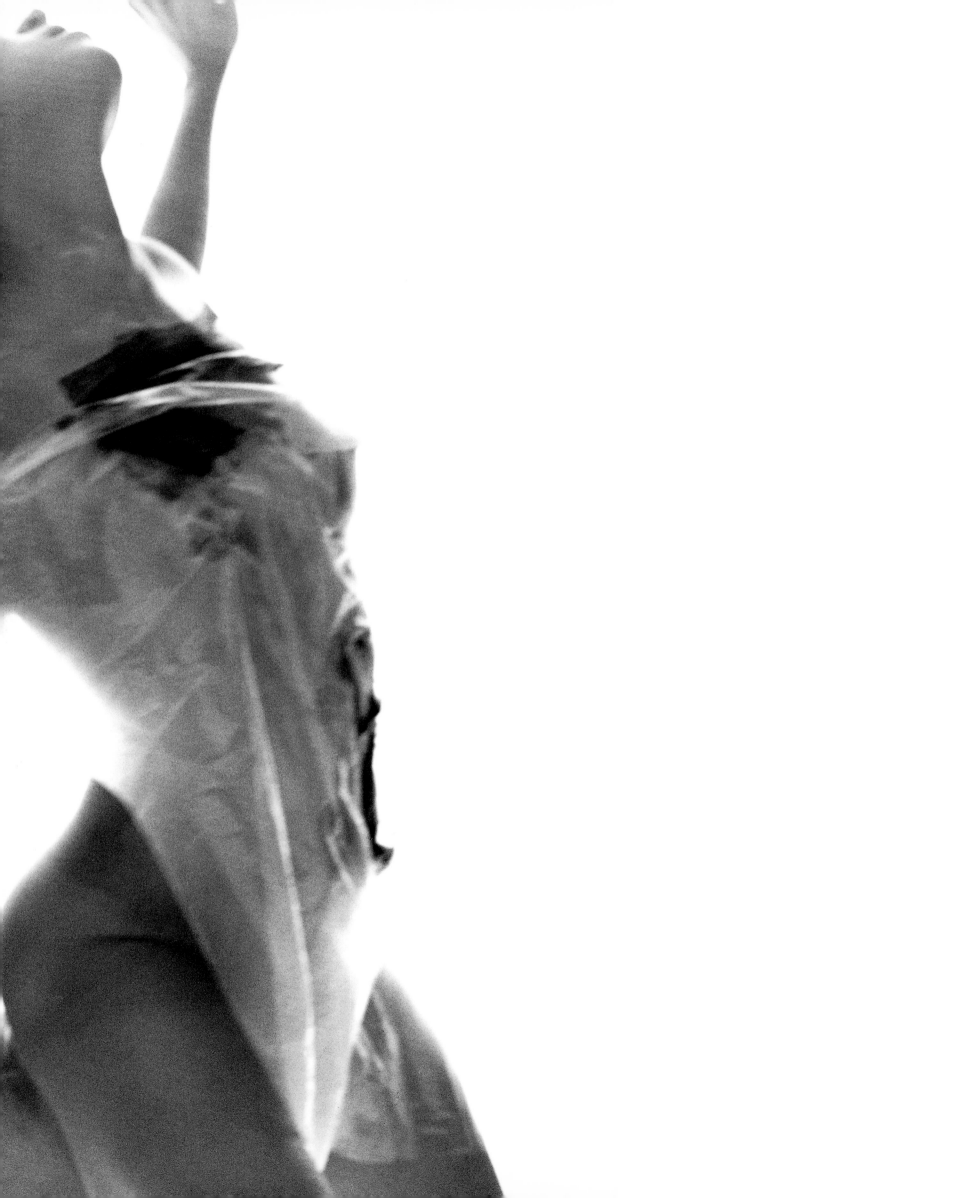

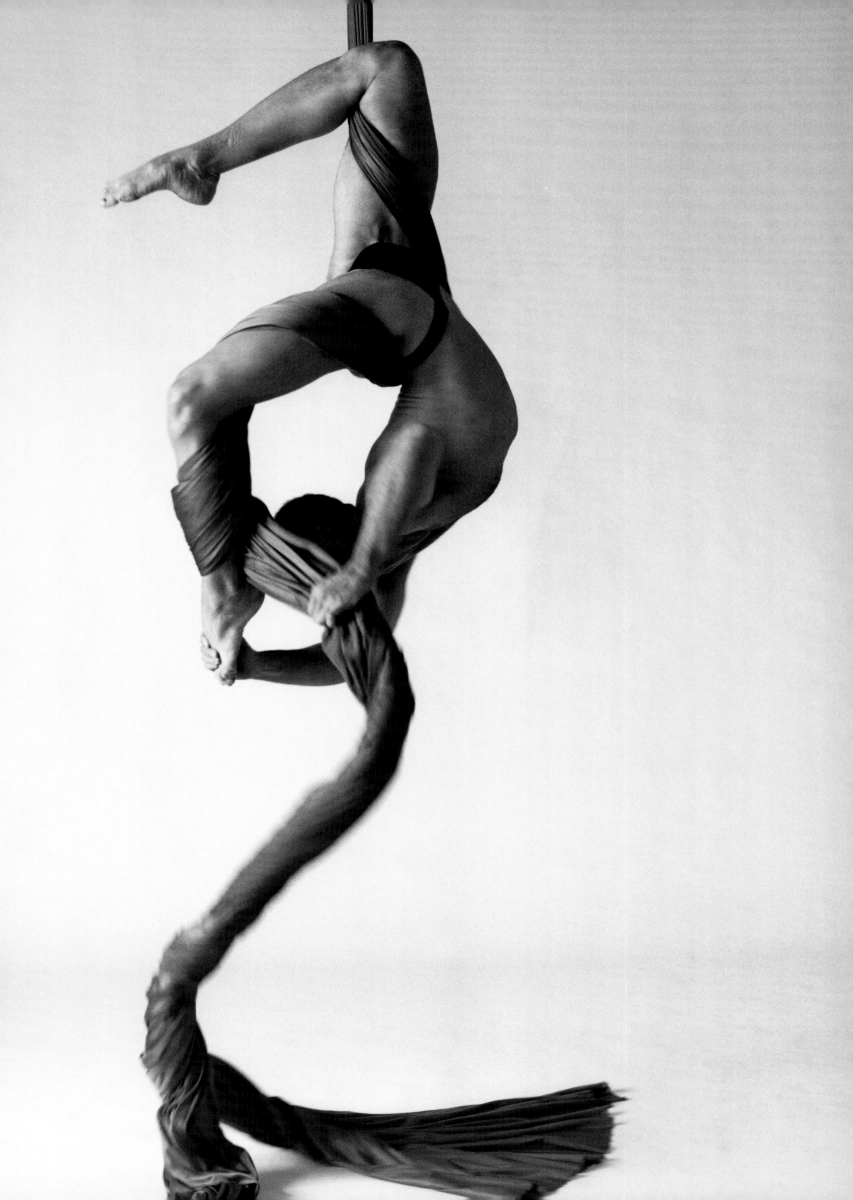

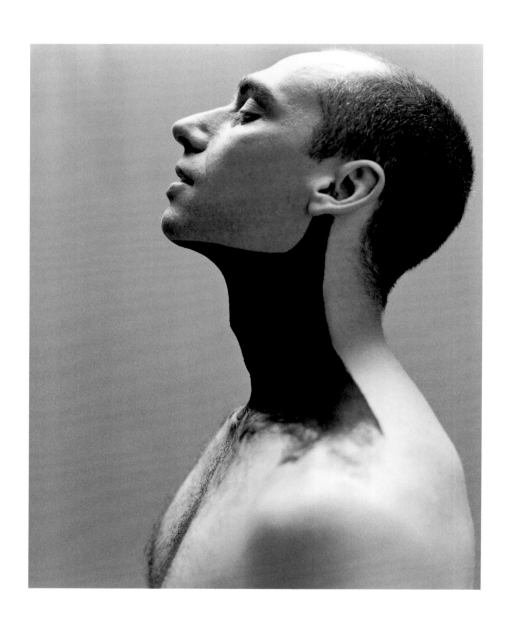

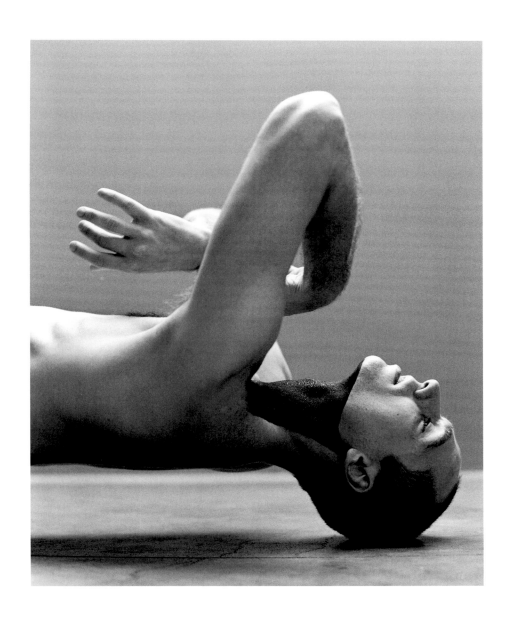

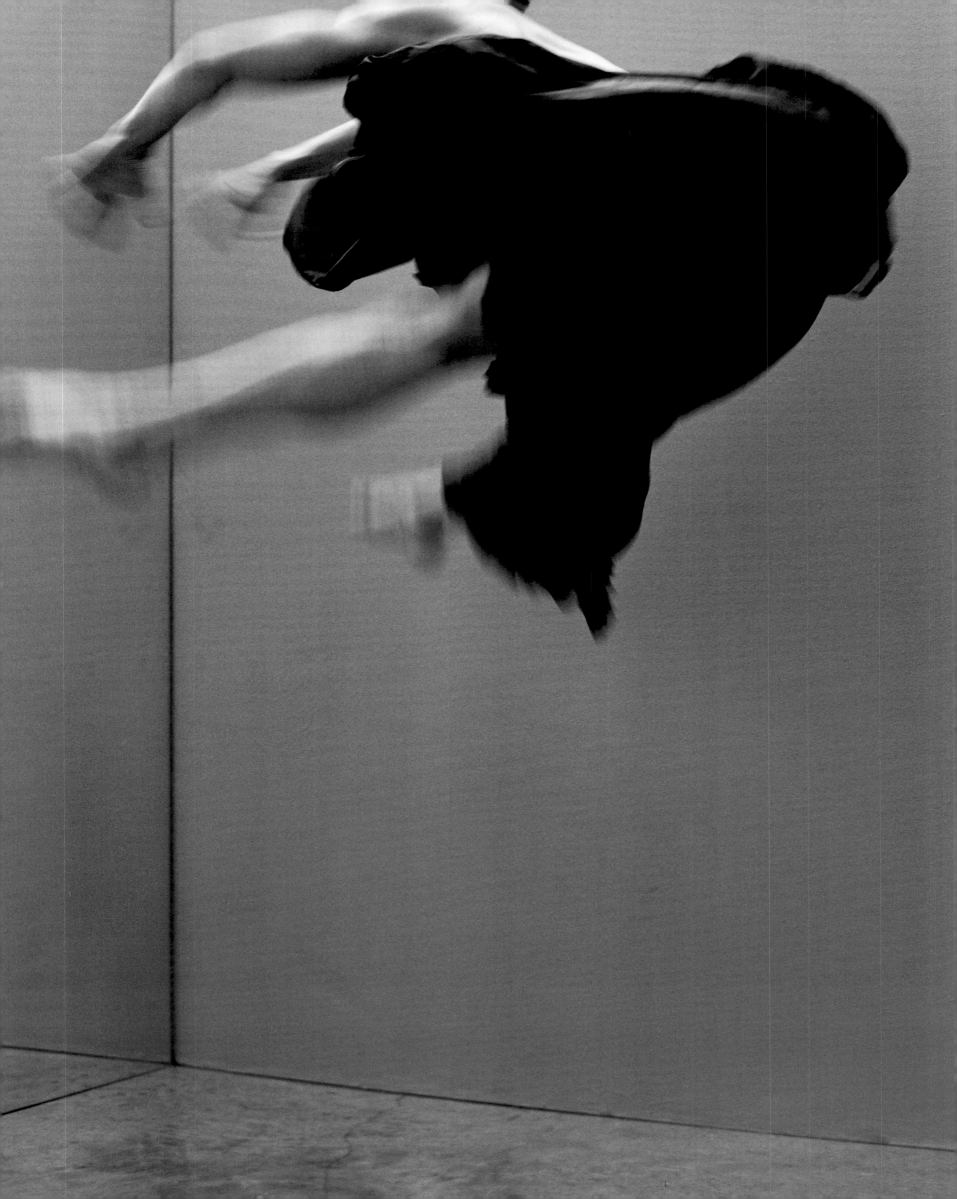

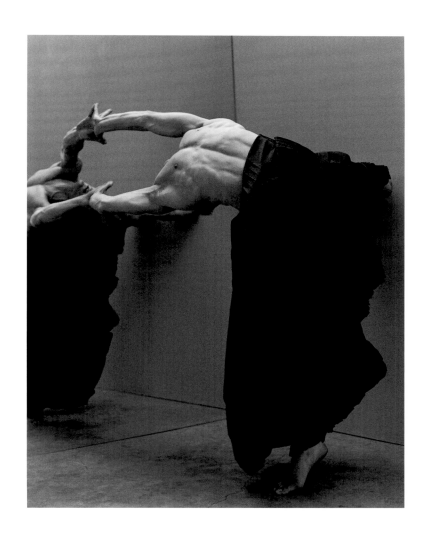

82

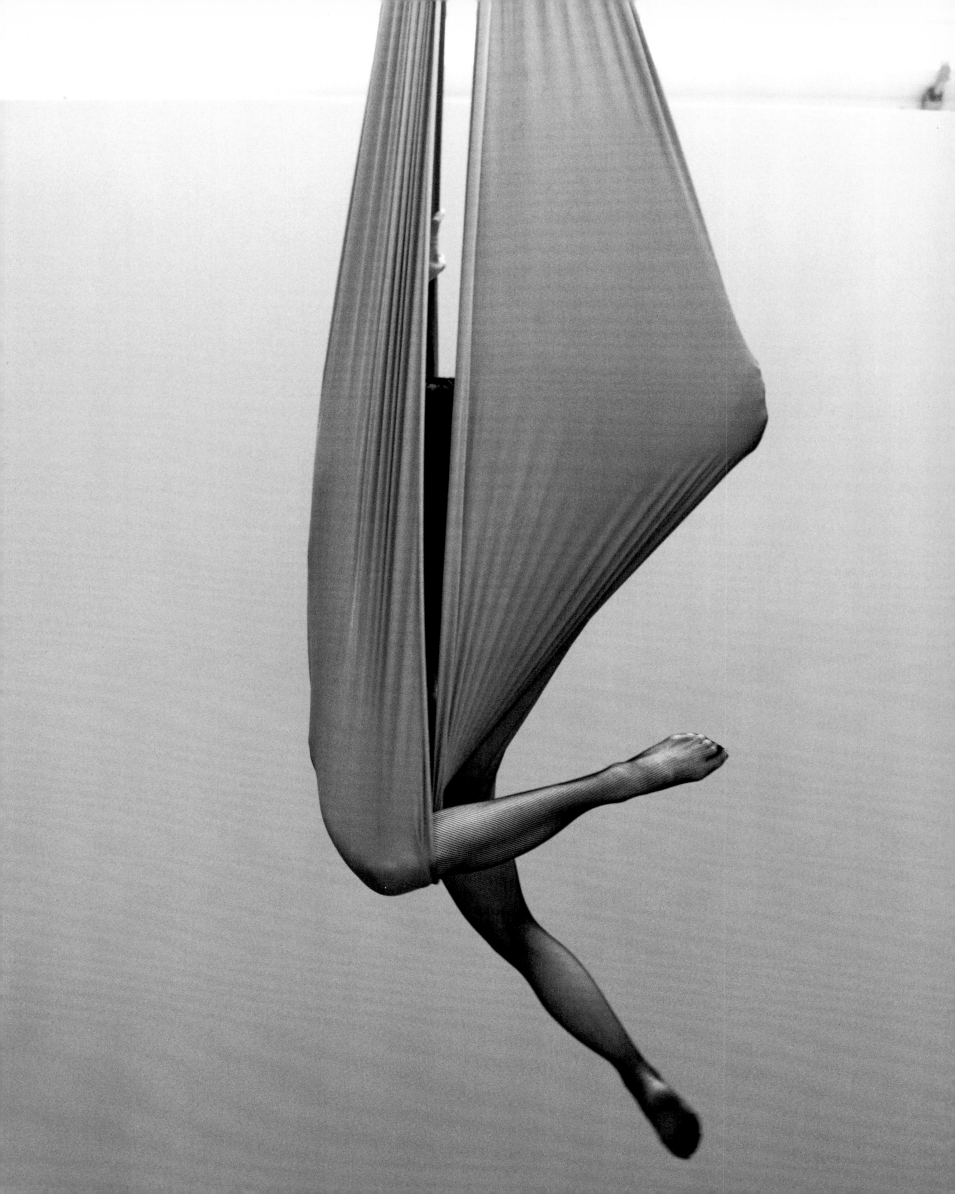

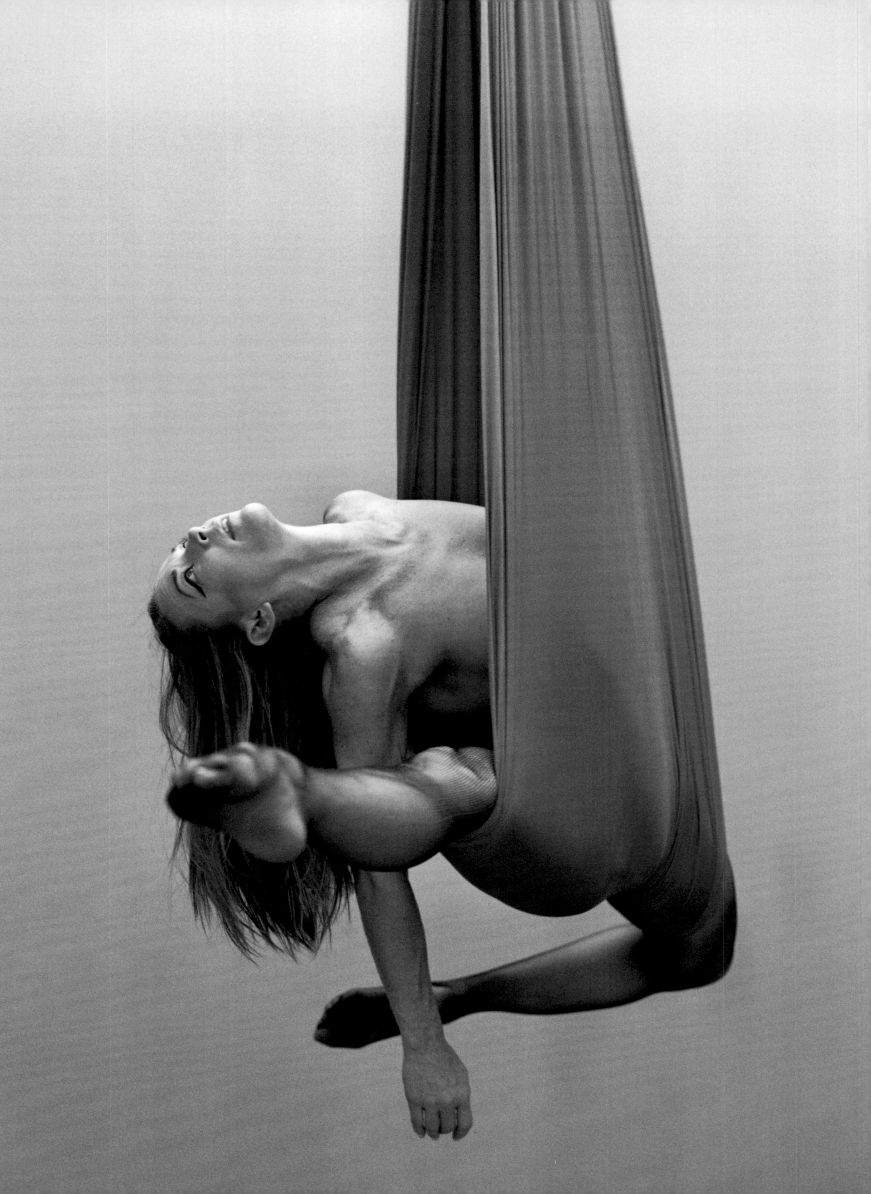

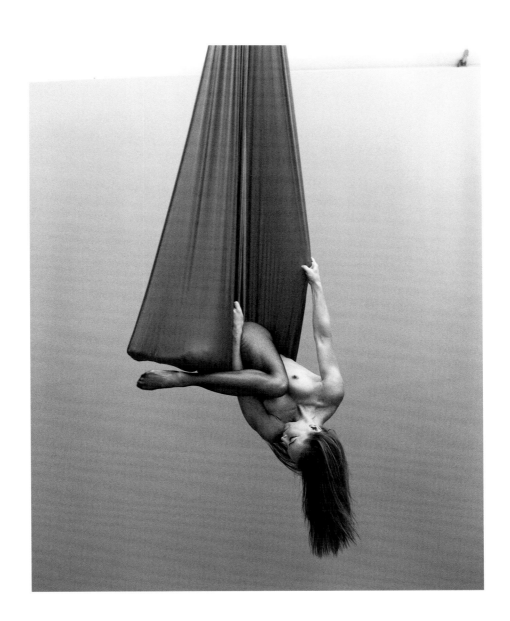

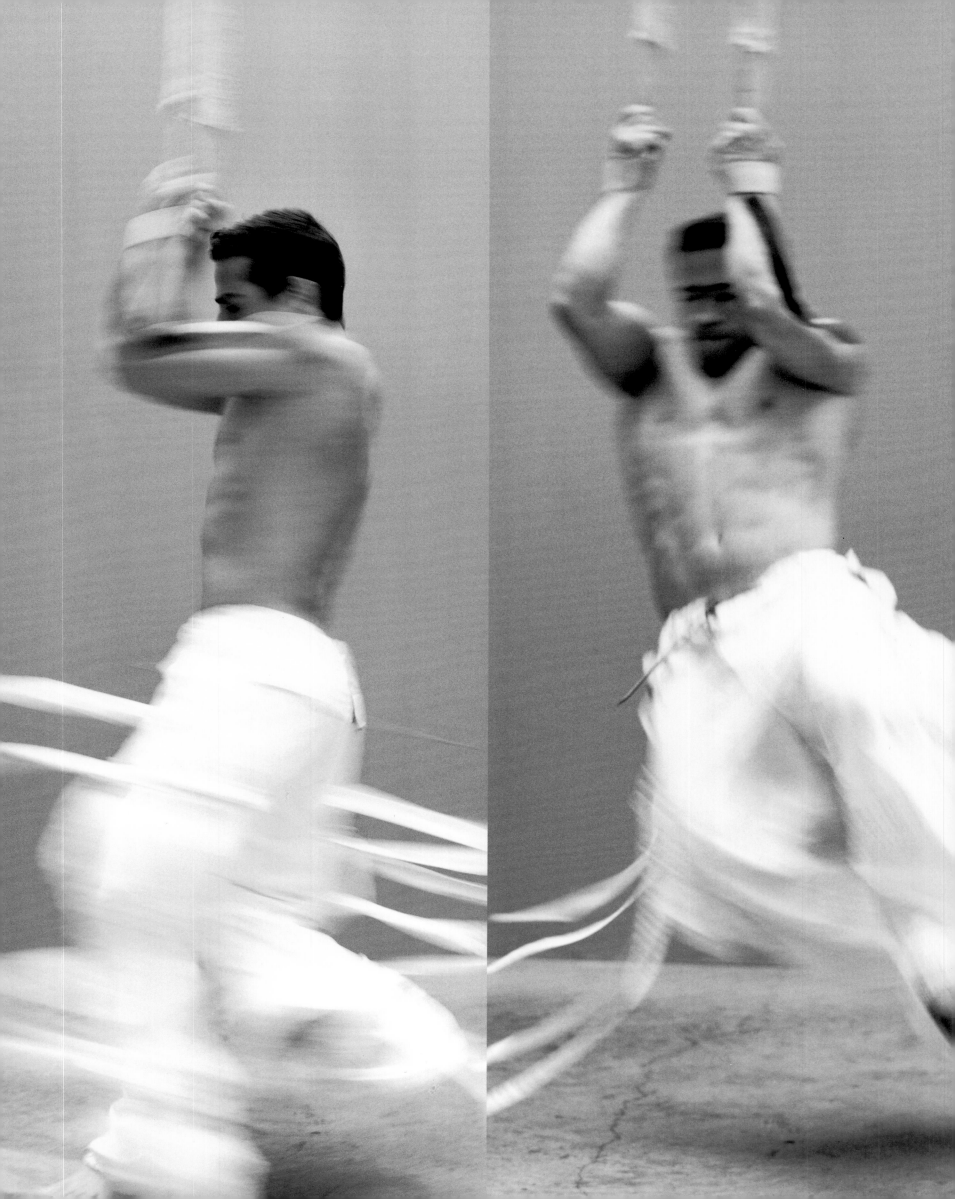

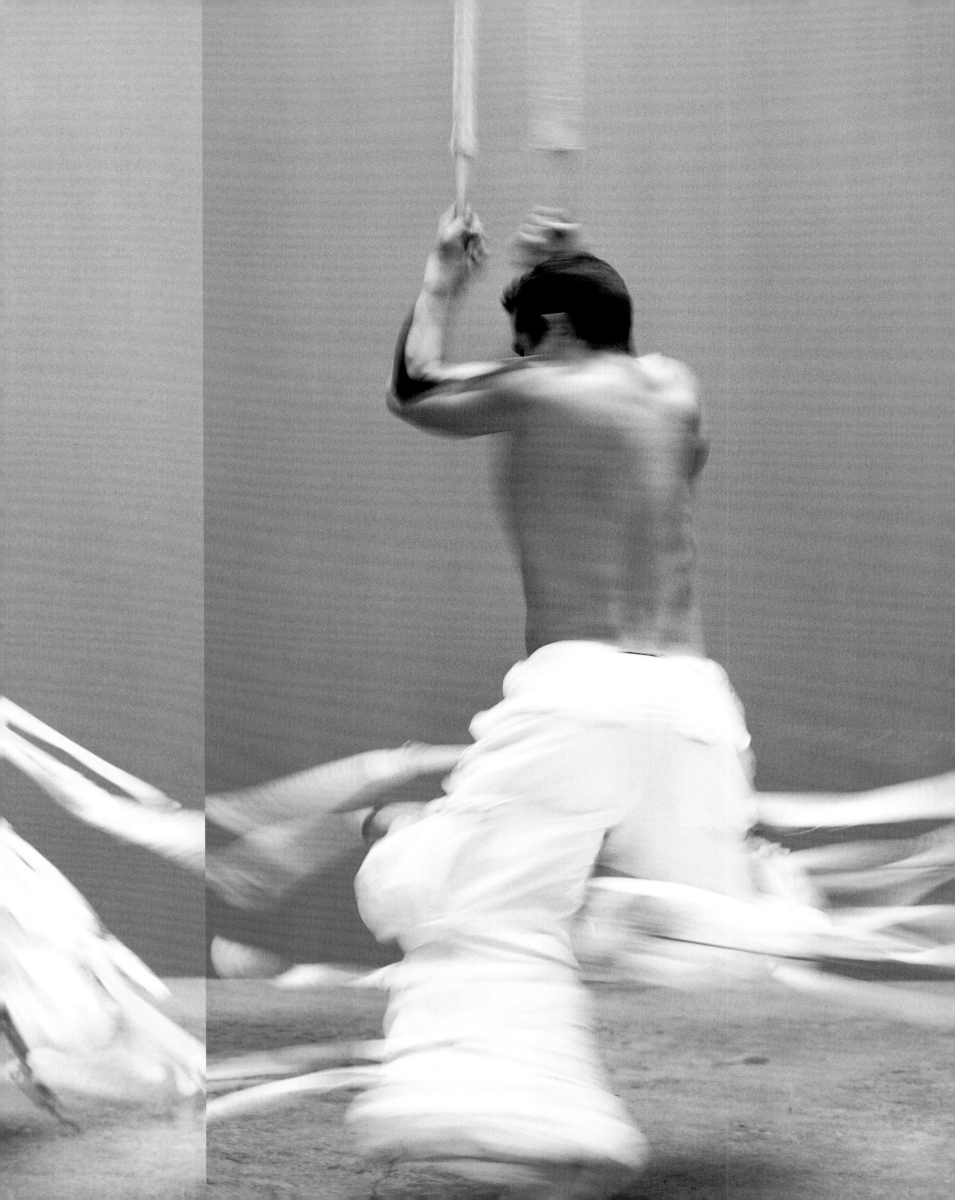

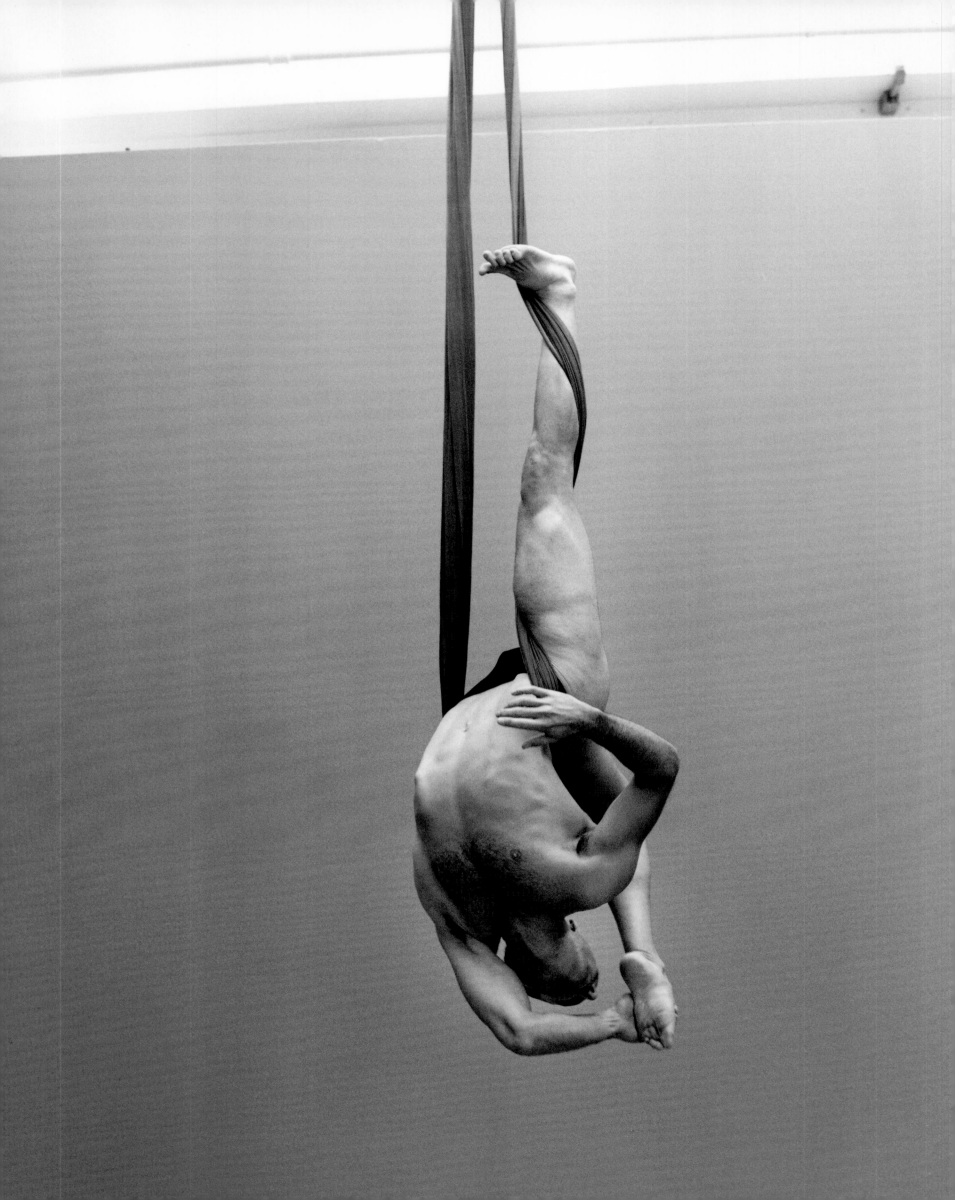

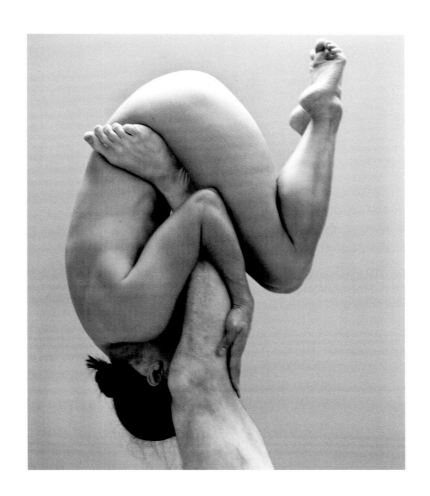

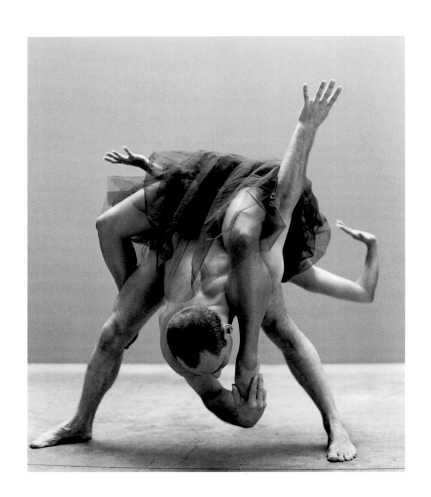

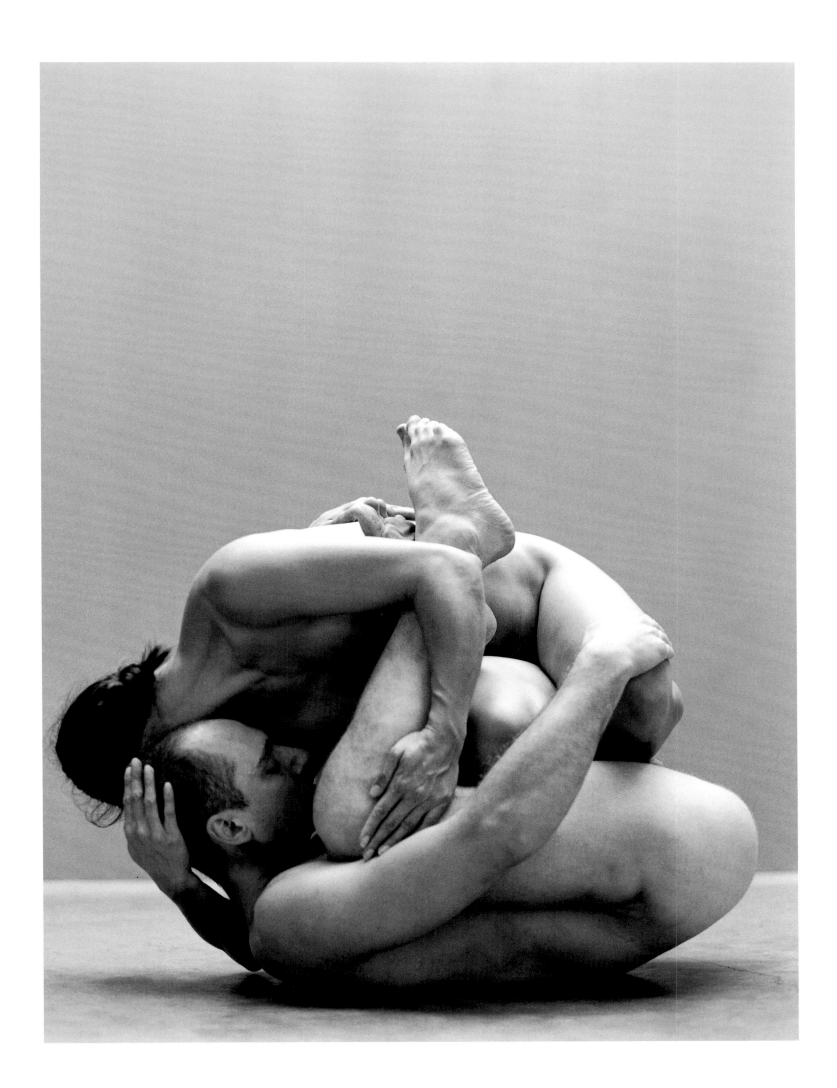

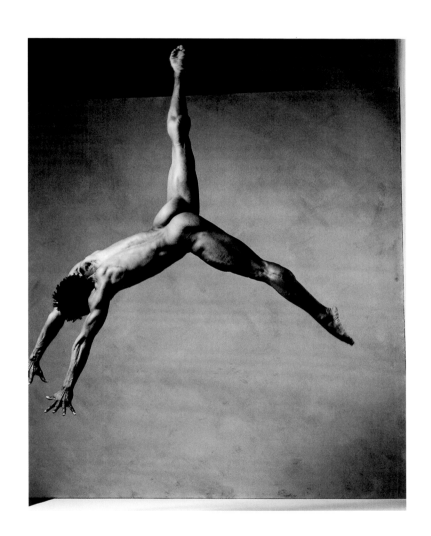

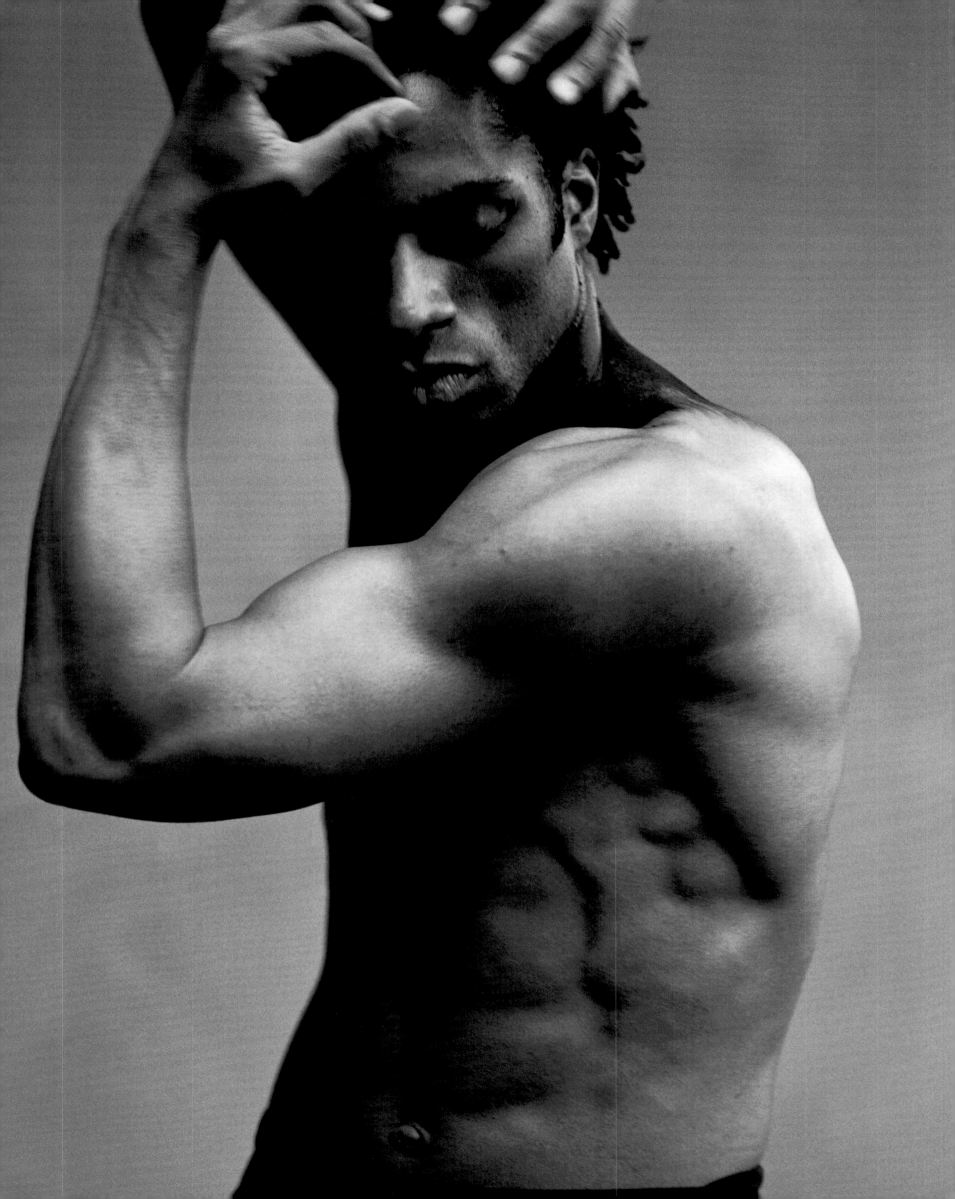

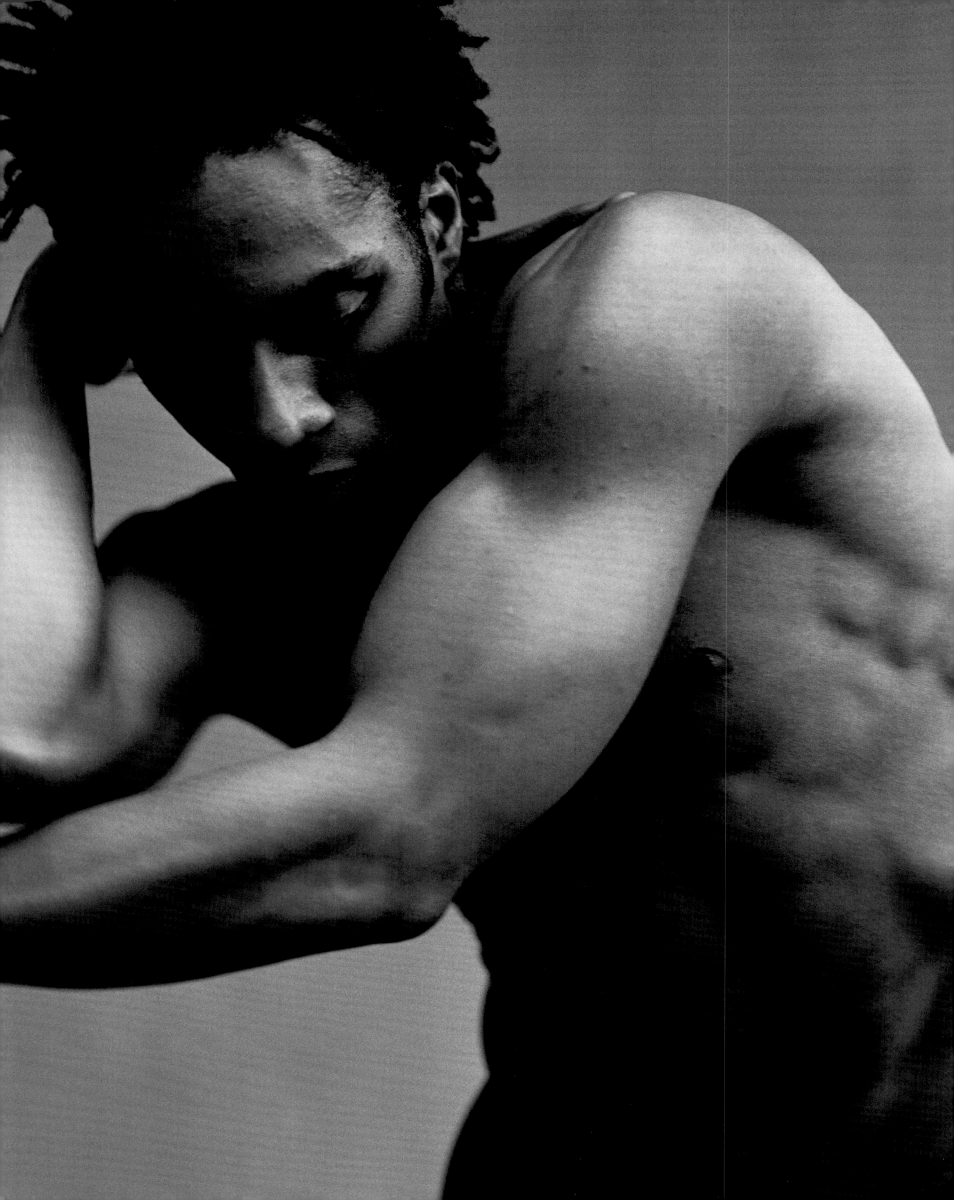

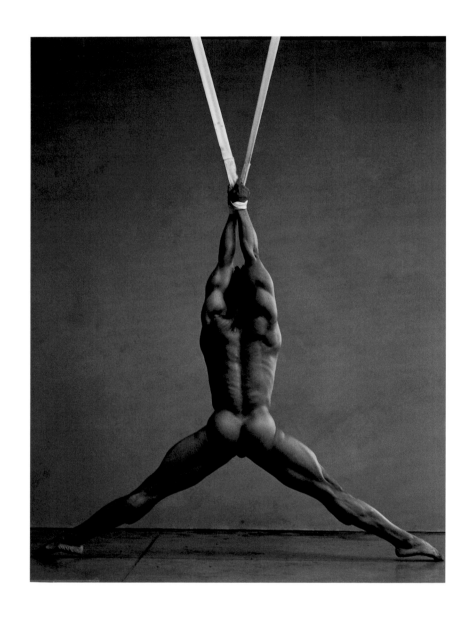

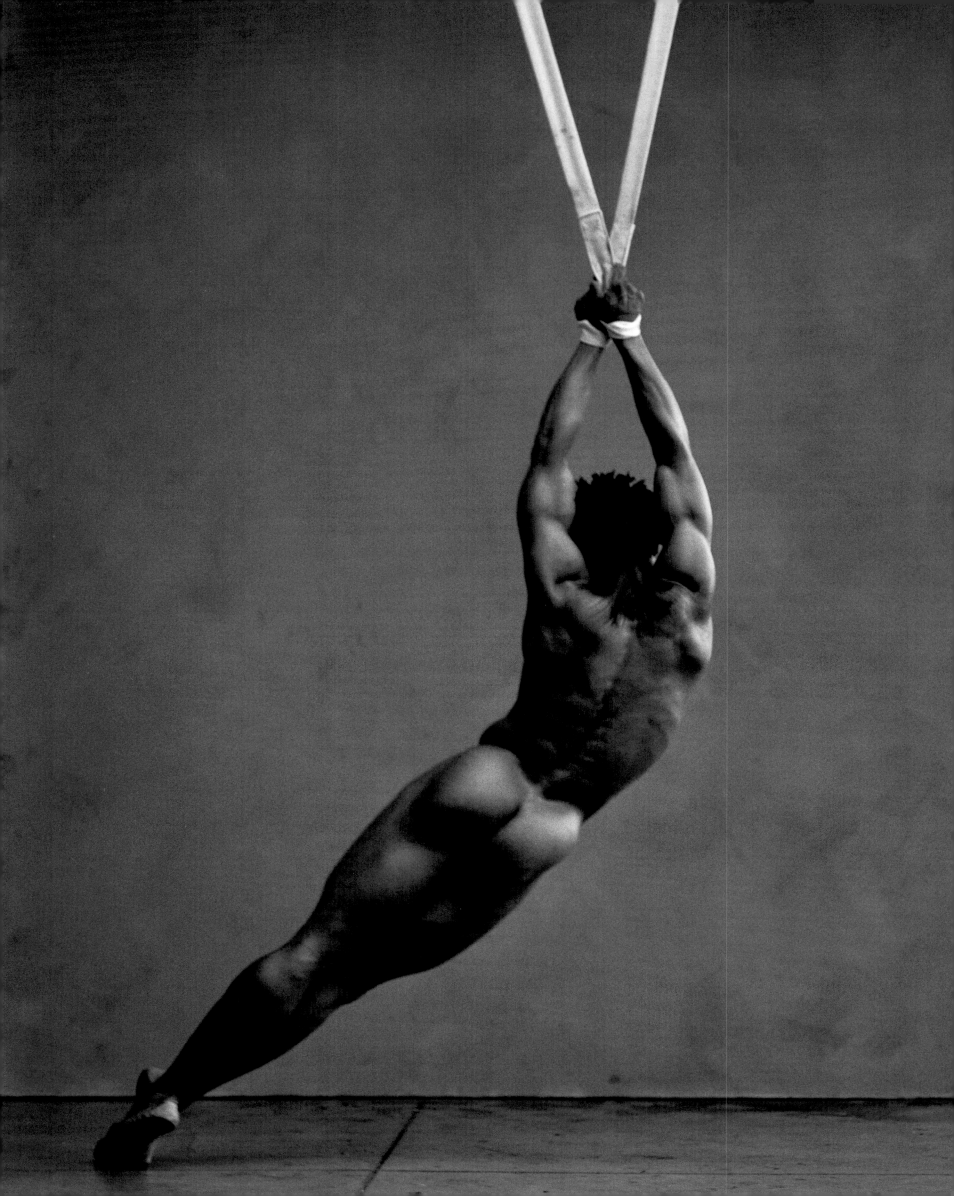

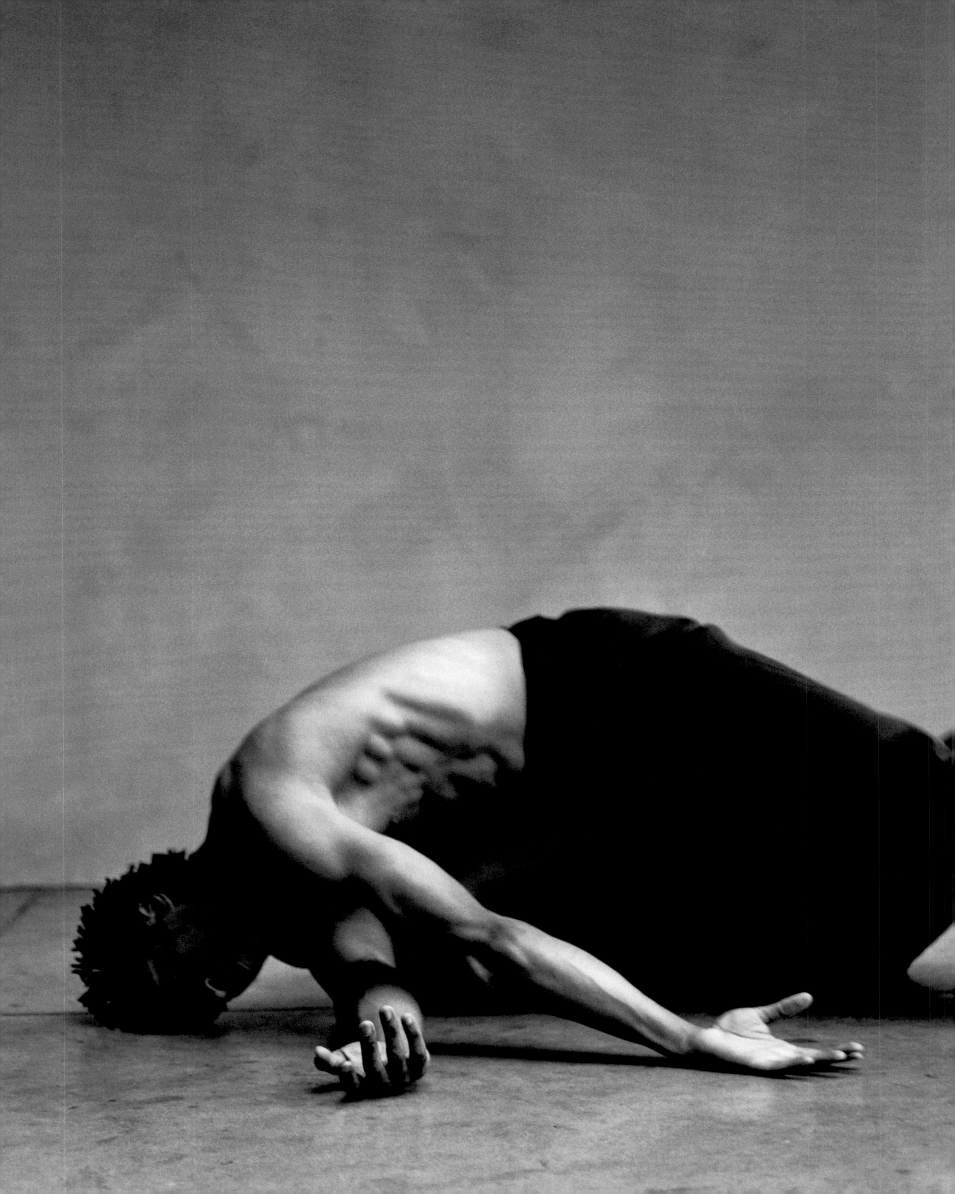

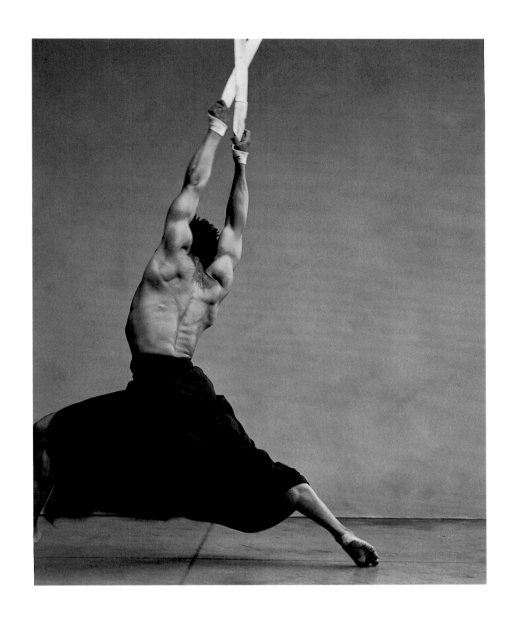

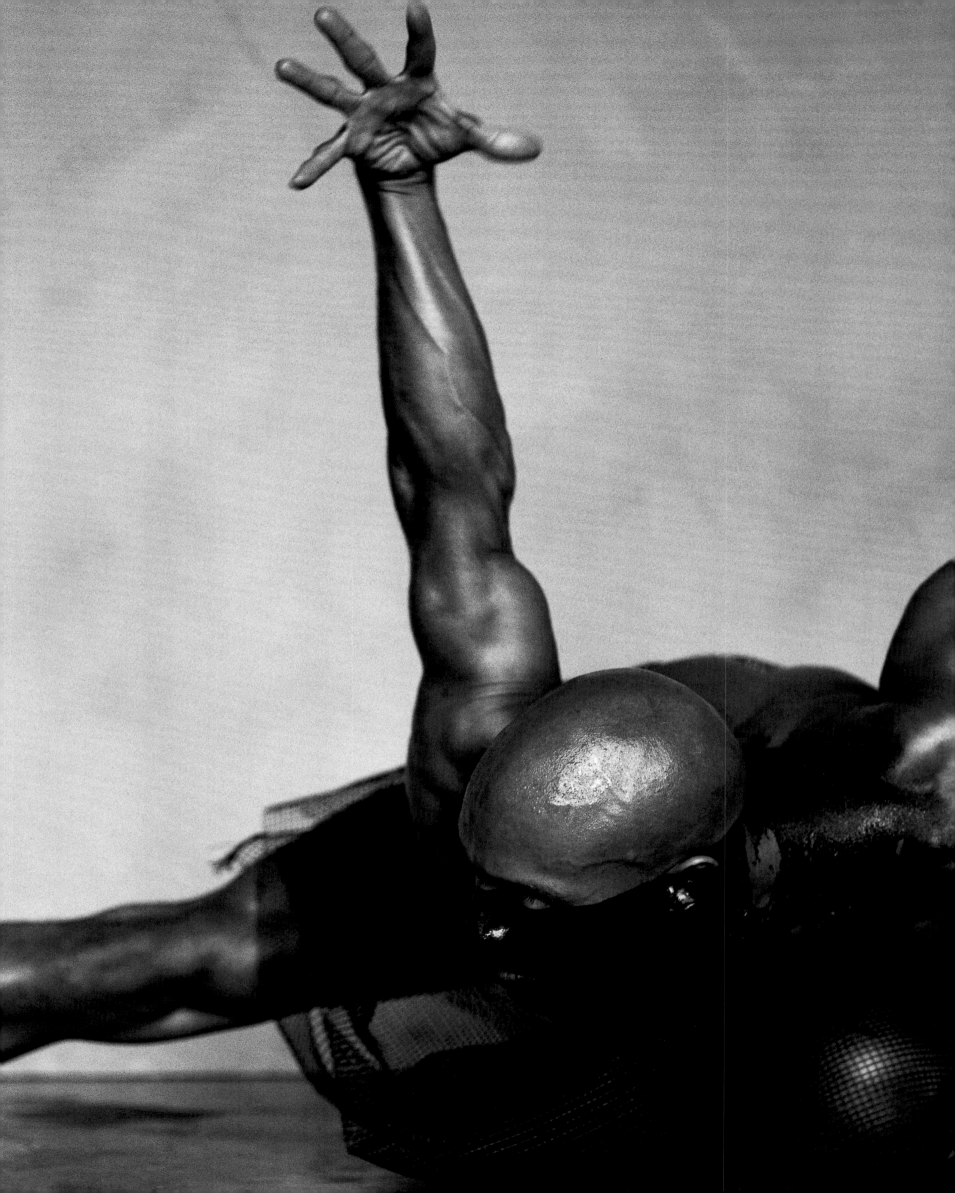

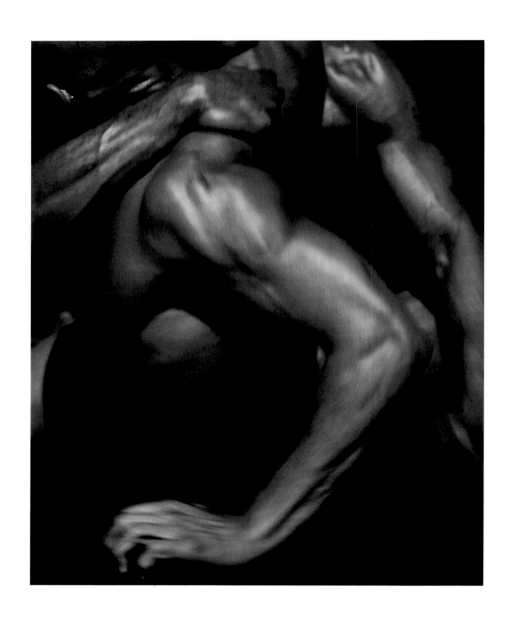

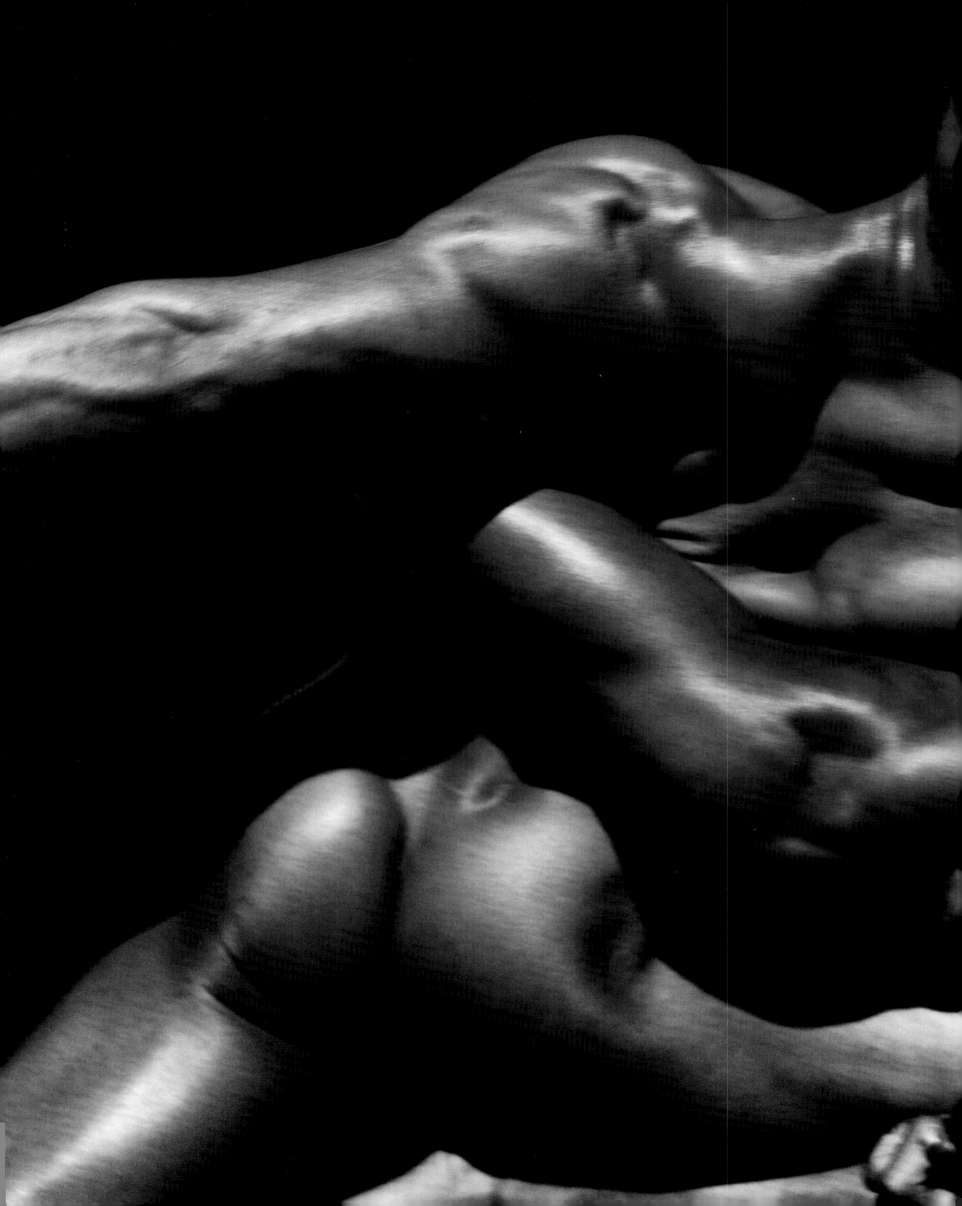

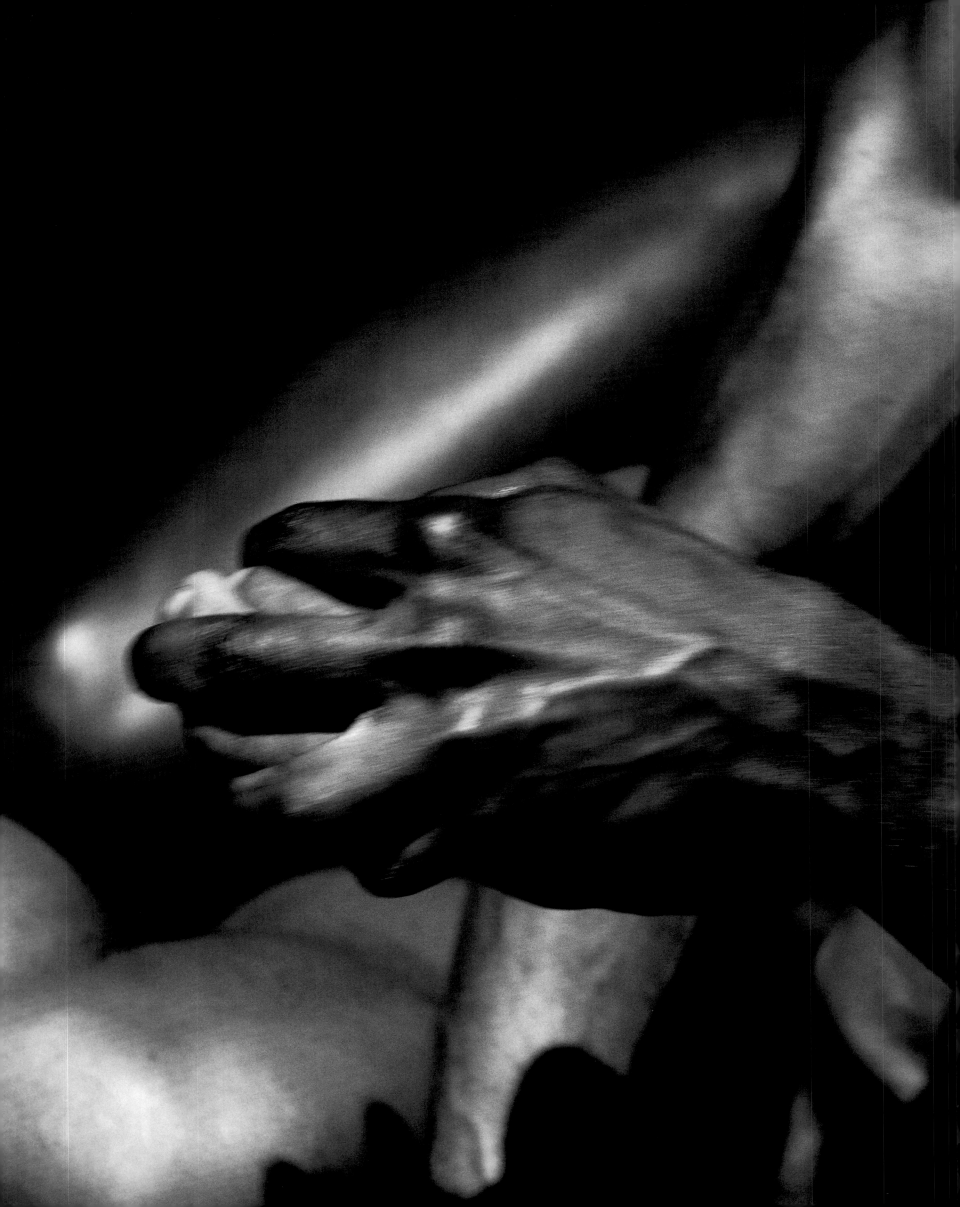

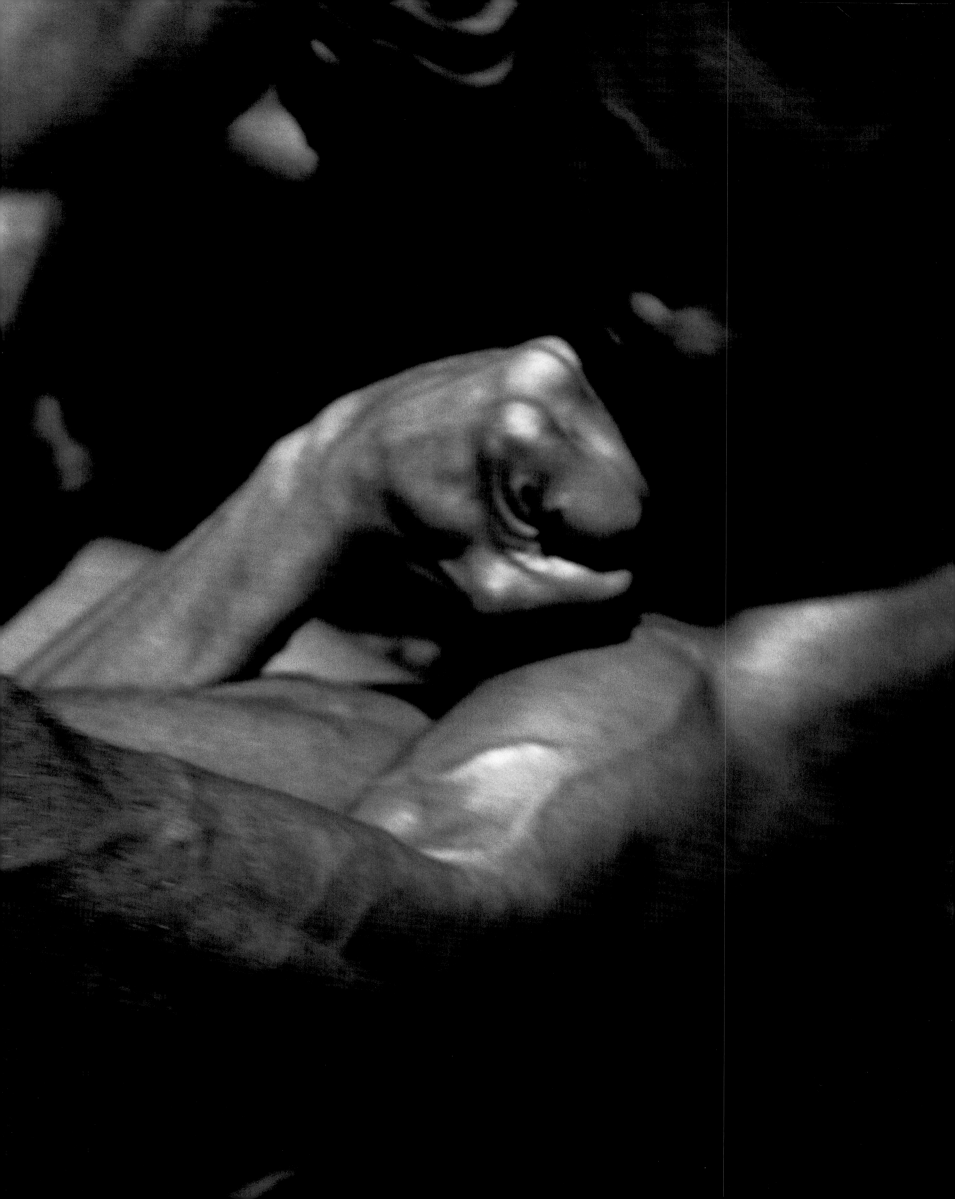

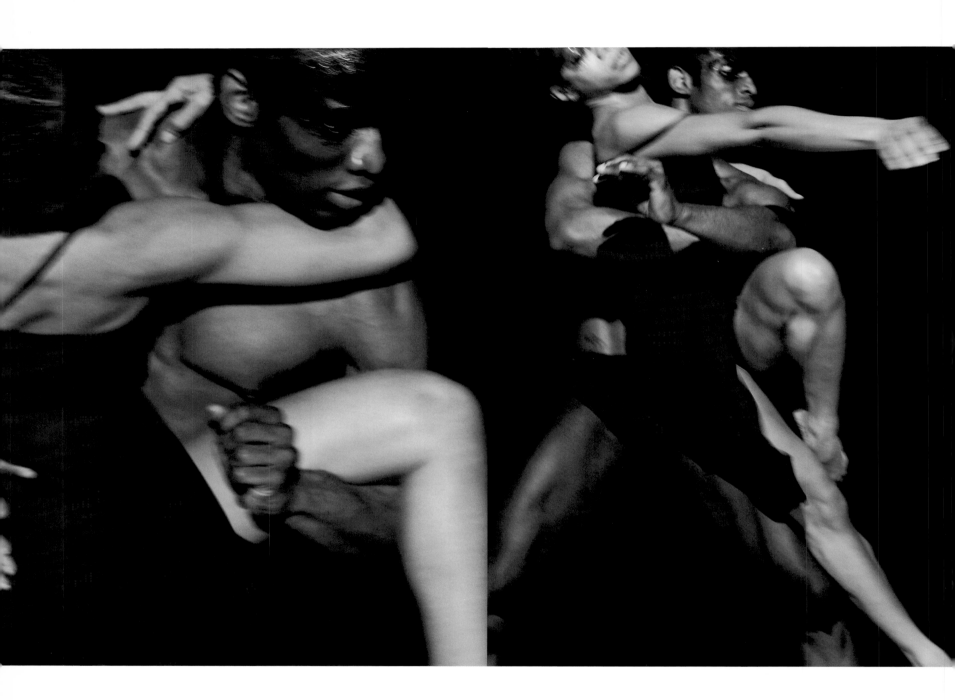

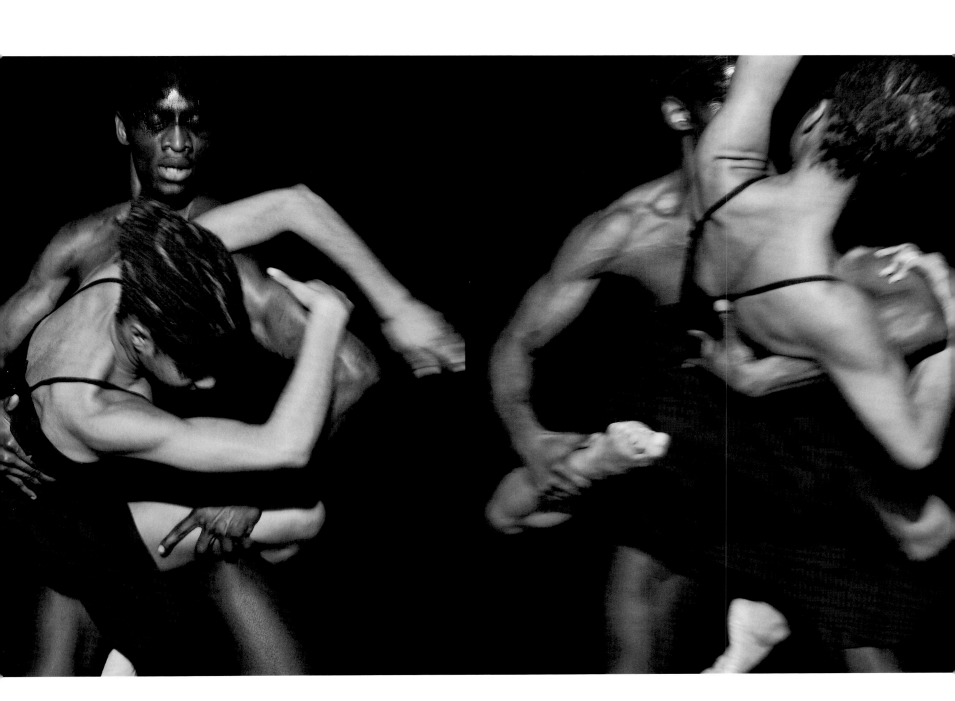

108

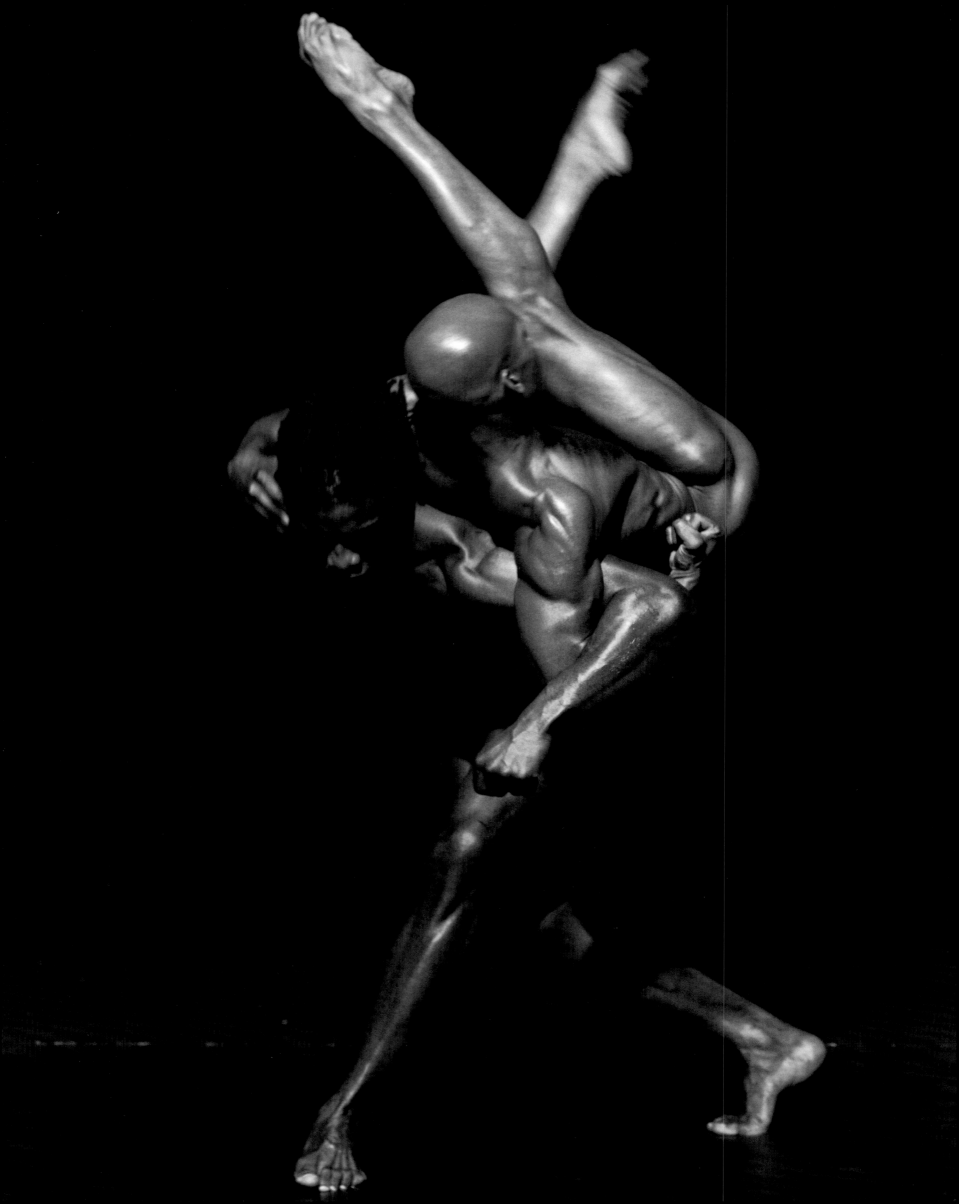

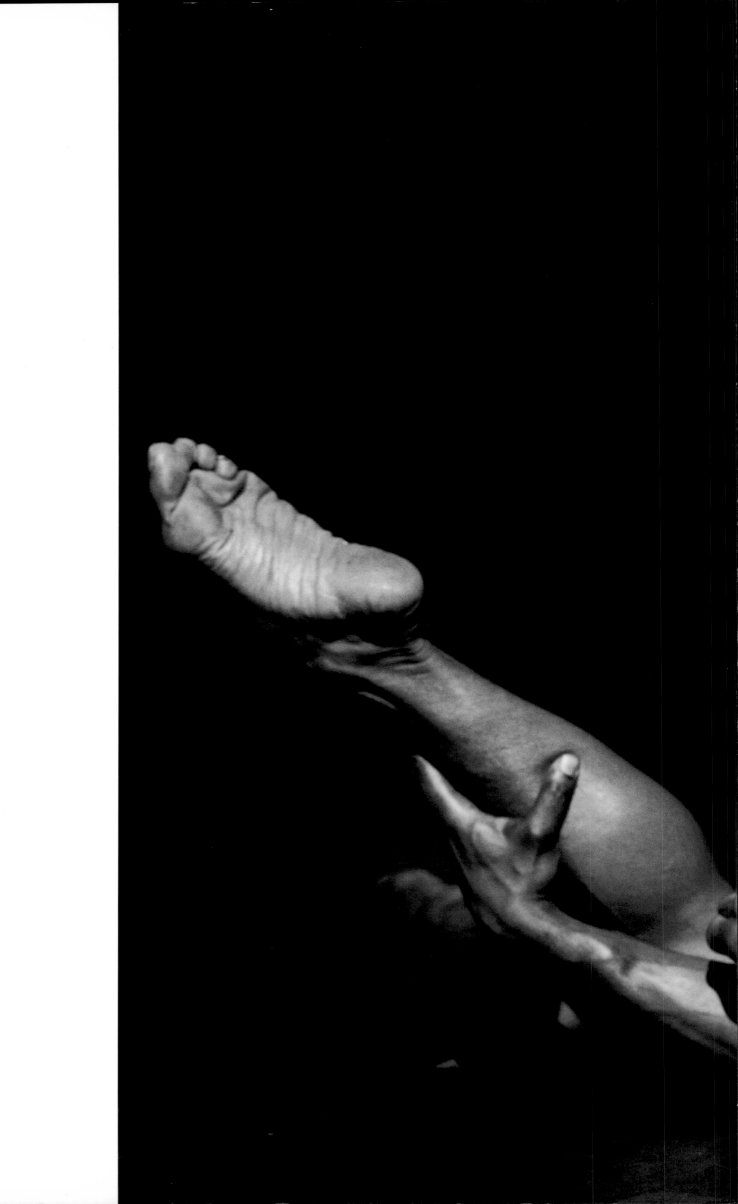

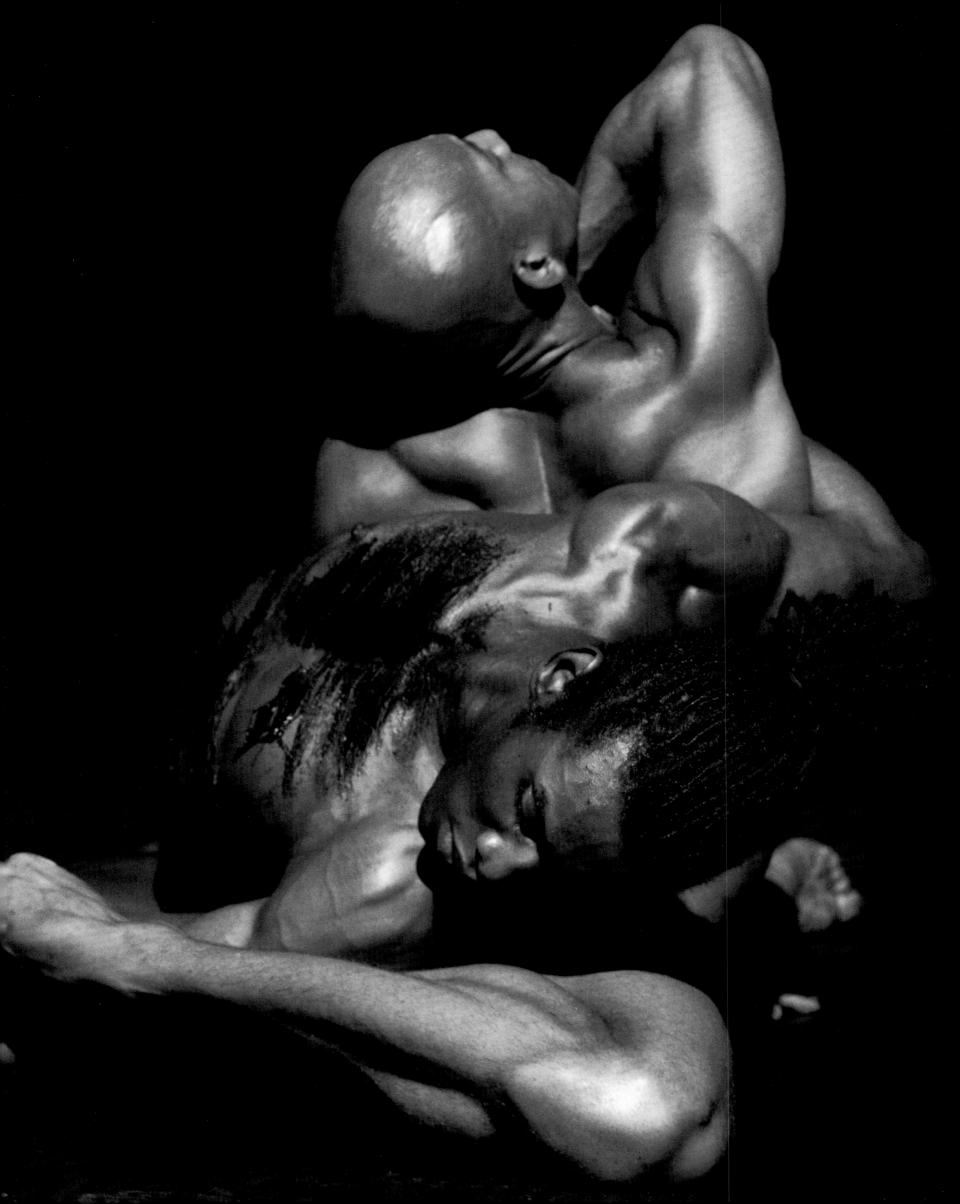

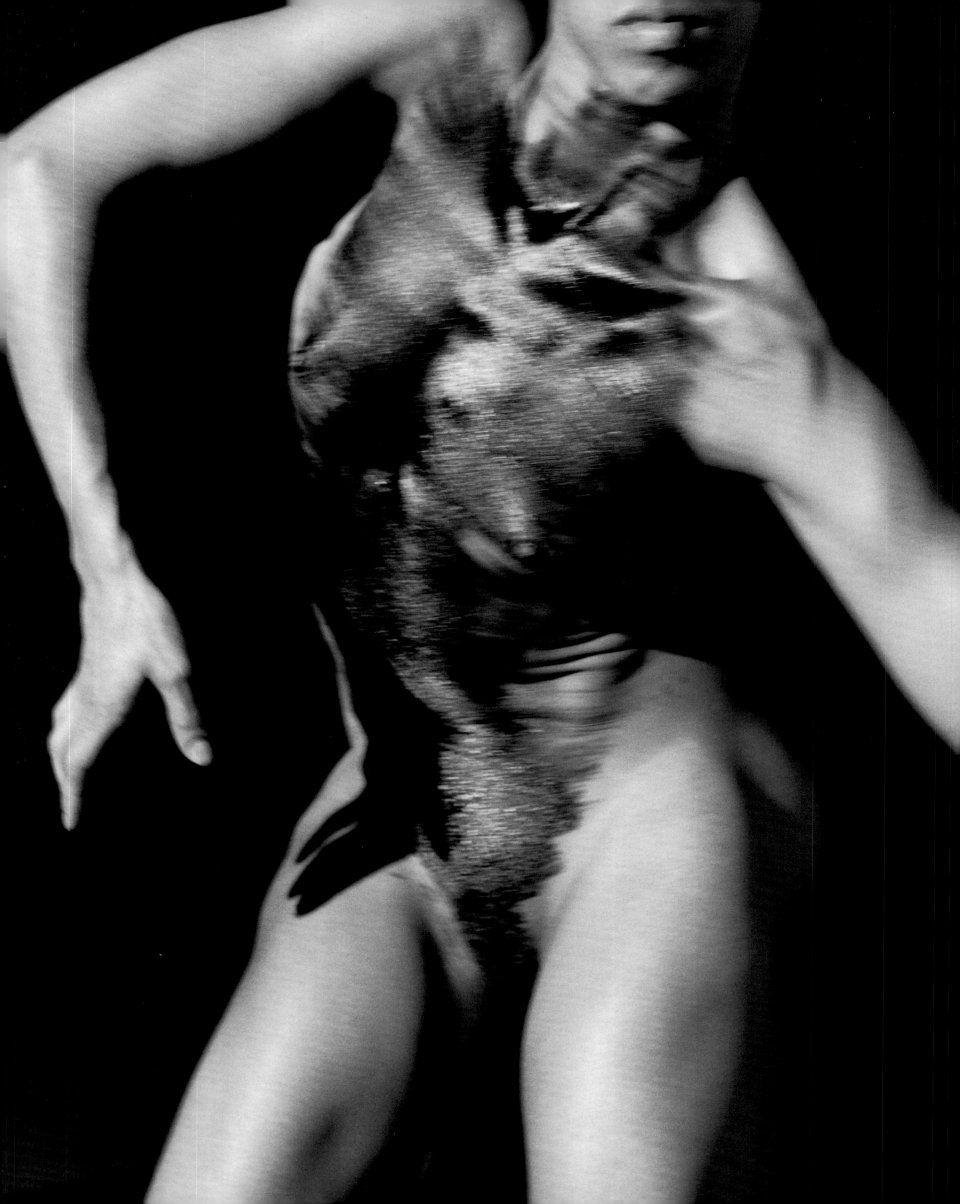

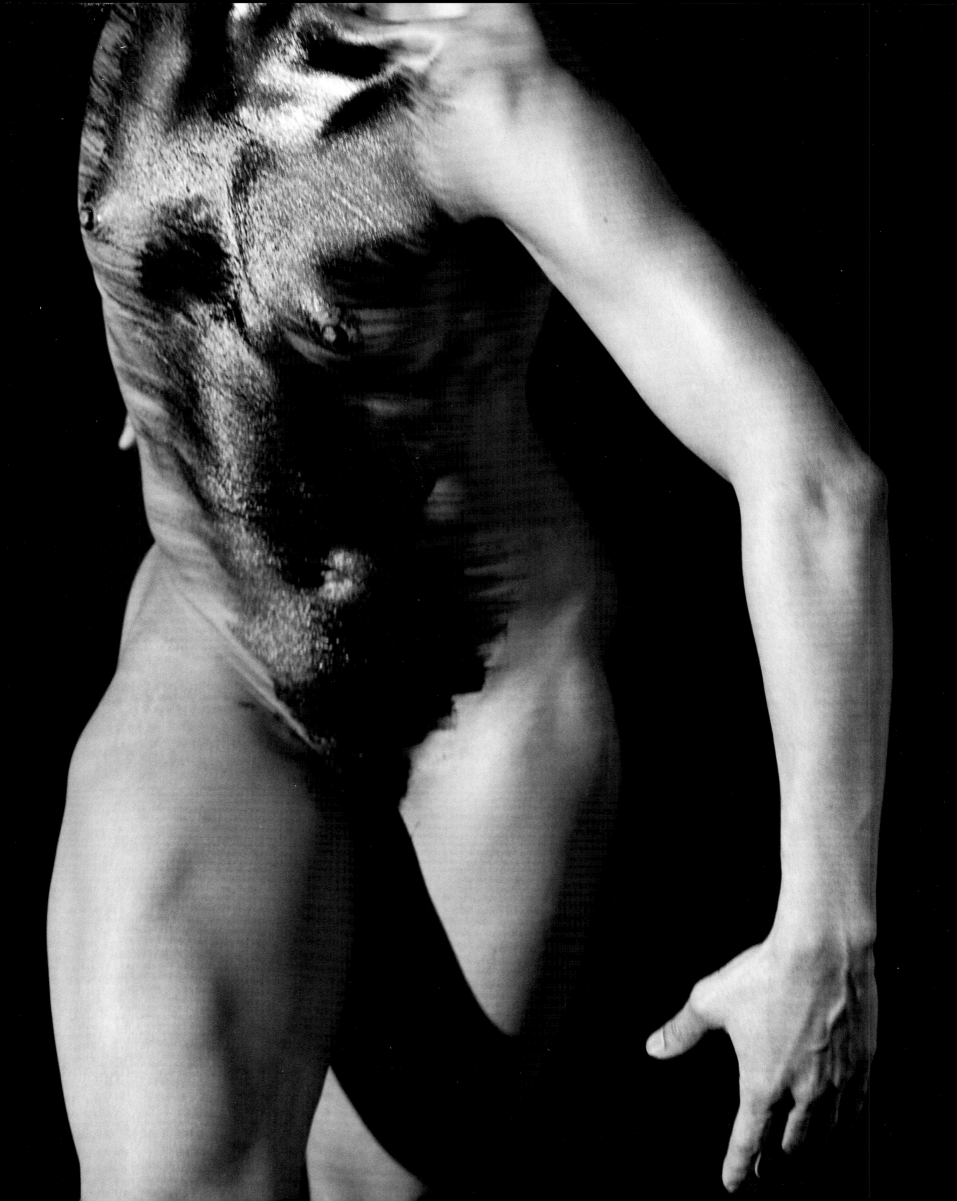

114

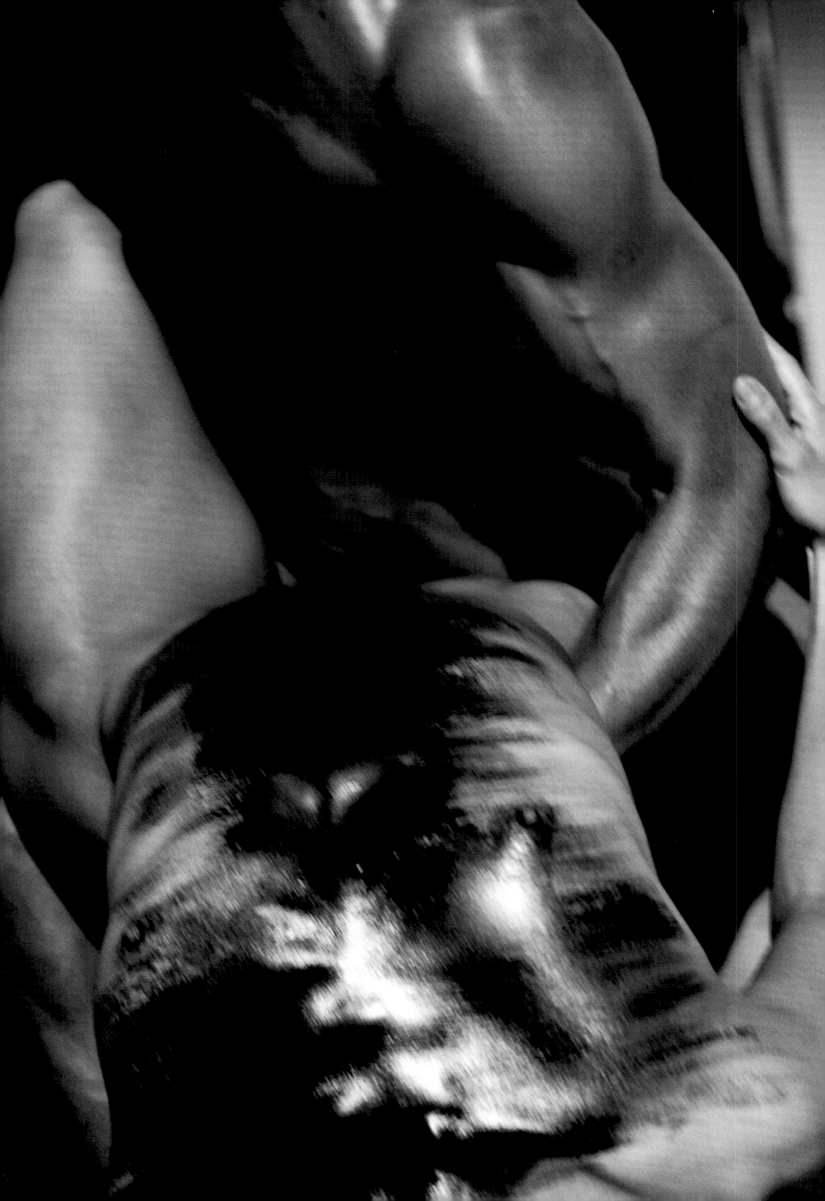

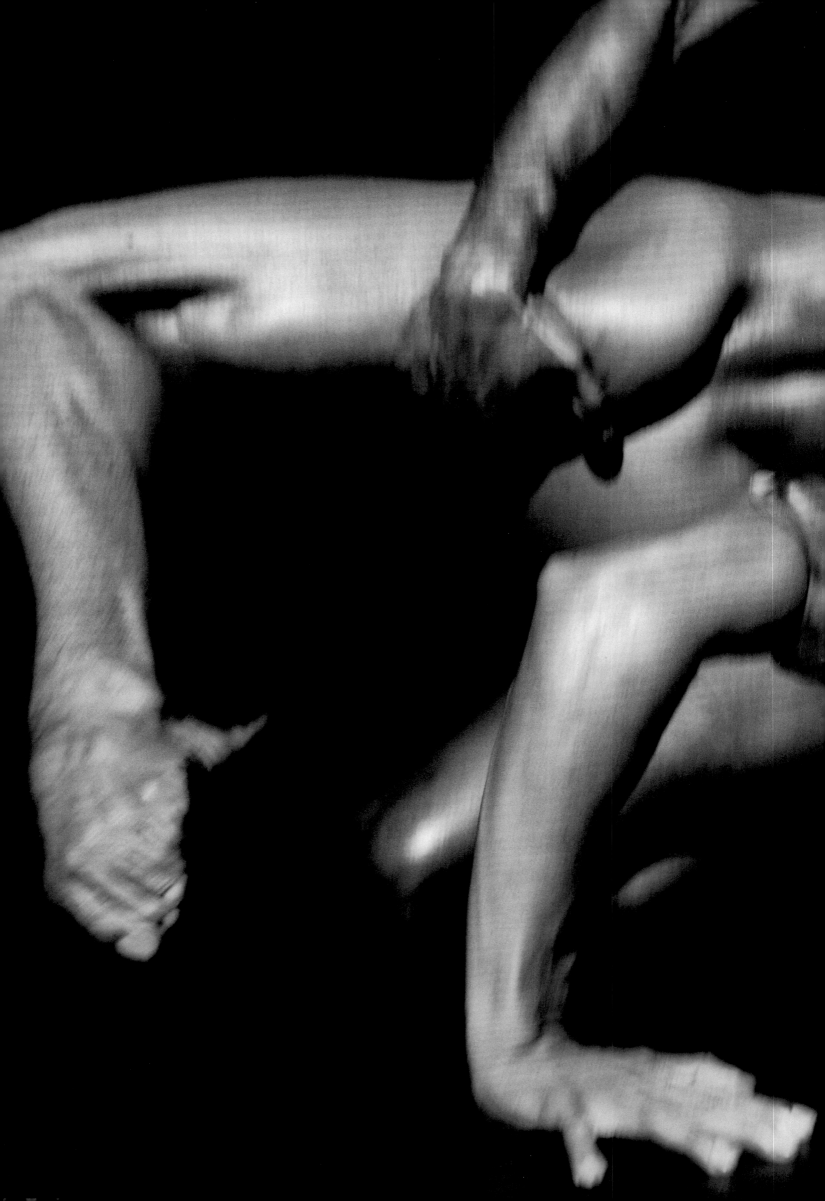

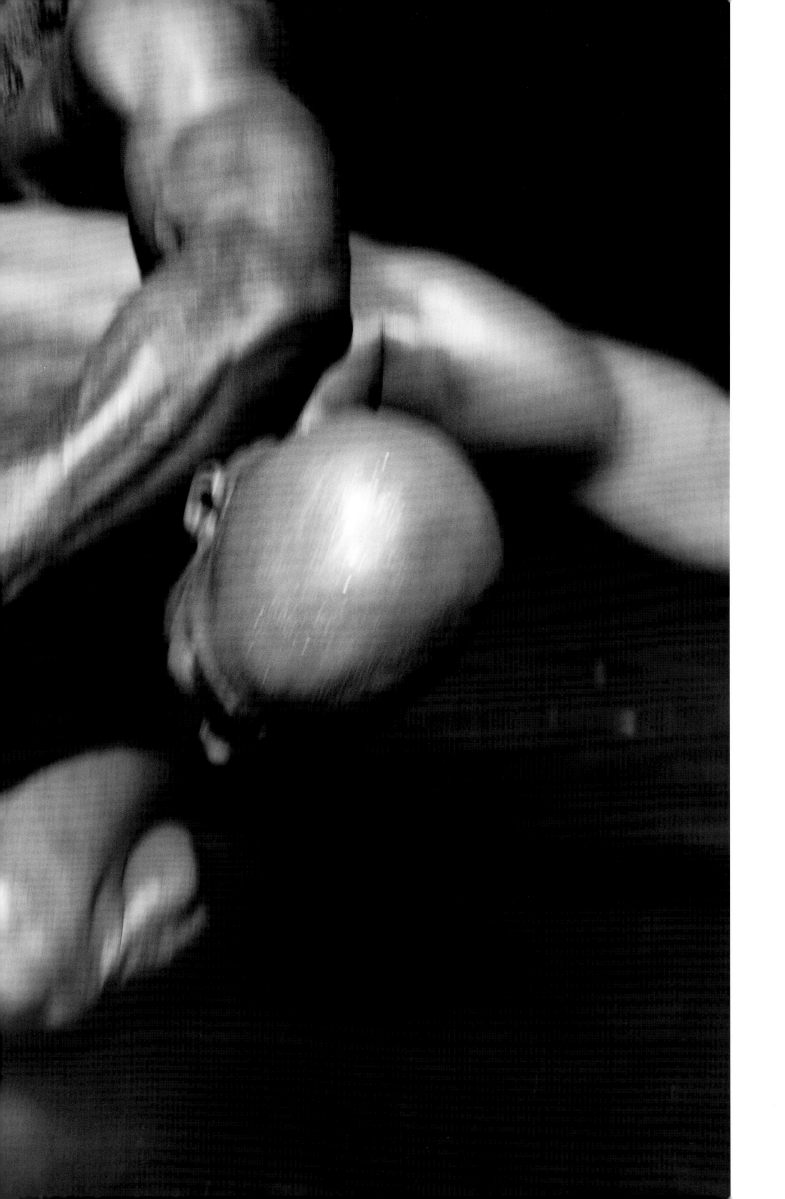

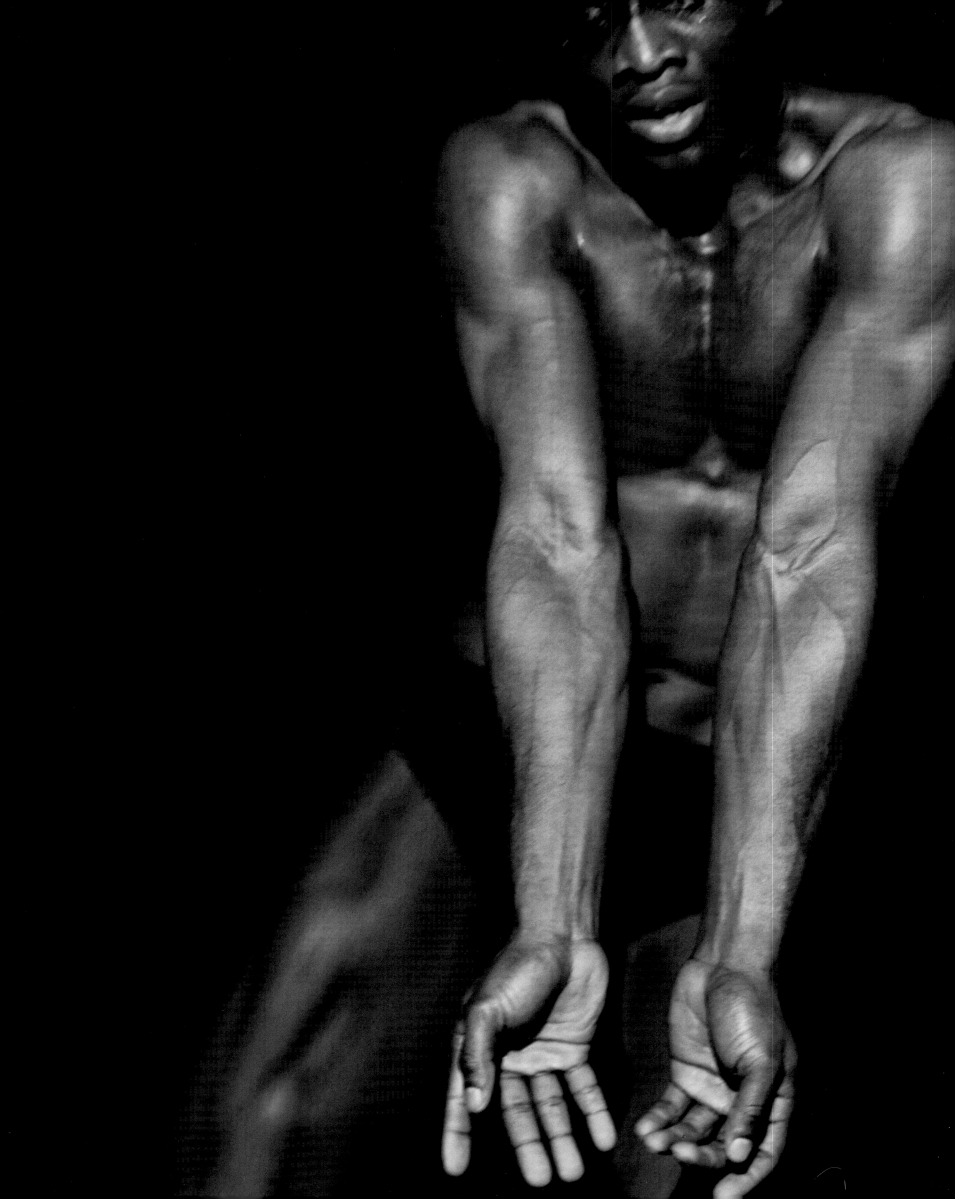

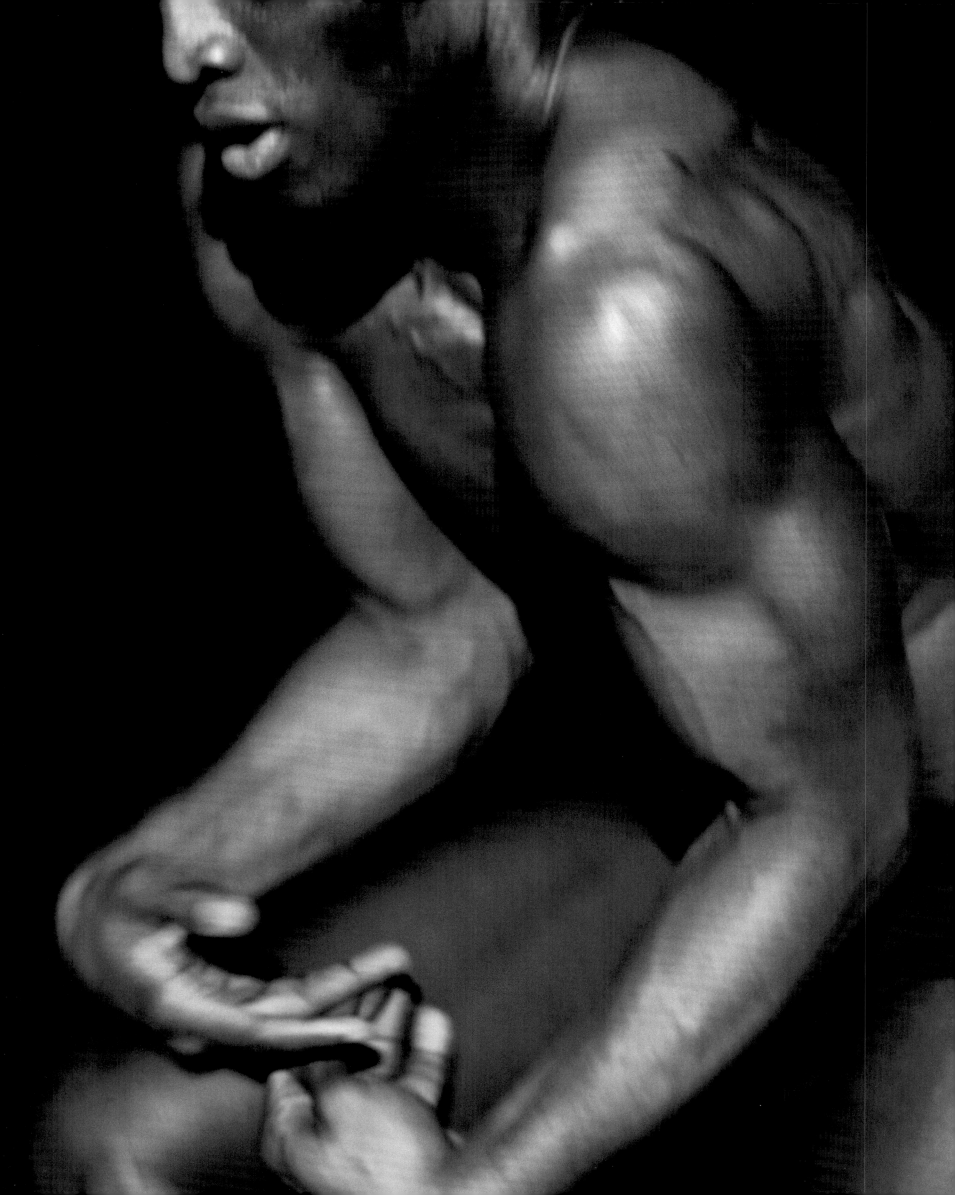

120

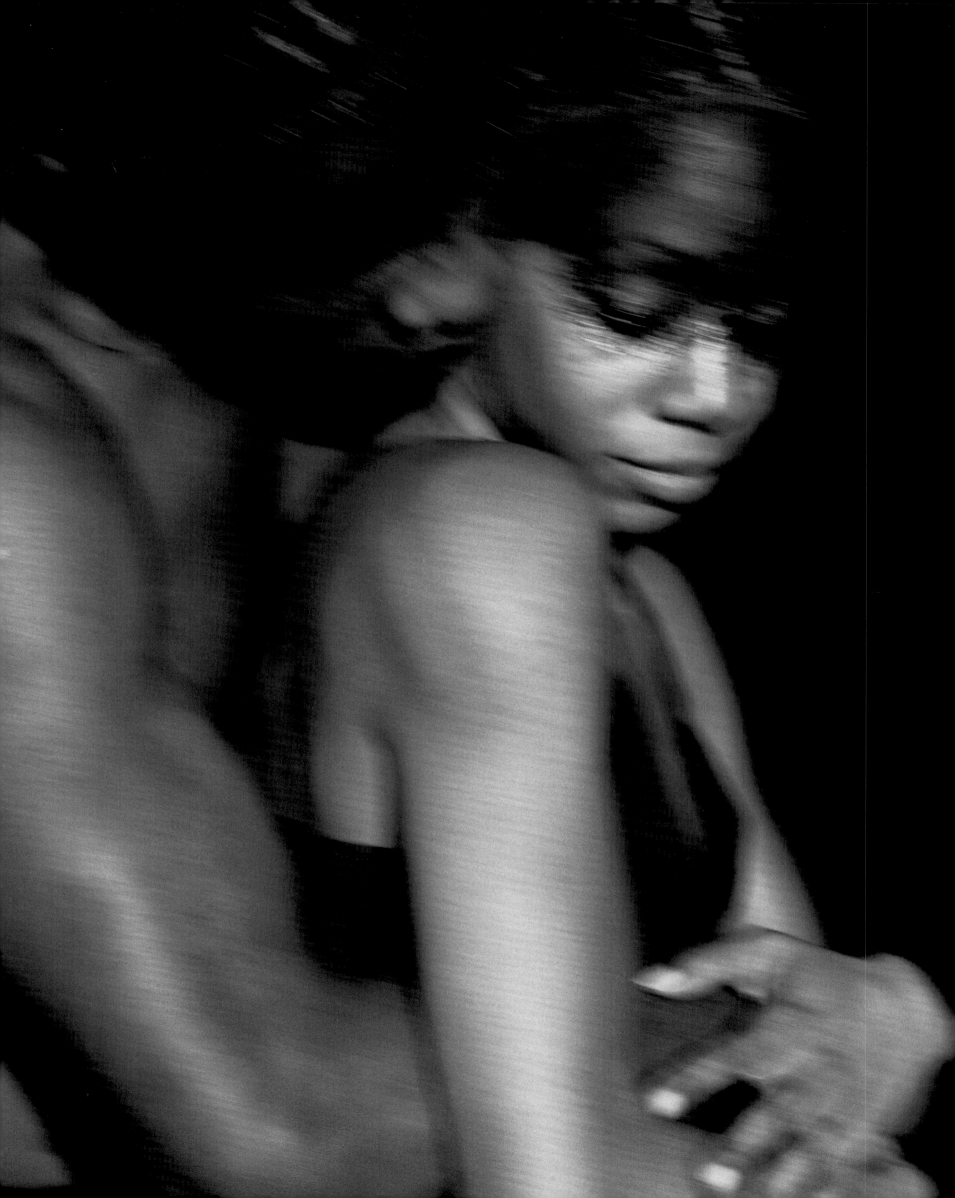

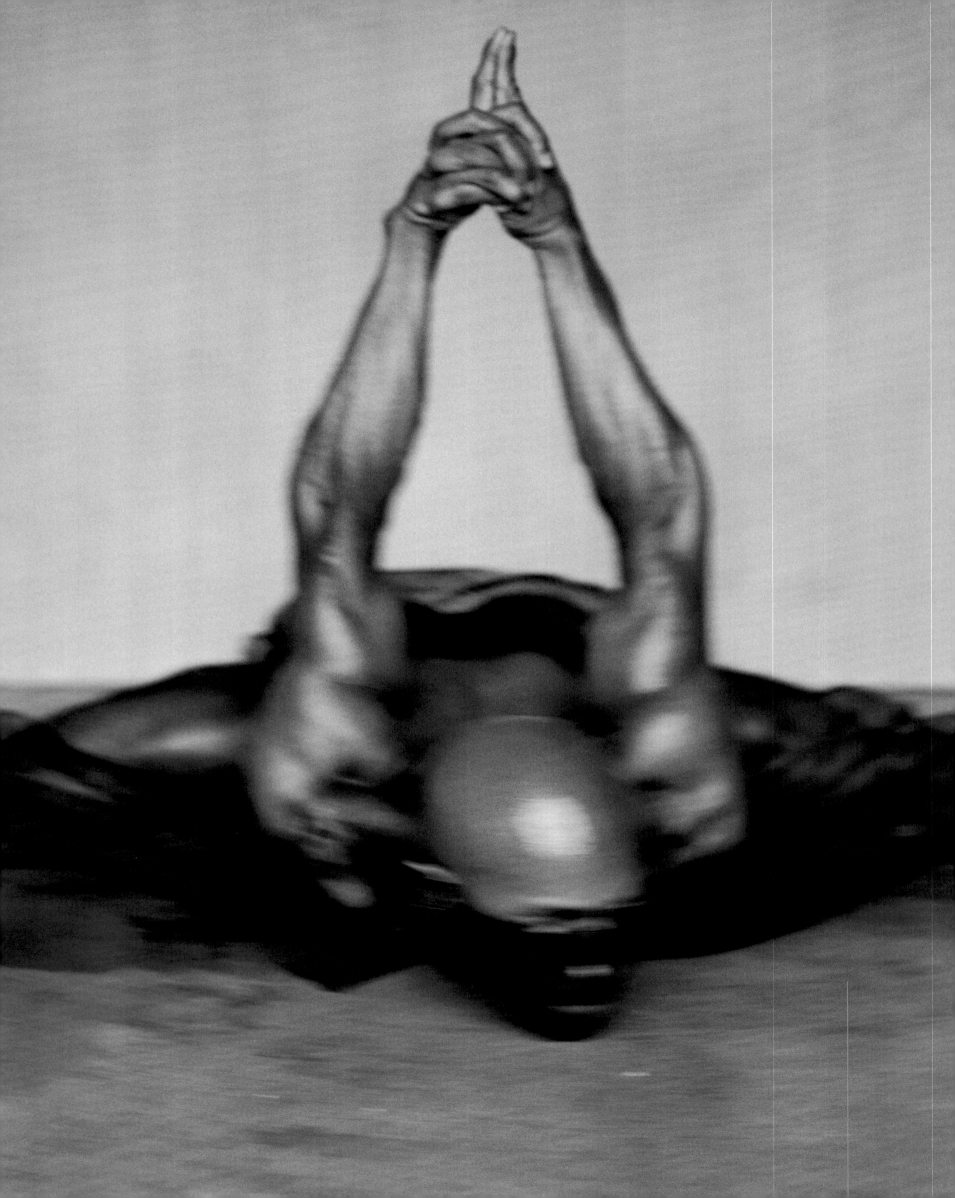

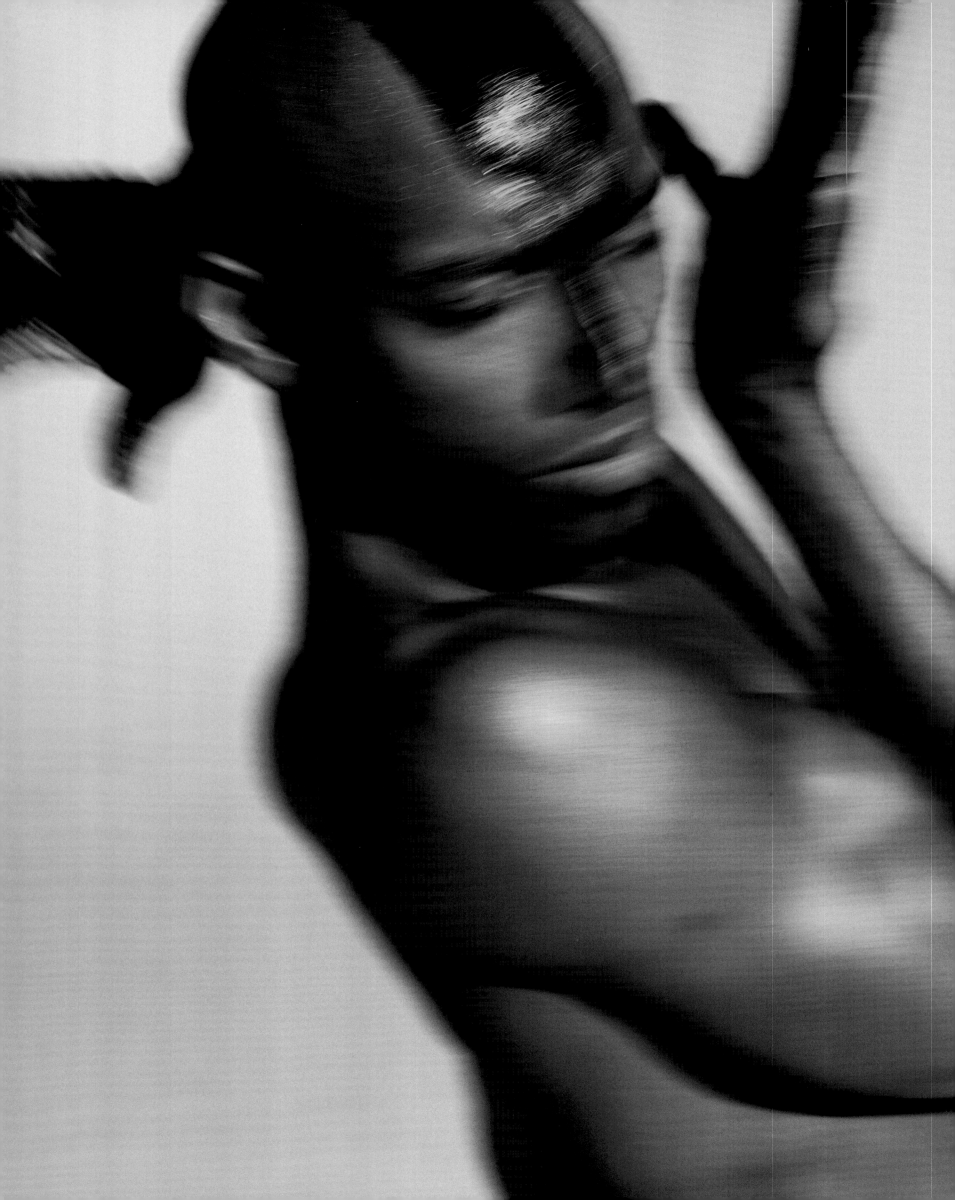

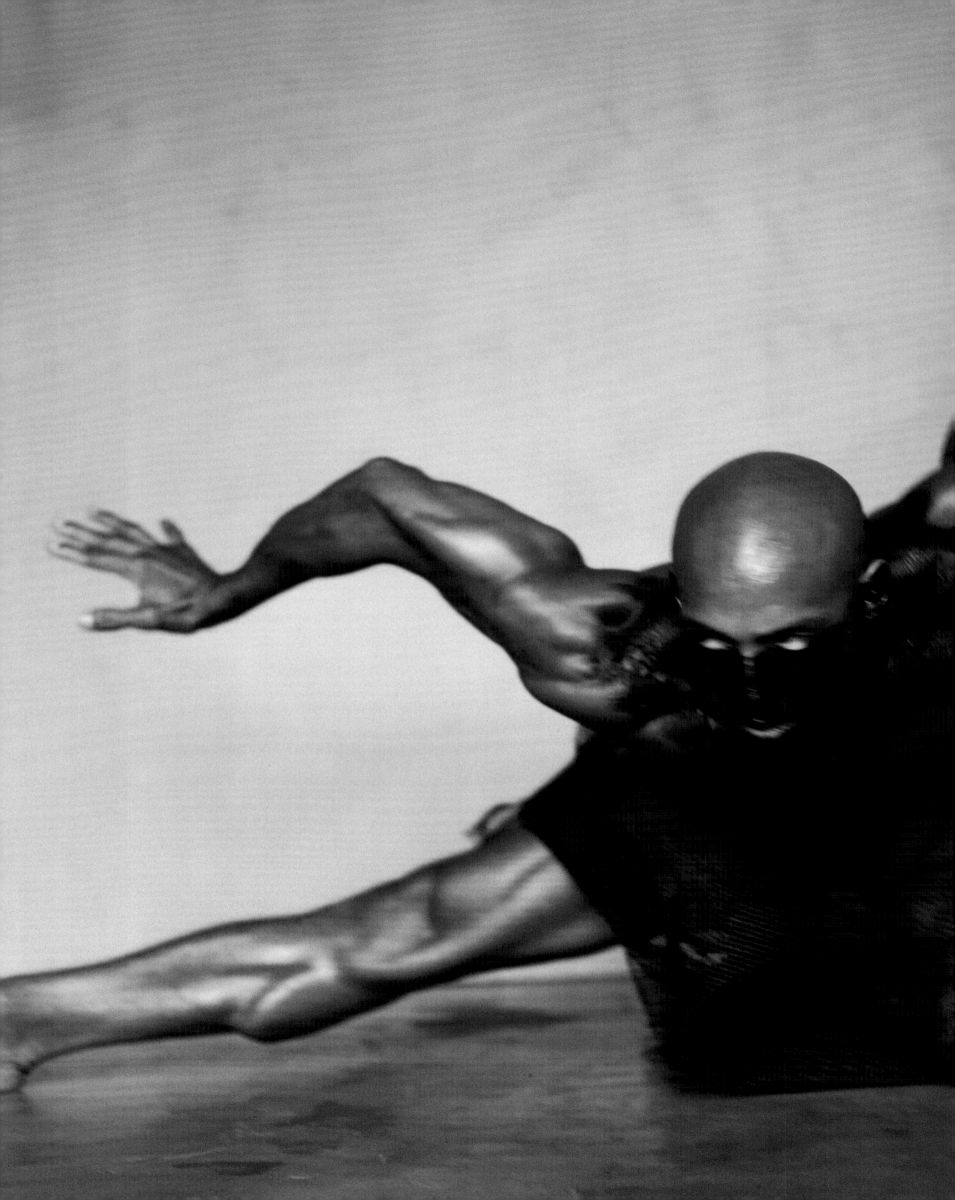

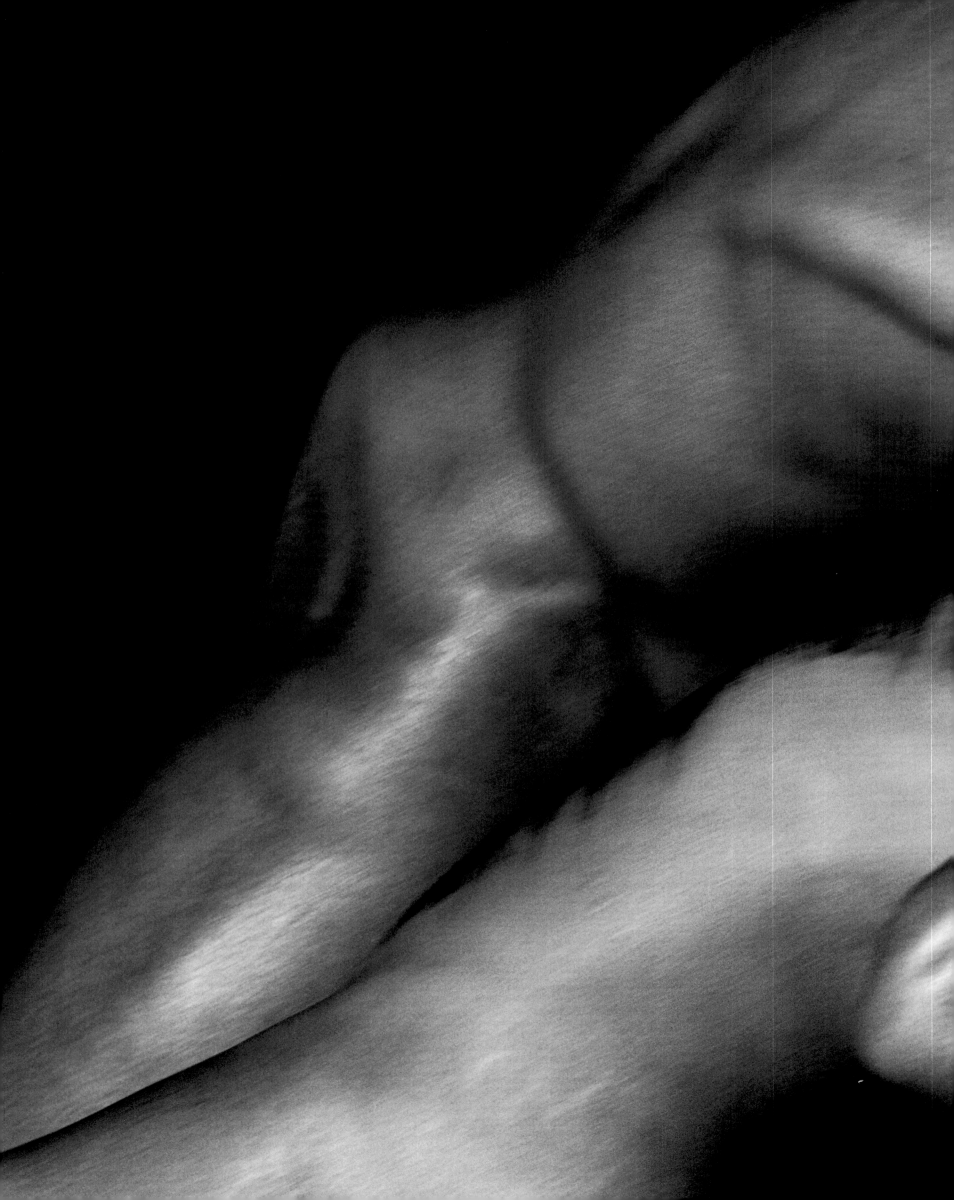

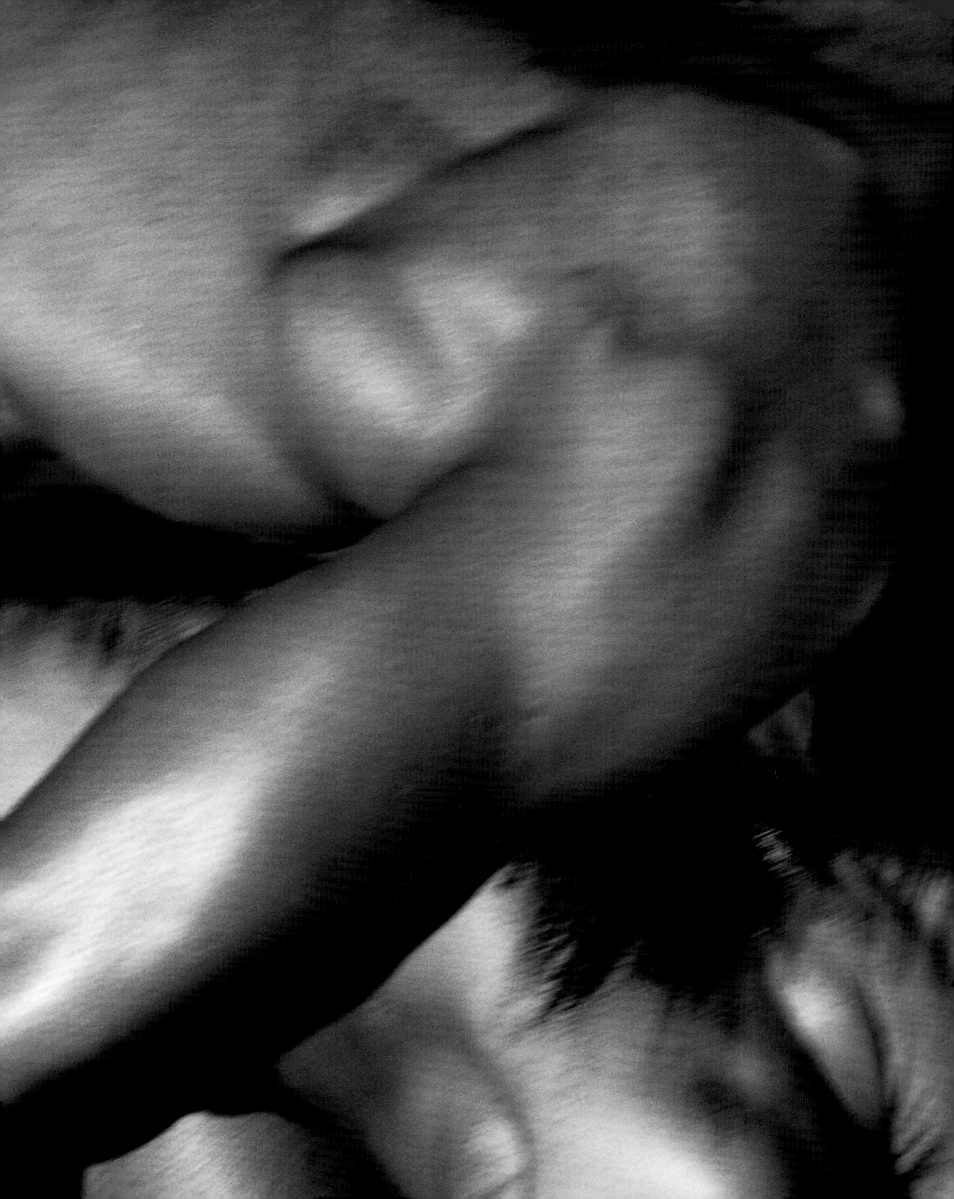

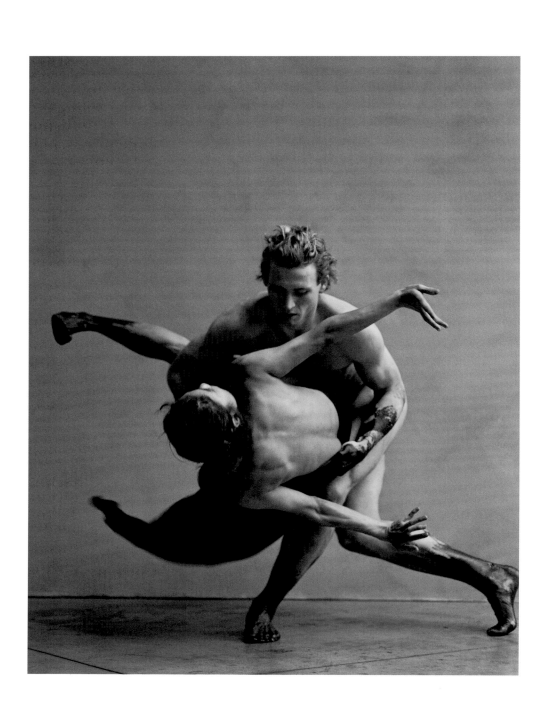

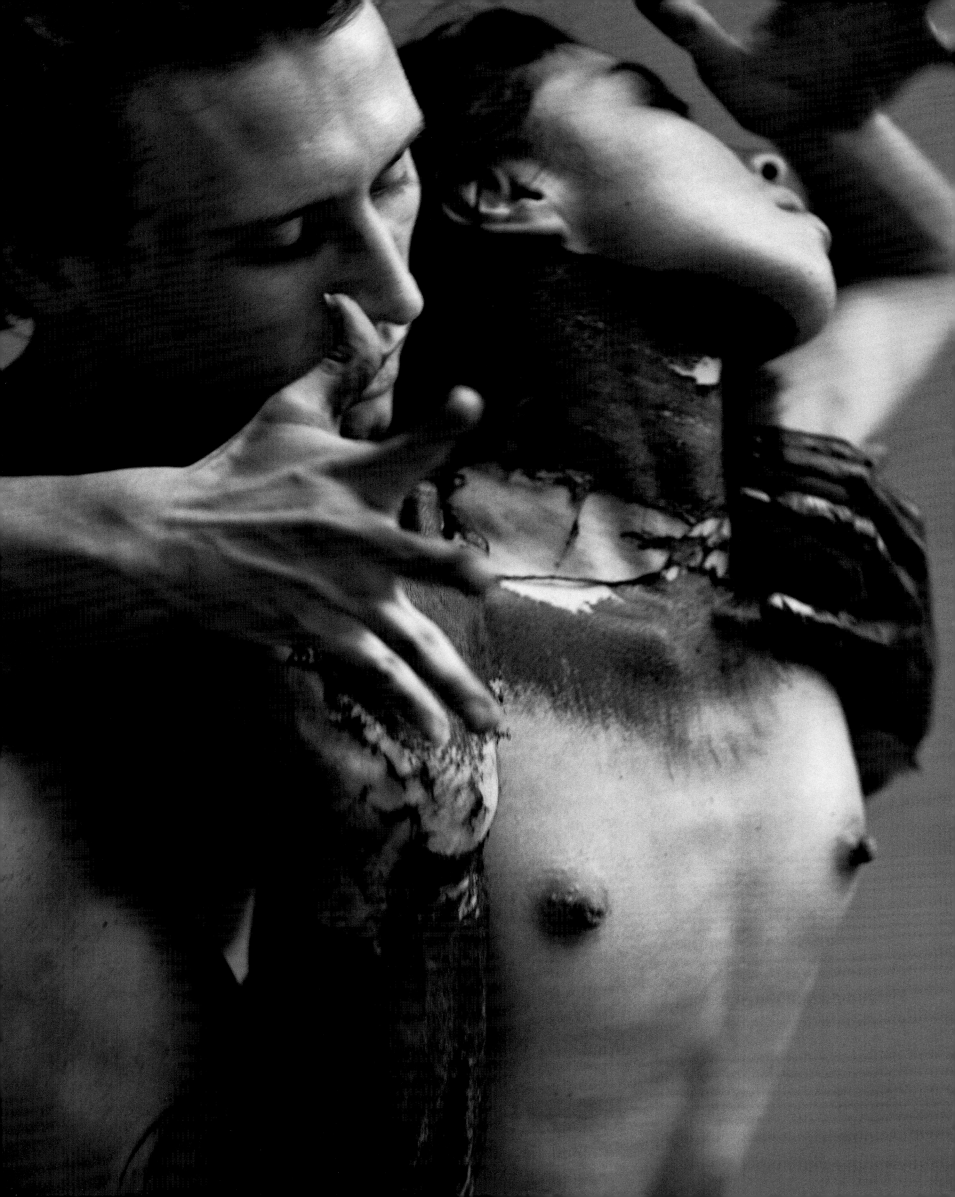

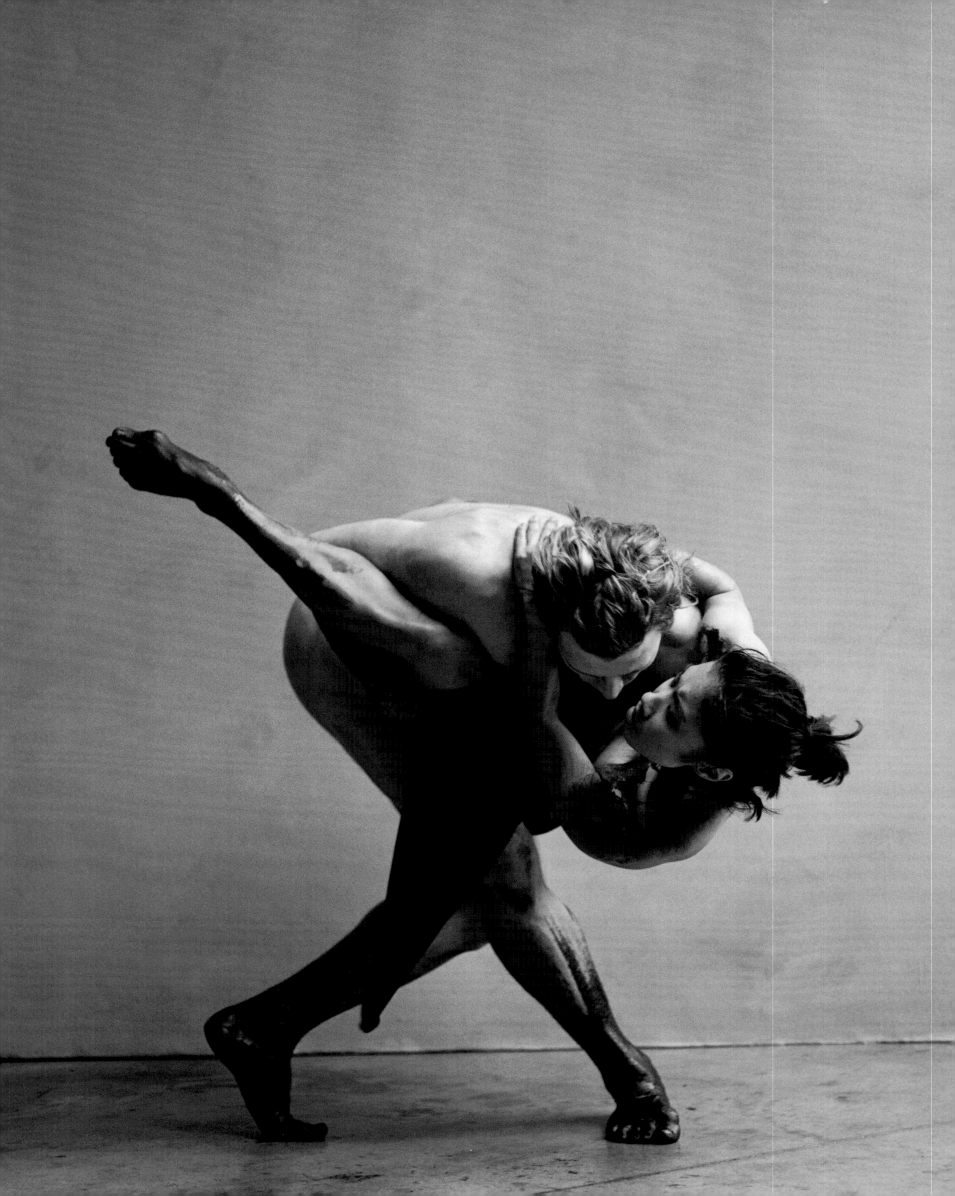

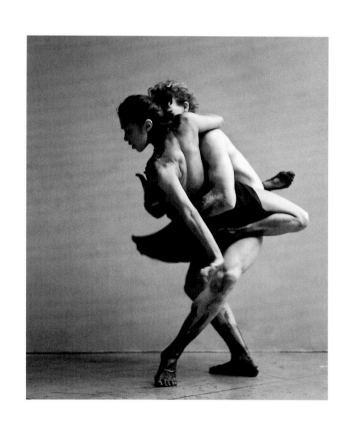

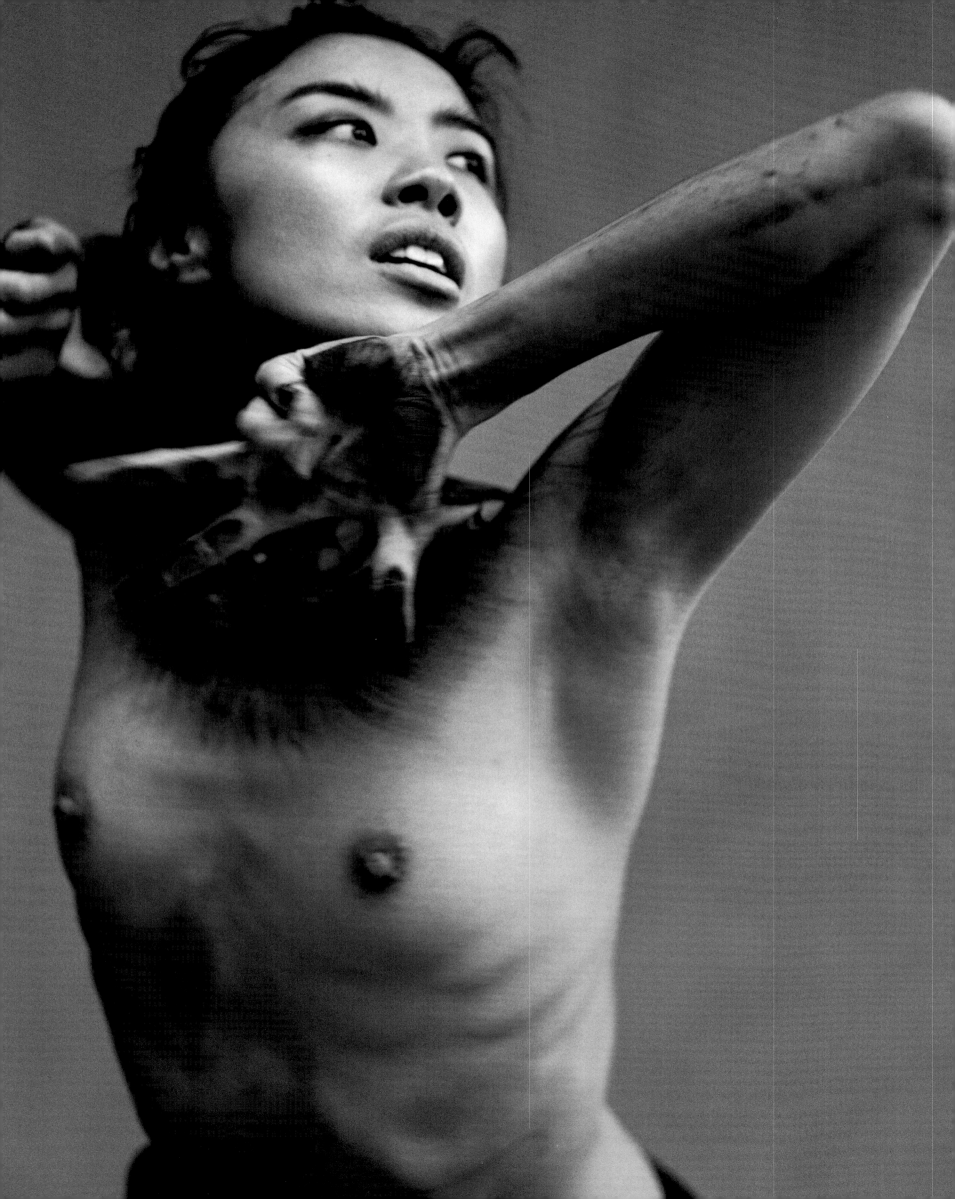

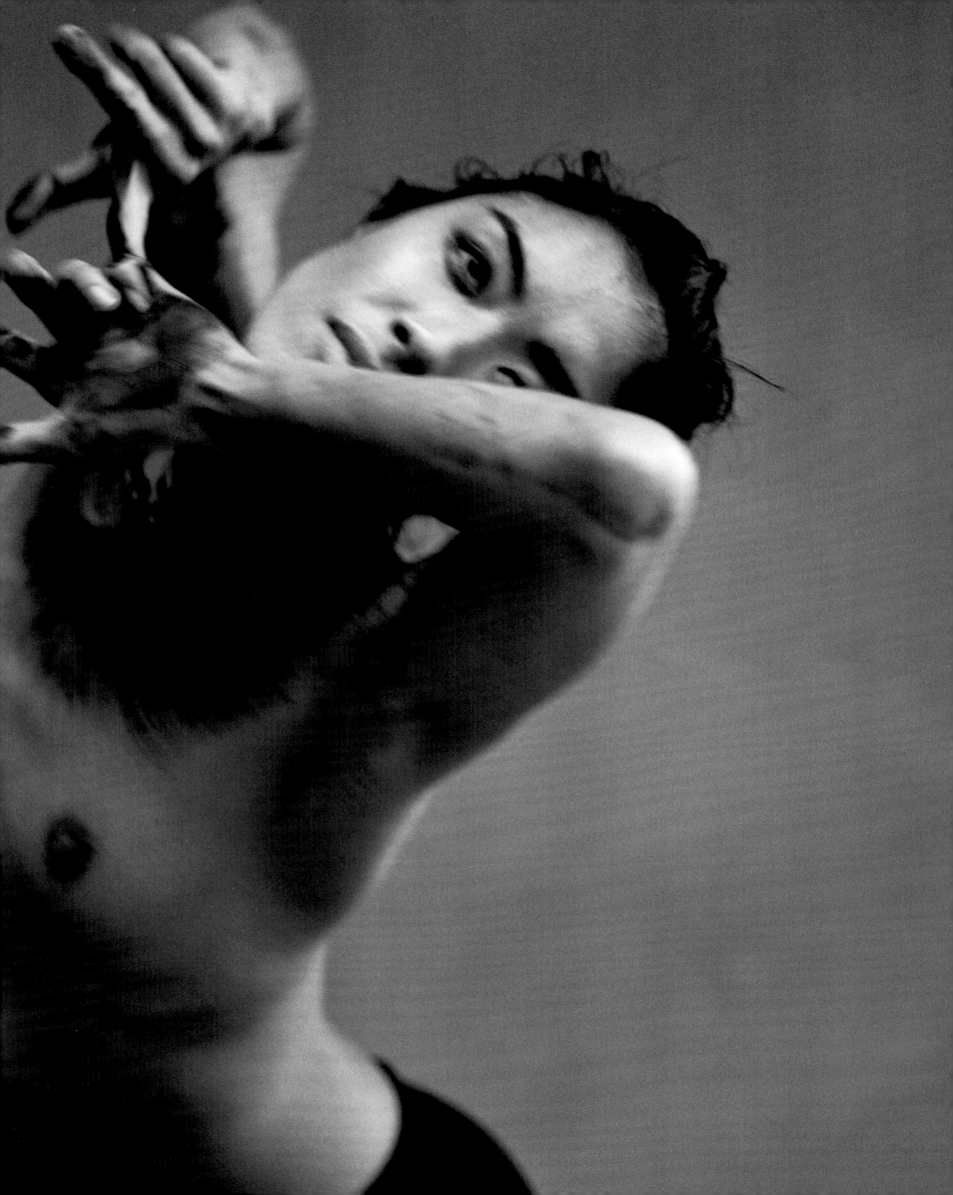

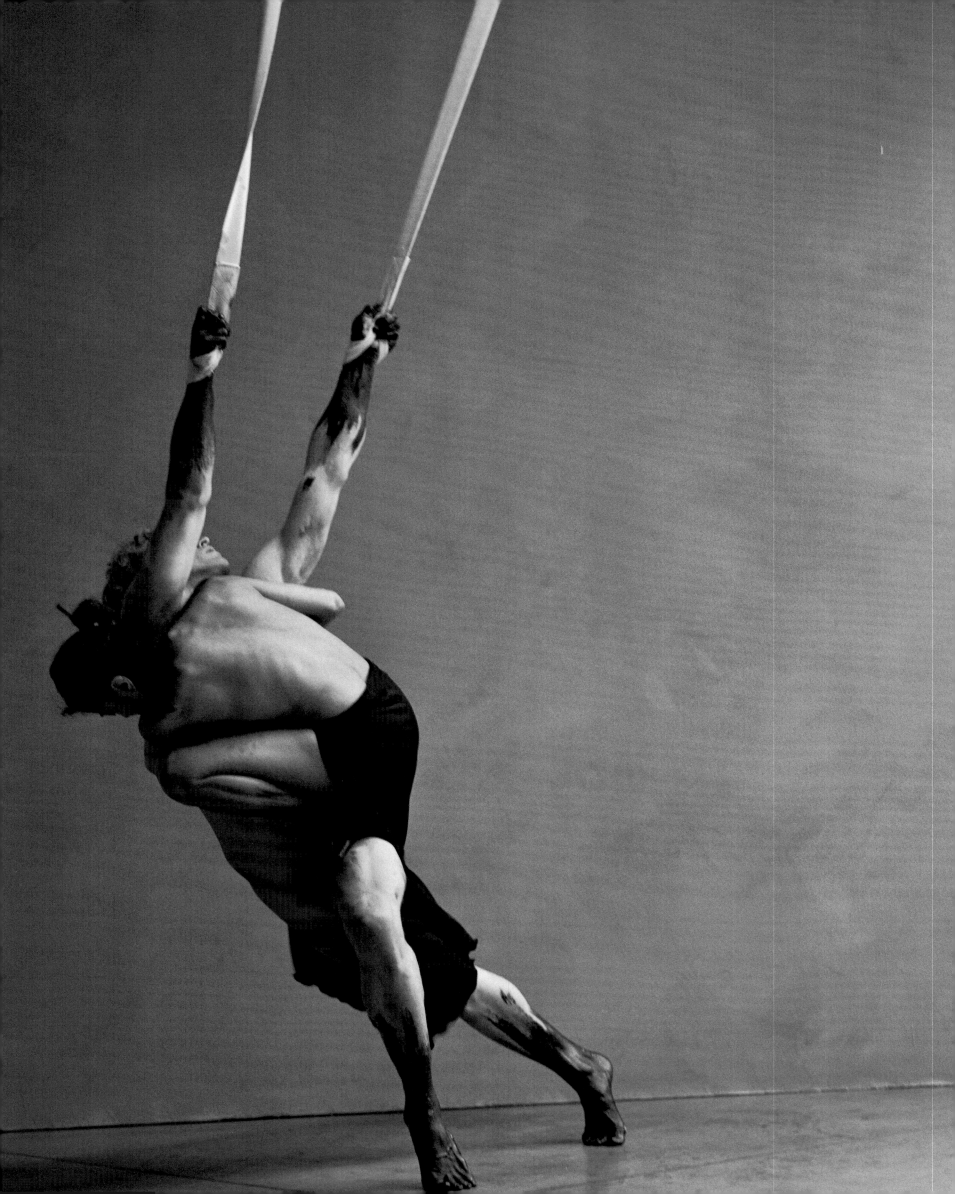

137

138

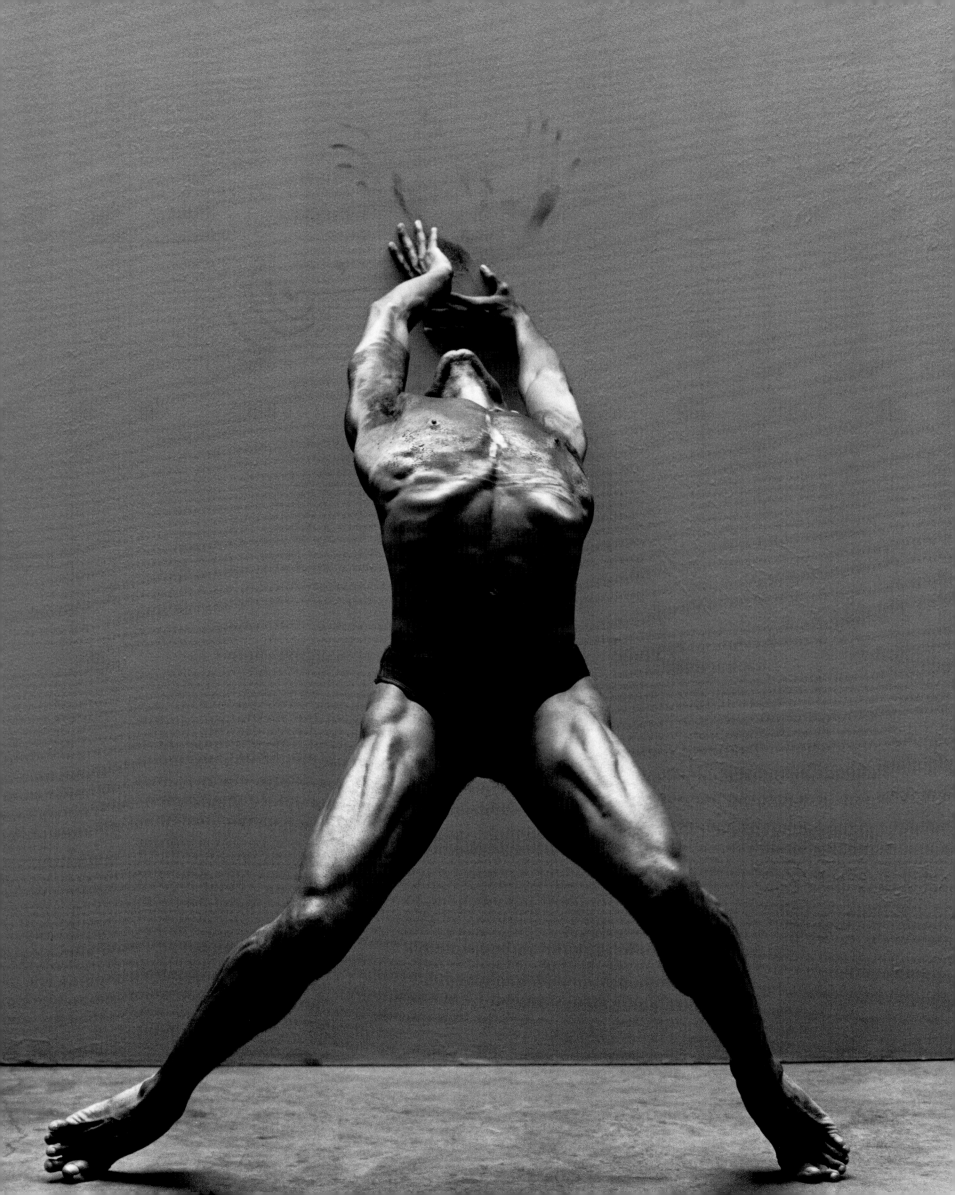

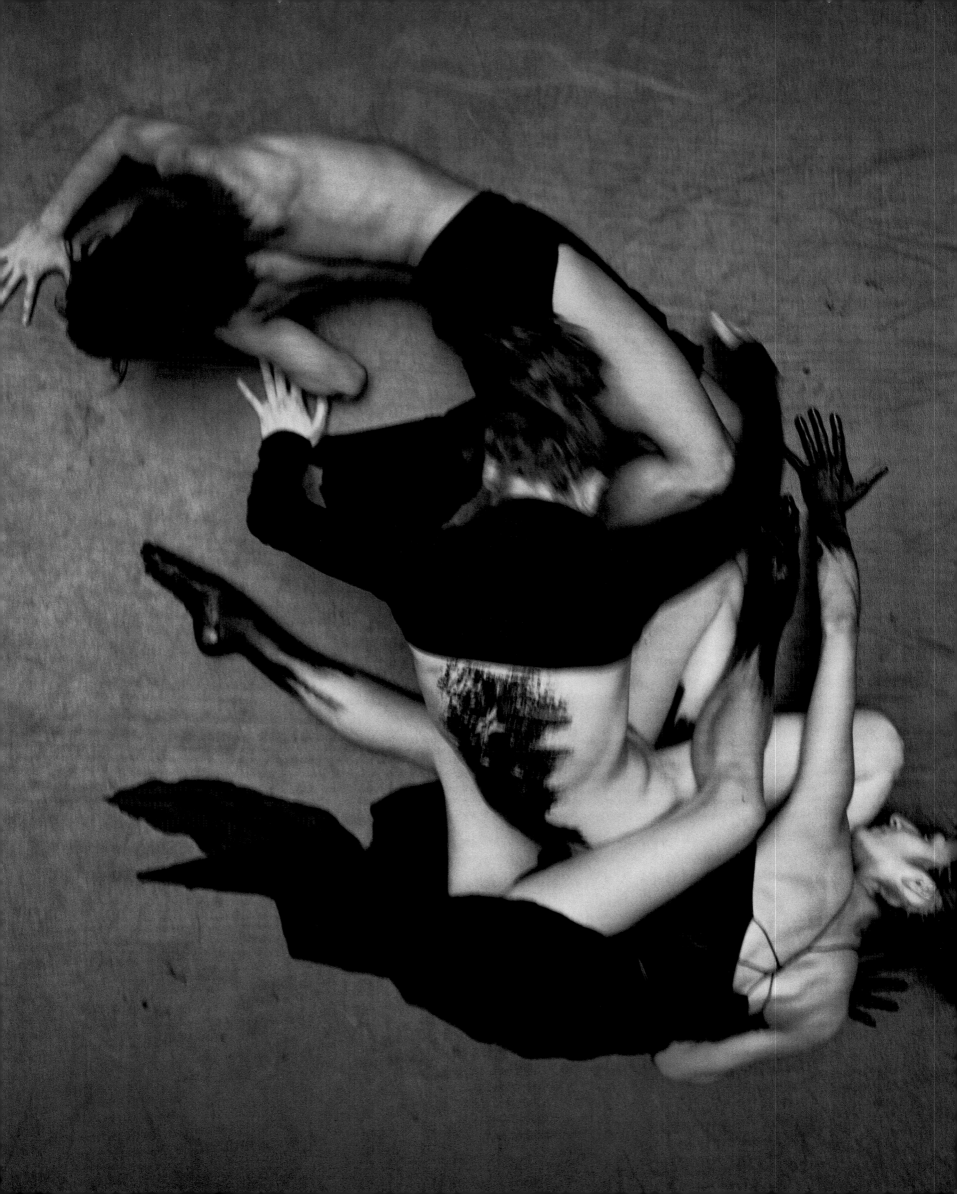

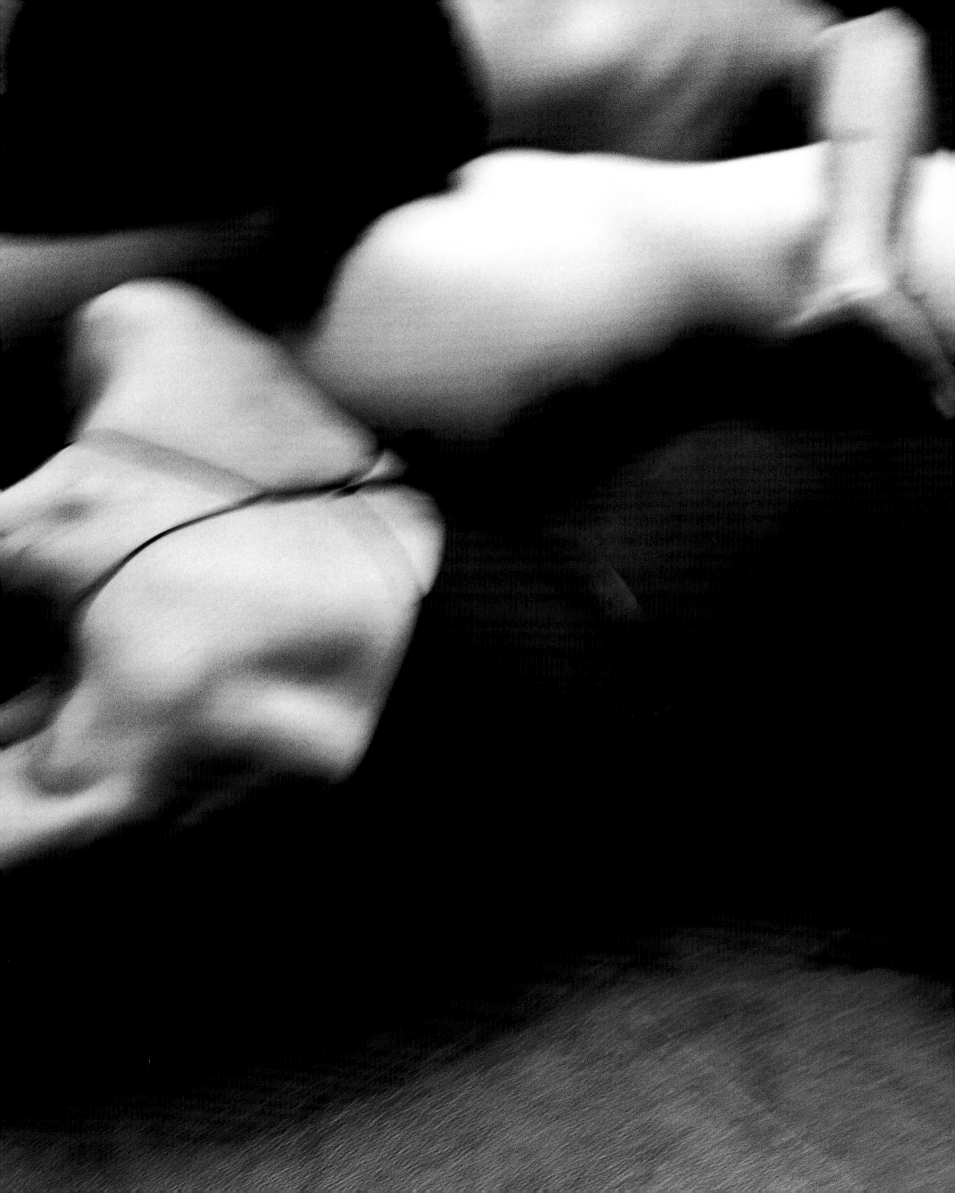

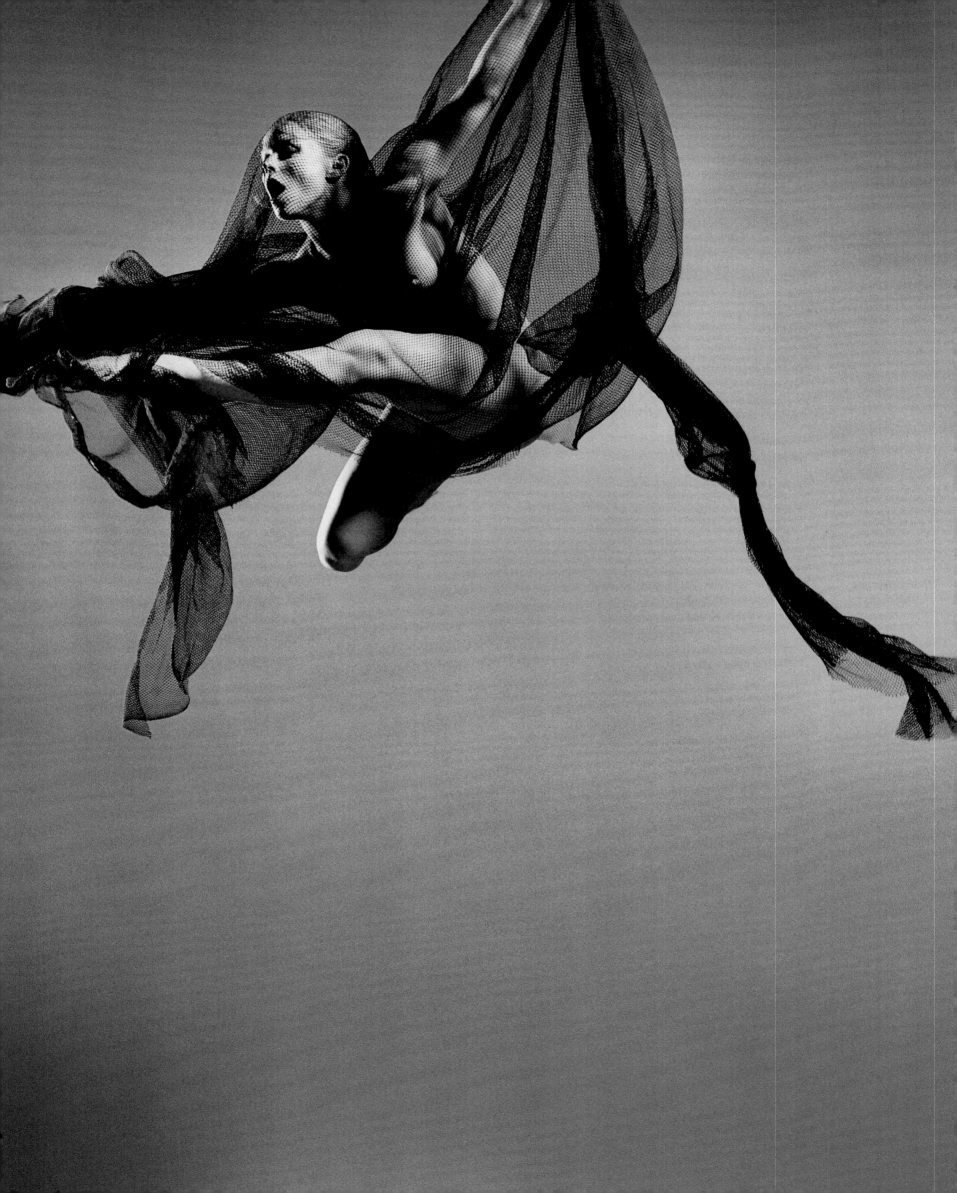

145

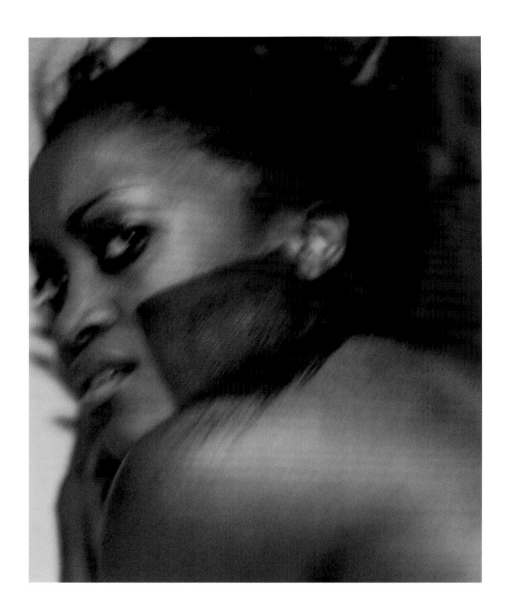

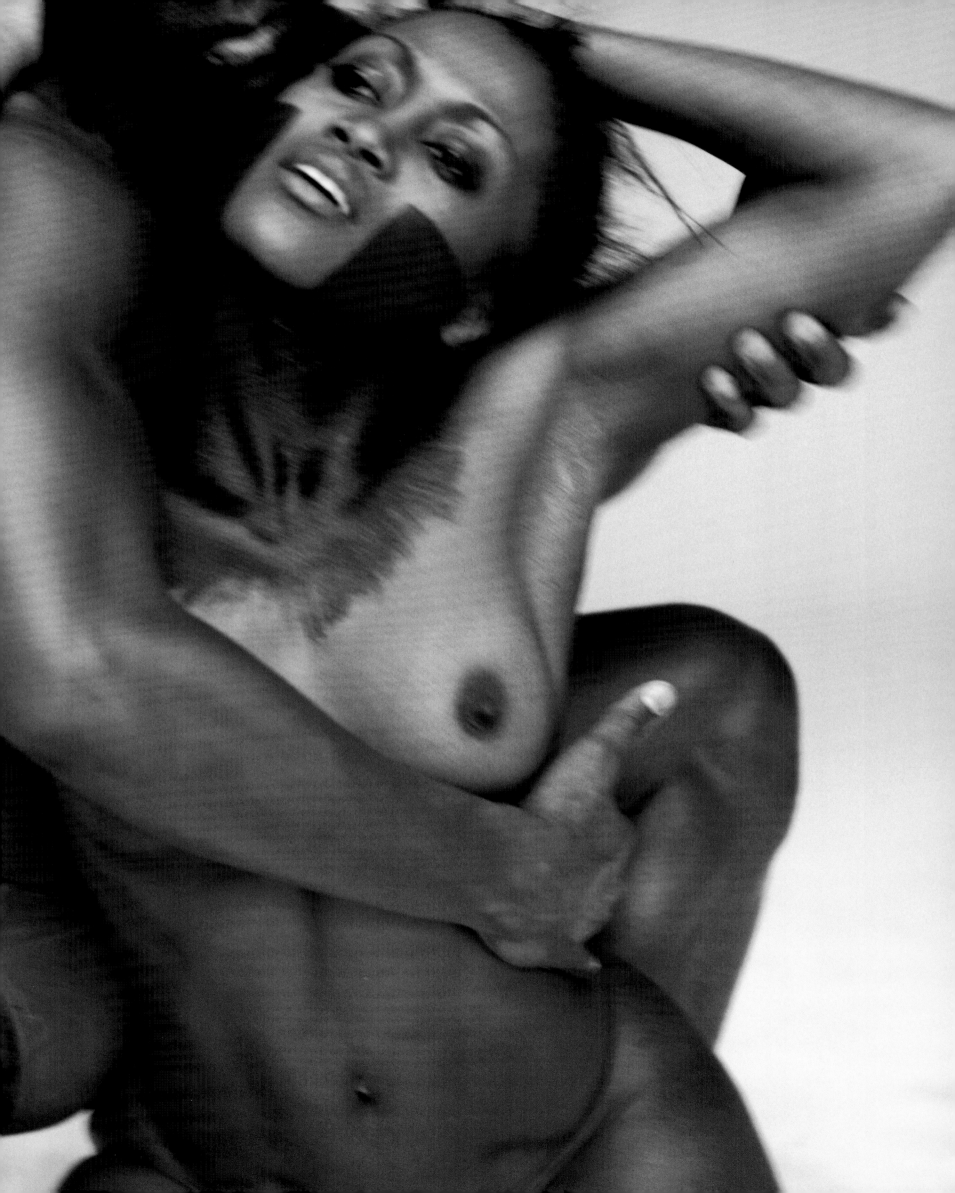

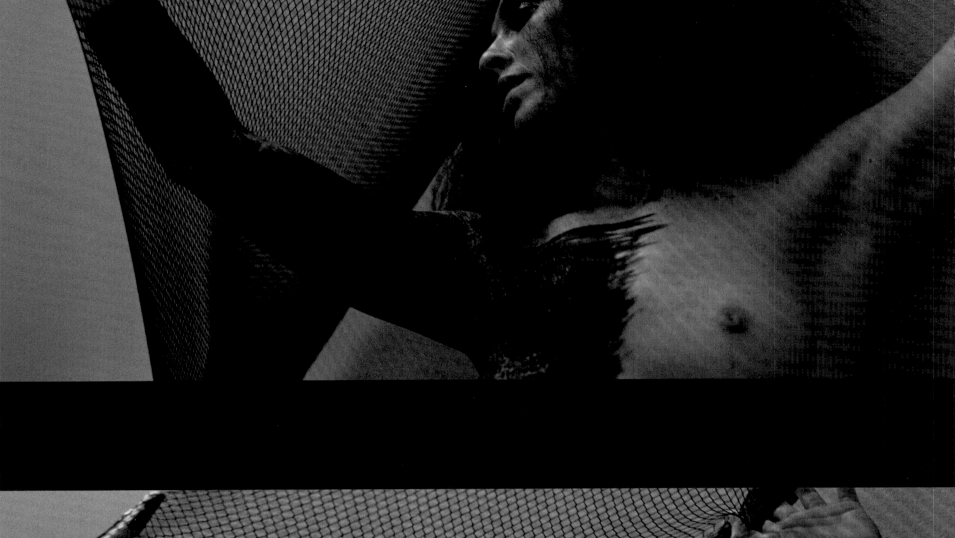
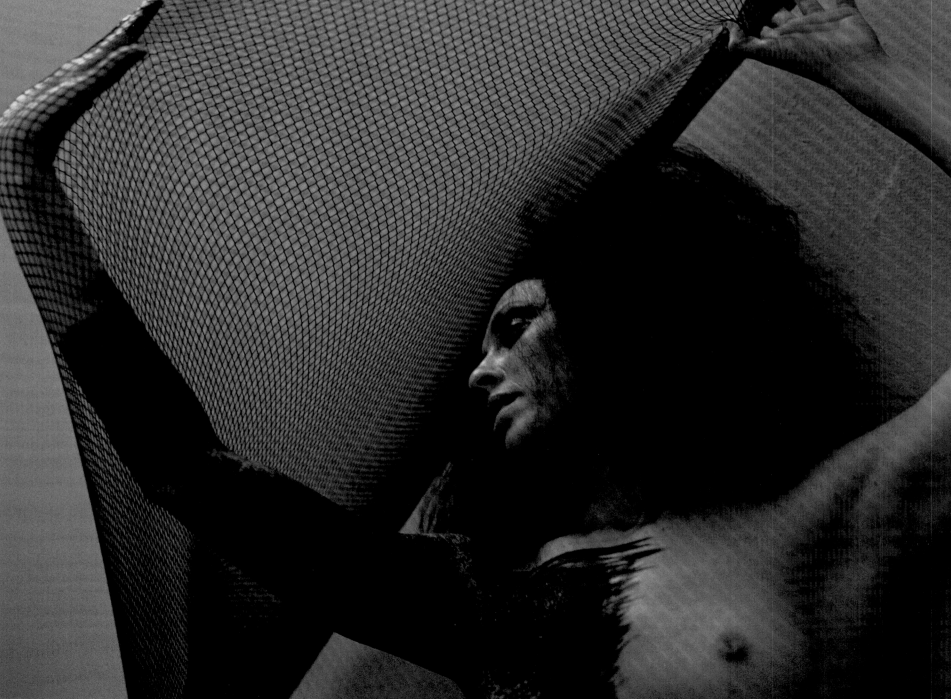

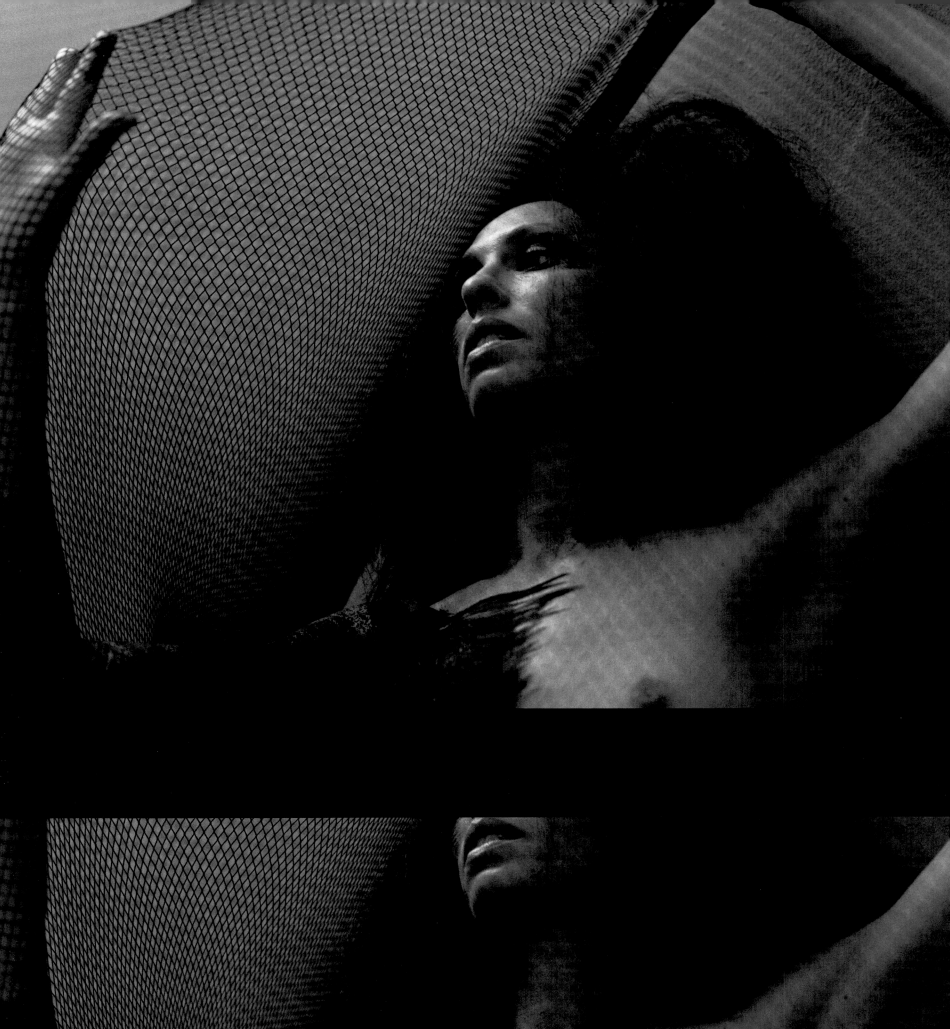

150

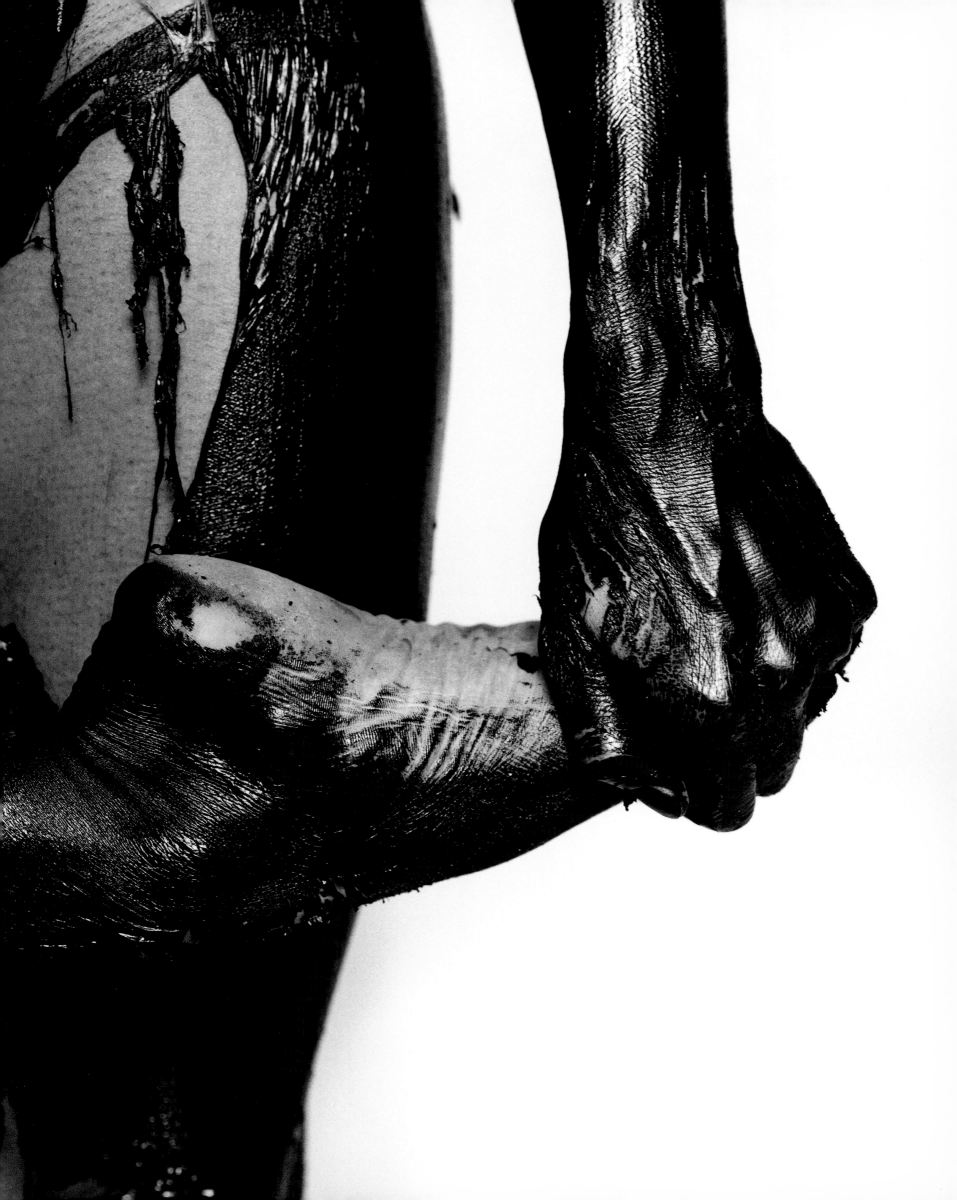

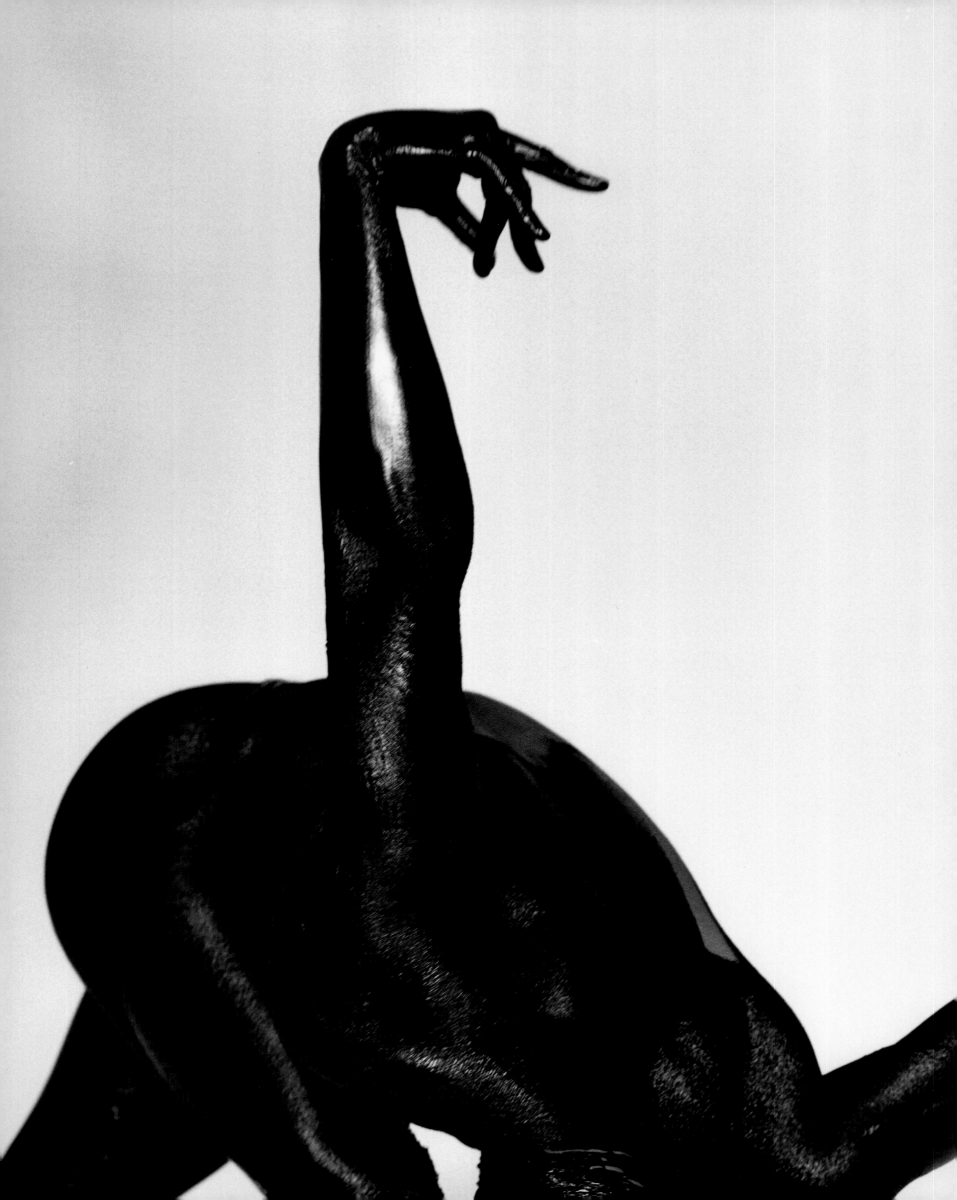

153

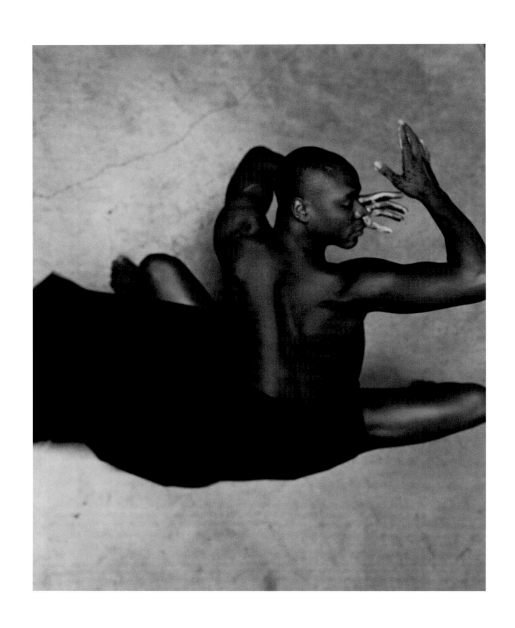

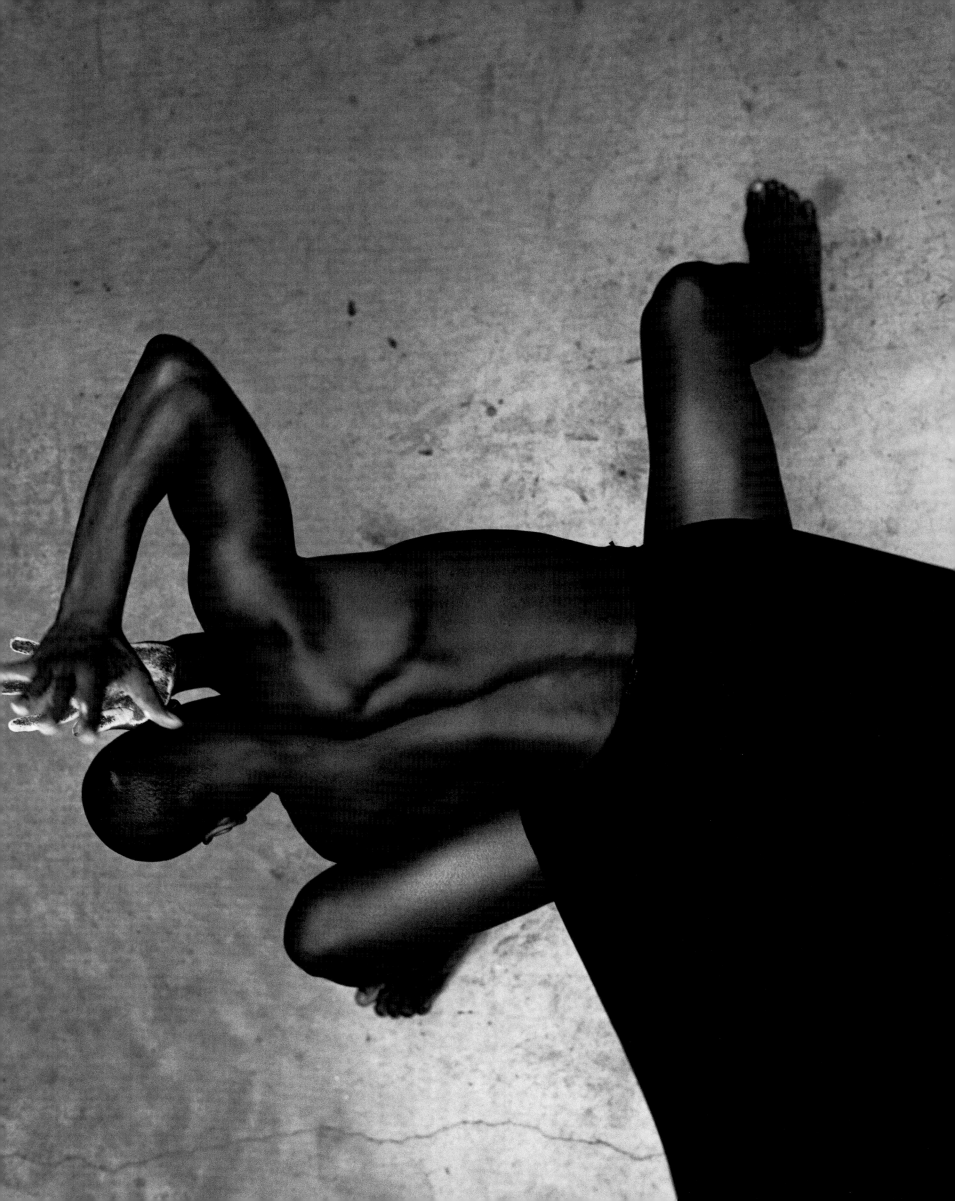

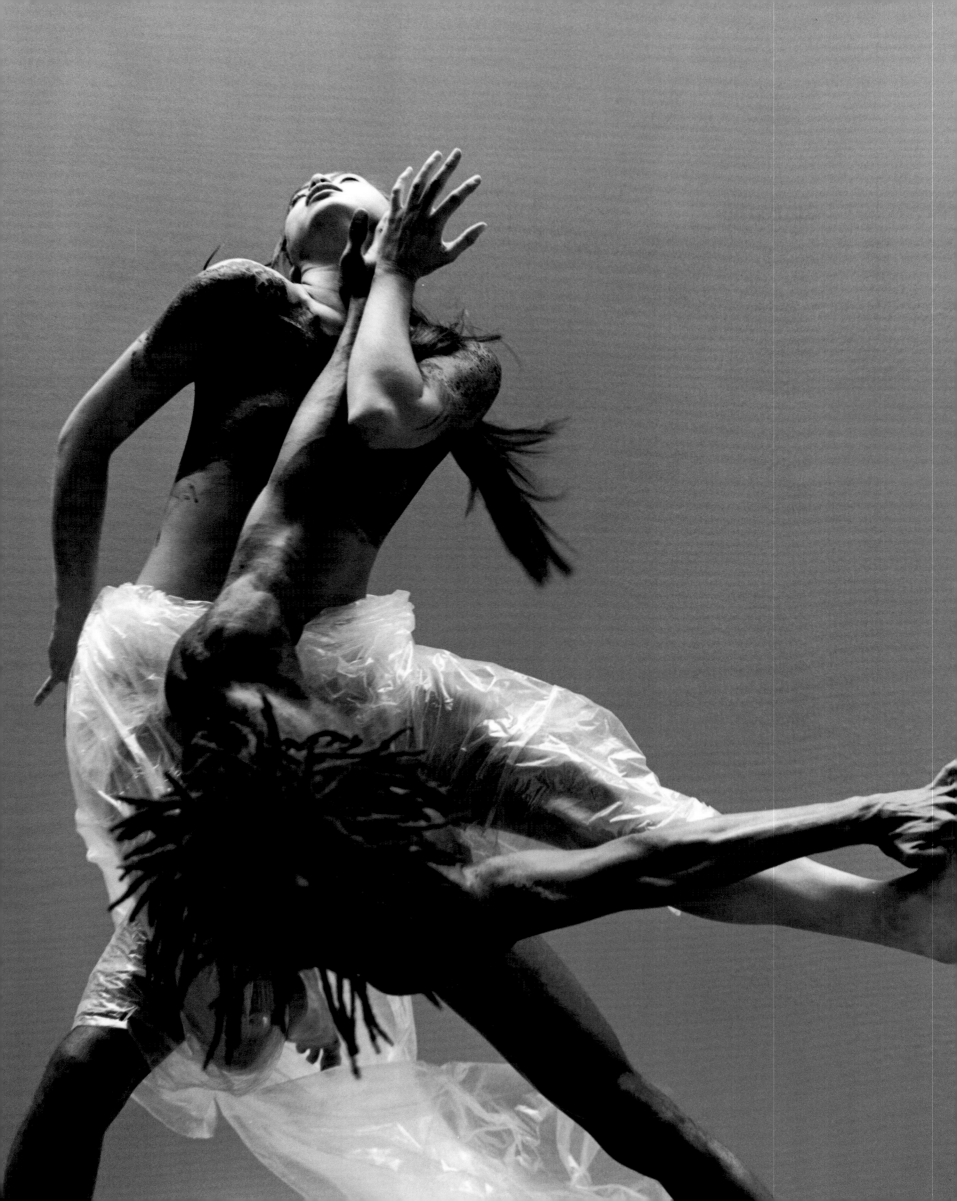

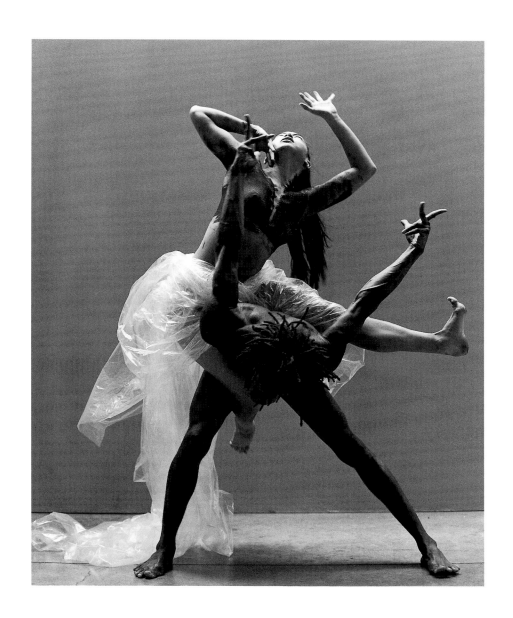

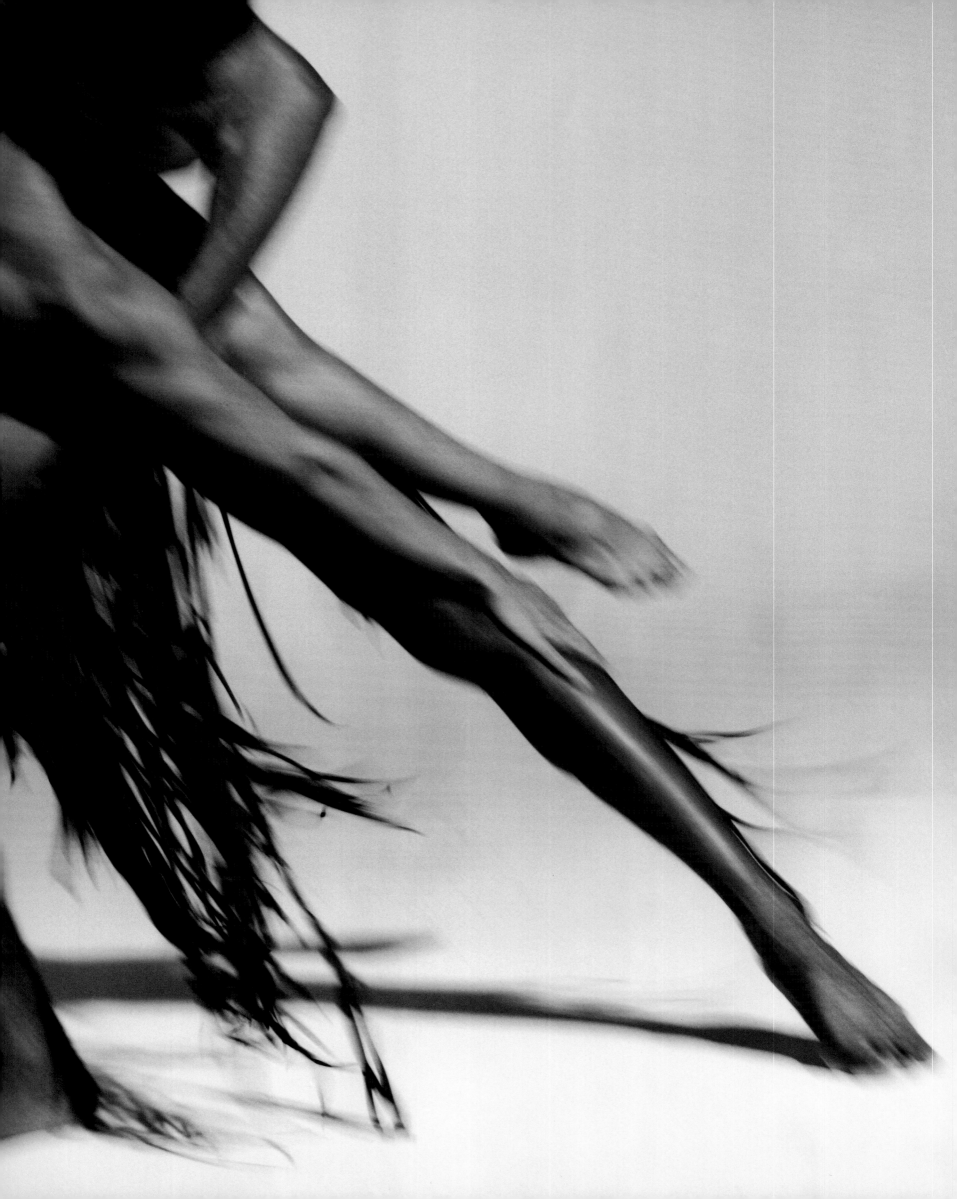

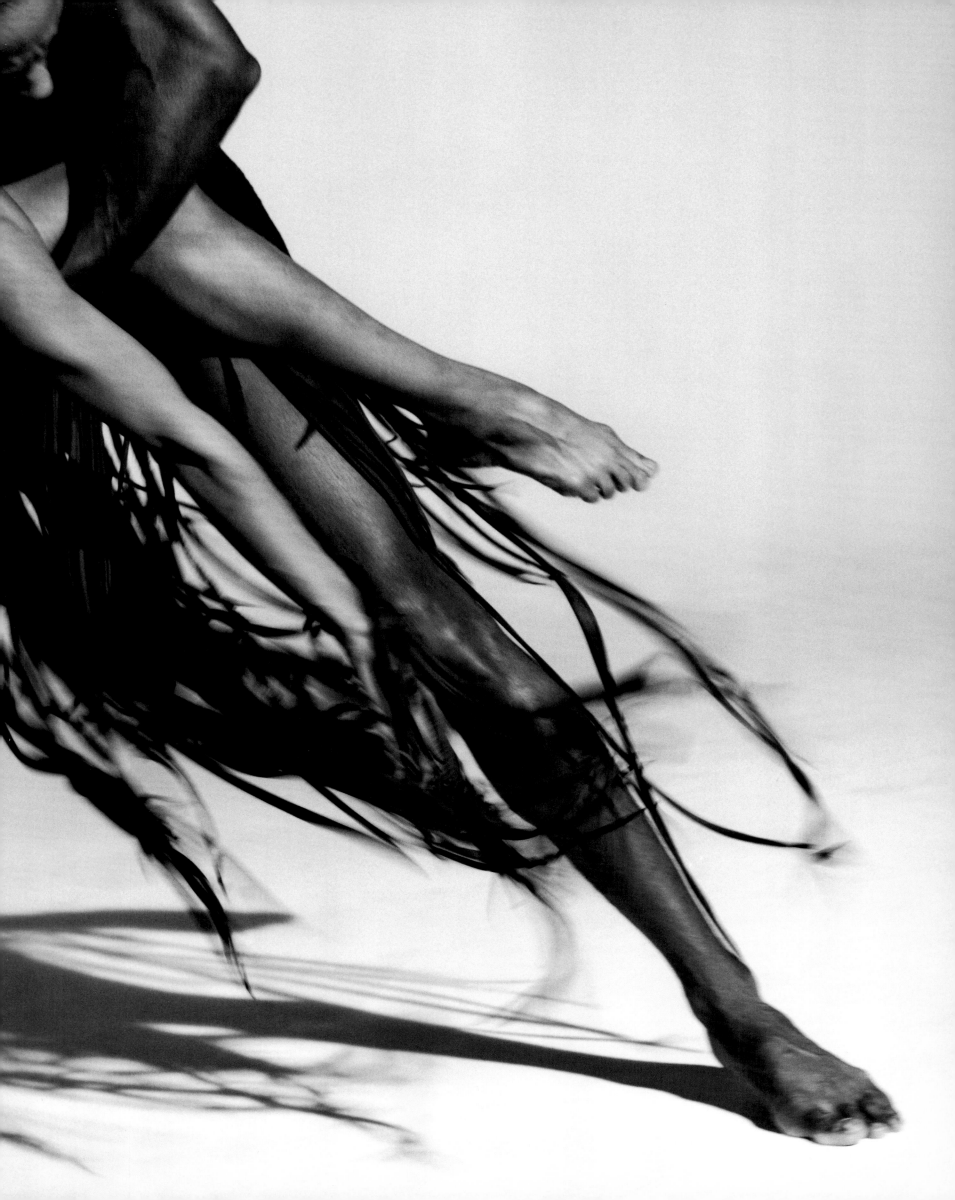

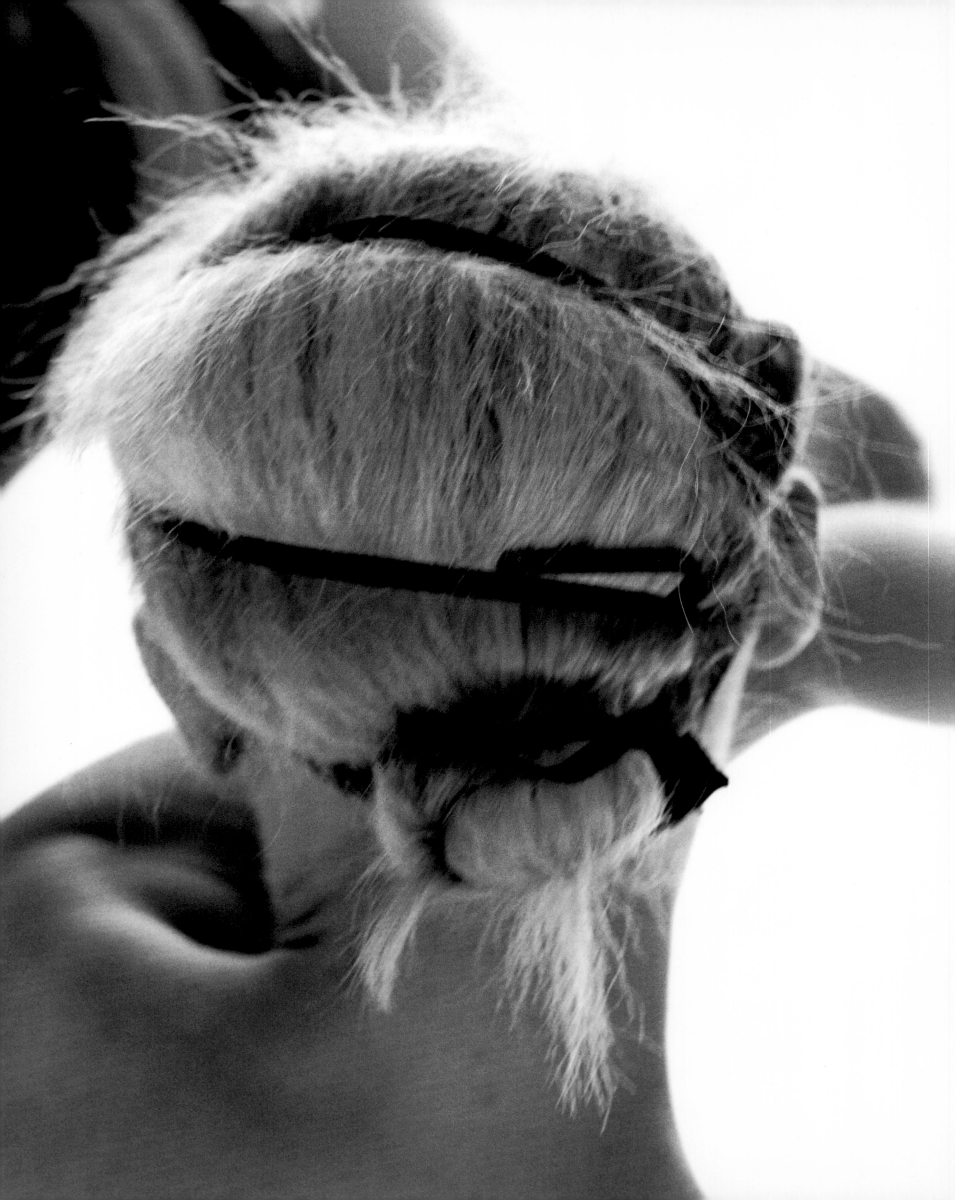

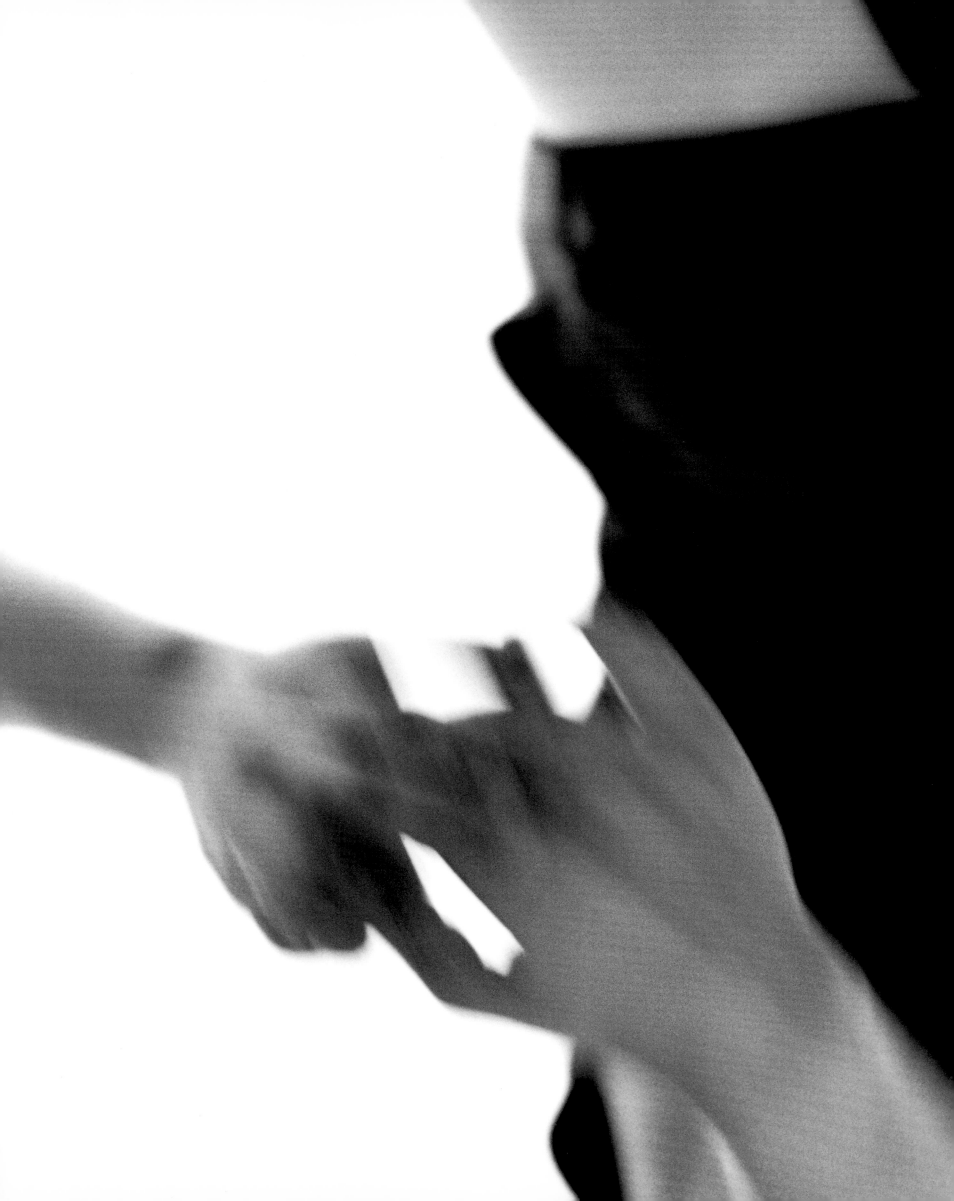

162

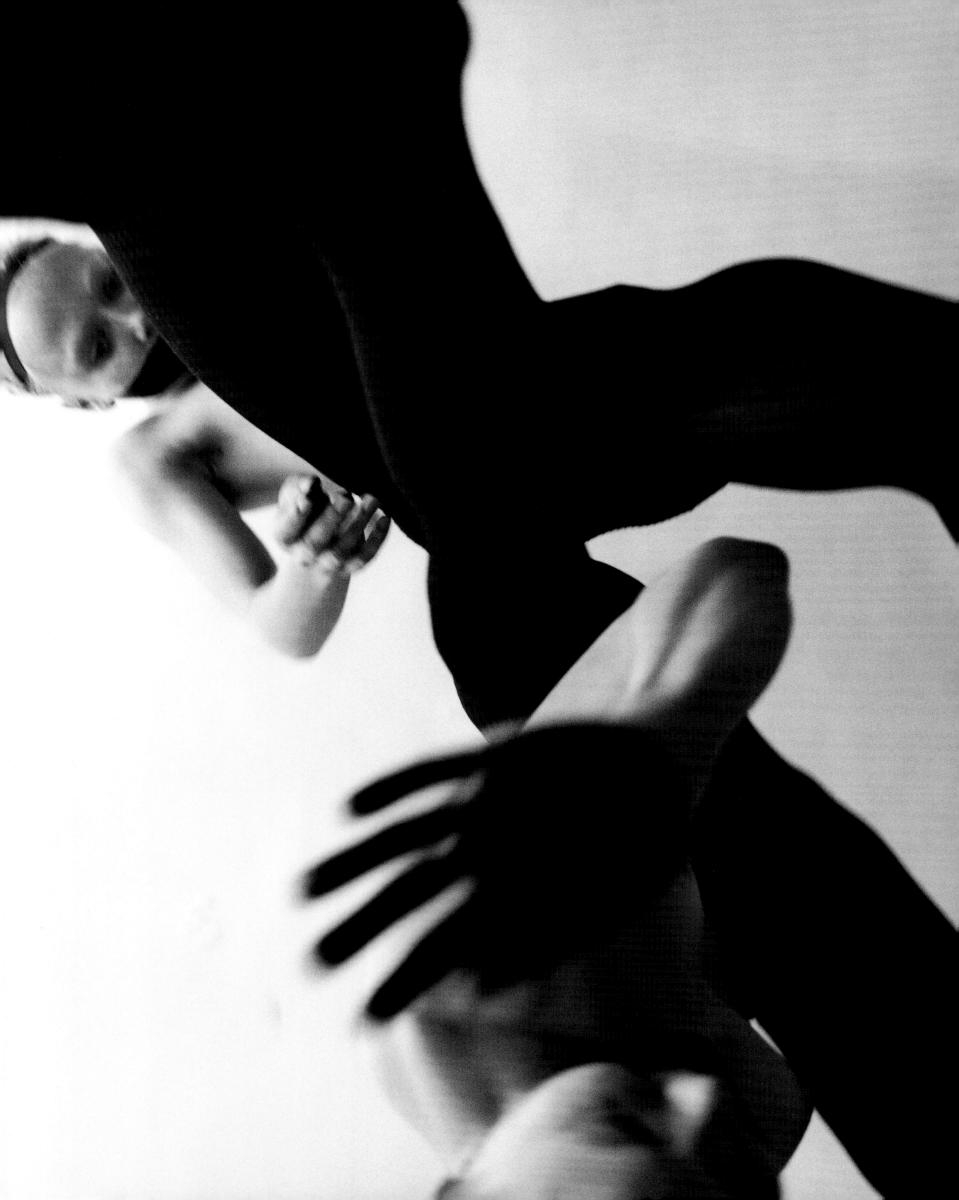

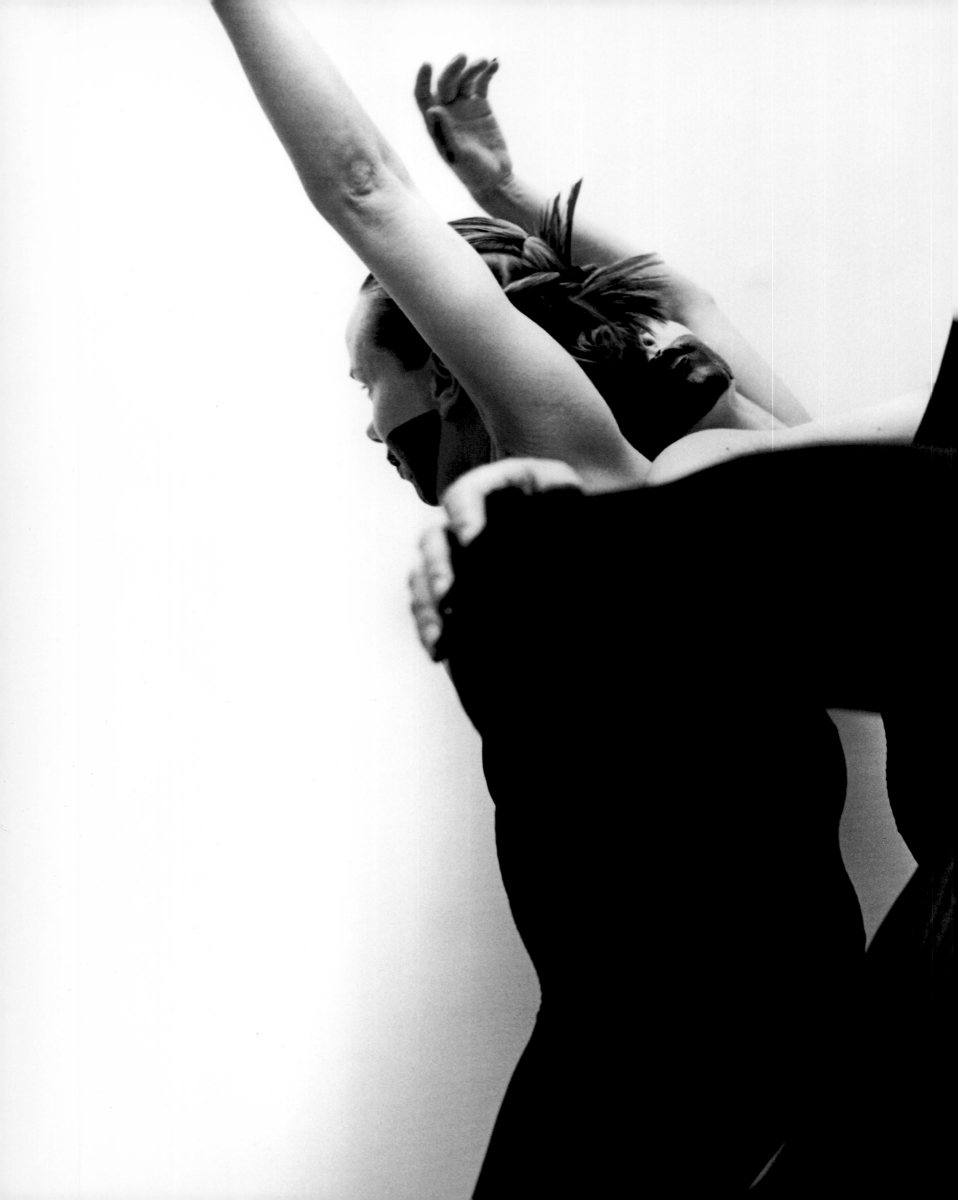

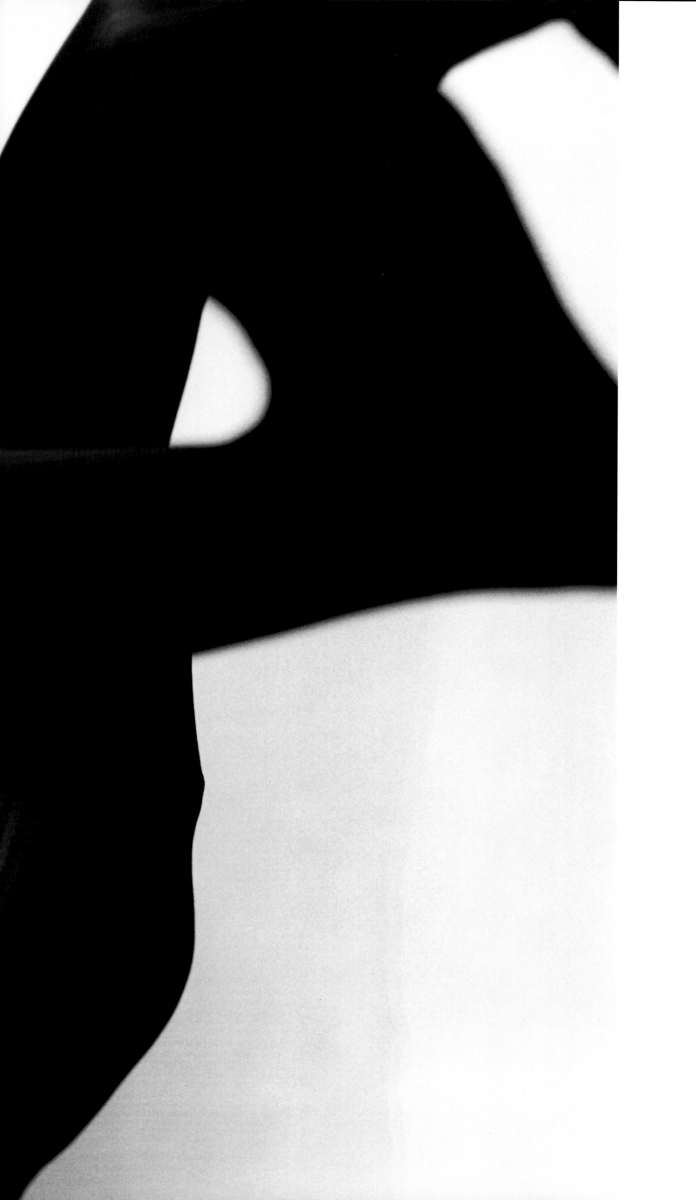

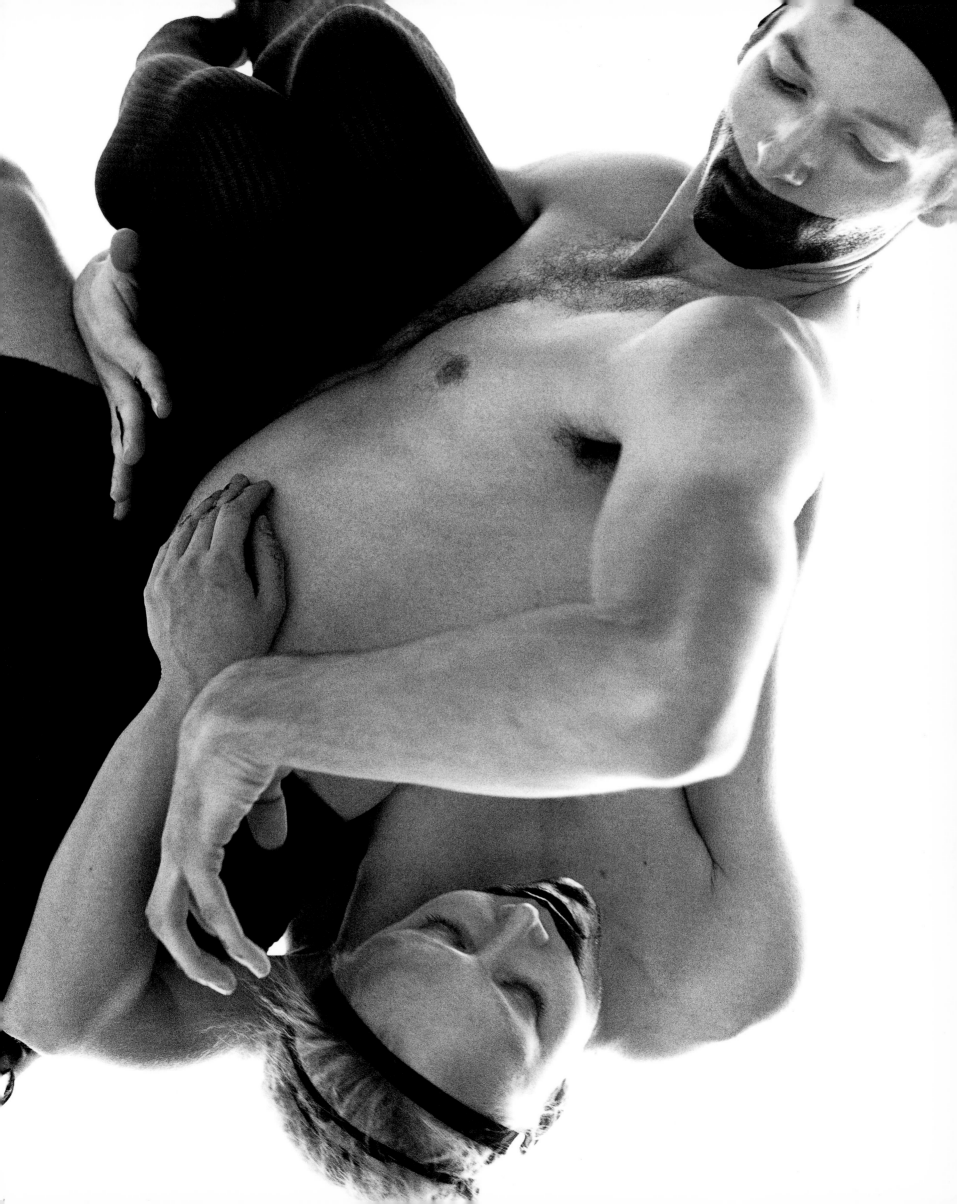

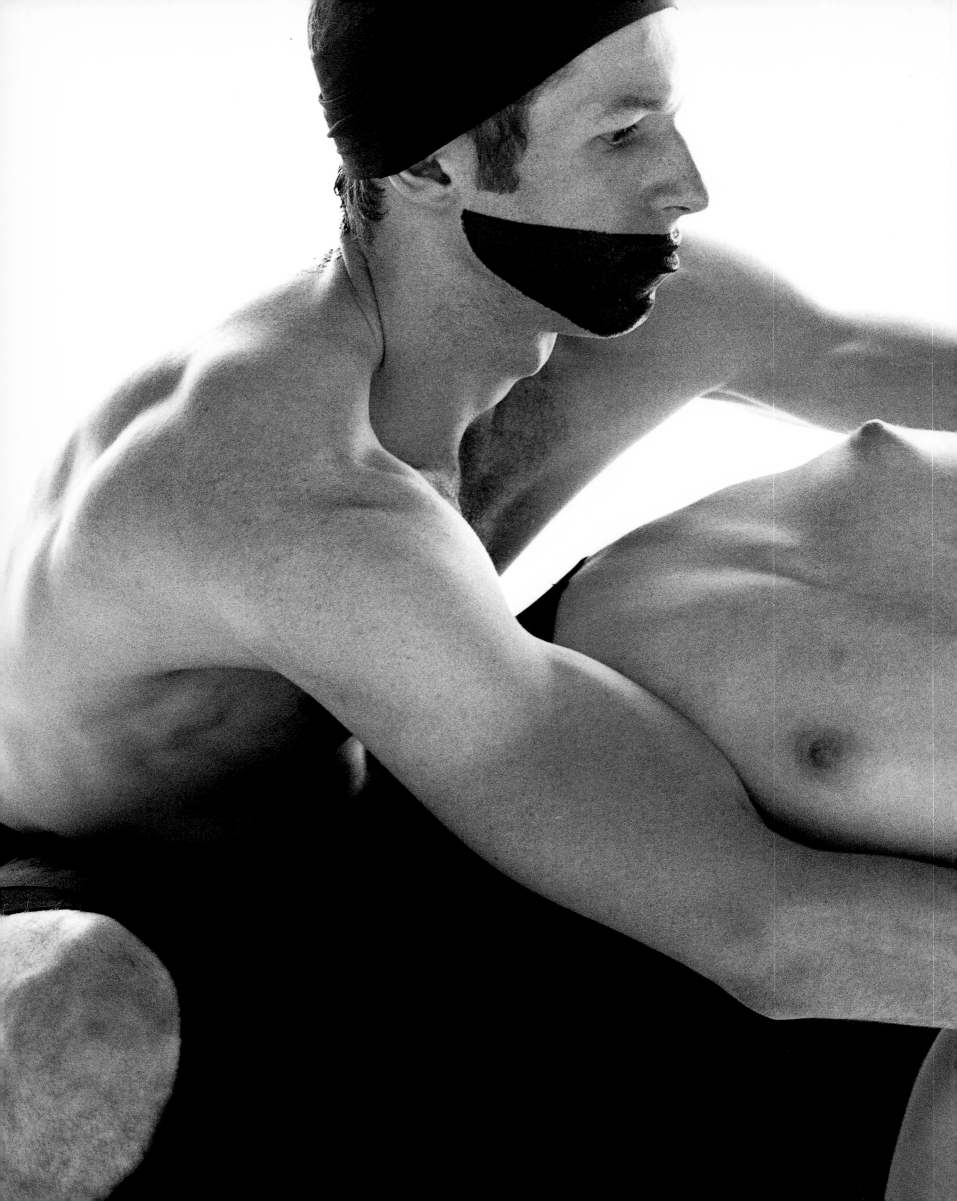

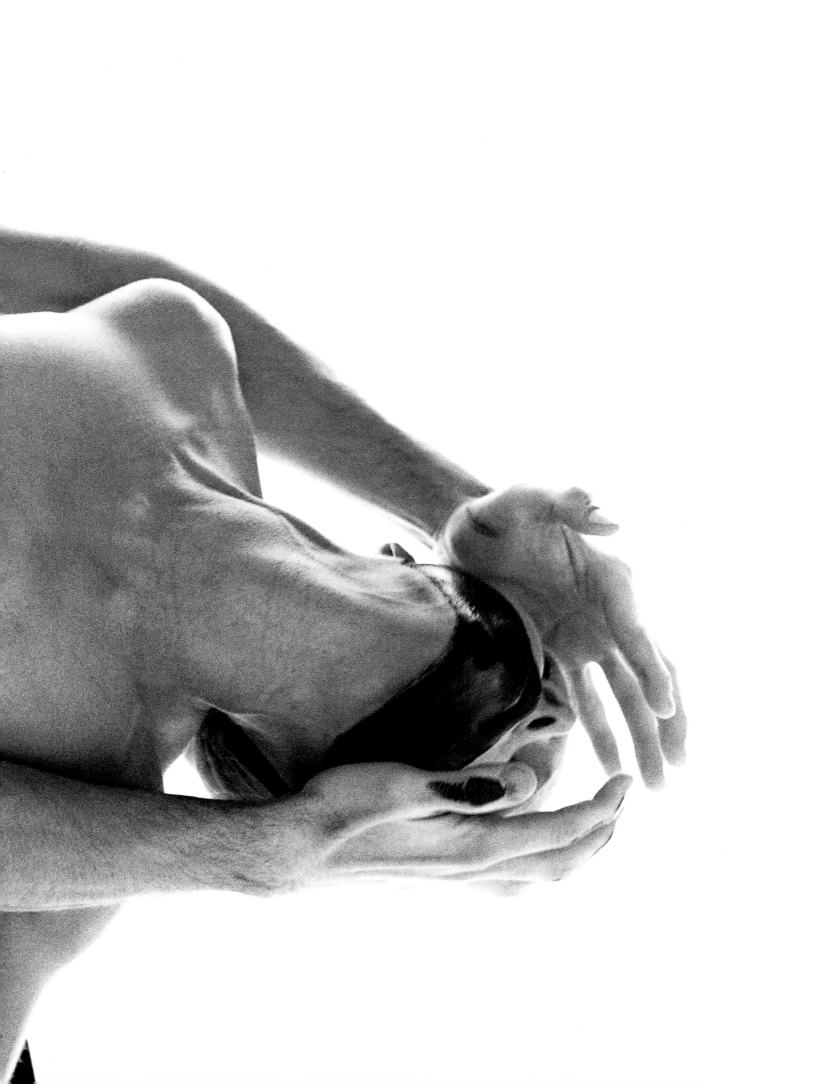

This book has become so much bigger than I could ever have imagined. It's incredible to be writing this realizing that after six years the book will finally get out there and **MOVE FOR AIDS** will become a global movement to support AIDS.

I would firstly like to thank Anthony Battaglia and Catie Dyce at Box Communications. For your innovative design Anthony, and for your patience, thank you so much! Without you both believing in this project, it would not be the same! I can't thank you enough for all the hard work, and endless hours of design and redesign and redesign, not only on the book but for the graphic work done on the whole **MOVE FOR AIDS** project as well as the documentary. That helped so much in making this a success. I know I've driven you both nuts over the years so thank you for putting up with me and supporting this.

To HUGO BOSS, who came on board as the global sponsor, I commend you on your support of AIDS charities, the arts, and individuals like myself who are out there trying to make a difference. Special thanks to Catherine Mitchell, Katja Douedari, Richard Presser, Knut Brokelmann, Jacqueline Goode, Emily Umbers, and Philipp Wolff who knew right away that **MOVE** was something that HUGO BOSS would support. This couldn't have happened without your support!

Thanks also to Matthew Kieghran for all your support and help.

Special thanks to all the dancers in this book that I photographed. Unfortunately a lot of them have not ended up in the final edit and I apologize for that. This book is about support and charity and I thank you all sincerely for your hard work, talent, and trust.

To my good friends Desmond Richardson and Dwight Rhoden for your support of this project. Your company Complexions Contemporary Ballet NY is such an inspiration to me. Keep up the incredible work! Thanks Desmond for your kind words. You are a true professional and such a talent!

Michele Armstrong was the producer on the **MOVE** project and did a fantastic job keeping things in order. Thank you for your dedication and vision. It was worth the wait!

Thank you to my assistants and friends who worked with me on this project. Special thanks to Brian Ferraro and Chad Tenario who have worked with me for four years now, and inspire me to be a better photographer. Also to my best Aussie mate Josh Clapp for your belief in me and the connection we have, I will always treasure that (also thank you for your help with **ONE yogamoves**!).

Thanks also to Jason Brown for your camera and editing skills...you helped make a great doco and I really appreciate your patience and focus.

I would also like to thank all the incredible hair and make up artists and stylists that worked so hard on **MOVE**. Special thanks to Francis Hathaway for so many years of beautiful creative work...you're an angel!

Without the constant support and friendship of Richard LeMay and Fred Jones in New York I don't know if I would have gotten back on the horse and finished the book. You guys have always been there for me through my whole New York experience to inspire and help me. I love you guys! Rich, thank you also for all your help on **MOVE FOR AIDS** with the documentary and for reminding me that the pictures were worth it. Michael Paternostro...I love what you do...you make me want to dance!

Thanks to my old friend Justin Melvey for taking me in when I moved to LA and was at such a low point! I love you Chachi!

To Pier 59 Studios in New York for helping me out with the shoot and giving me Studio 6!

To Phototechnica Australia for doing the prints for the book...Evan you did an amazing job! Thanks also to Jeff at Lexington B&W in New York for your help with **MOVE** and for so many years of great service.

THAN

Special thanks to Trey Laird and all the crew at Laird and Partners New York! Trey you gave me so many breaks for work in New York I can't thank you enough...I love the work you do and your team of creatives are the best! Thanks also to Hans for always pushing me!

I would not be where I am at today with out the help of my agents...So thank you to all of them that I've had to date....

Special thanks to Dolores Lavin and Katie Shanahan from DLM Australia for all your hard work. To my New York agents Julie and Edward Kauss at JGK, thank you for all your support and all the staff who help me every day.

When I look back now on my career I can really see how much *Not Only BLACK+WHITE* magazine, Australia helped me get established and realize my style. Karen-Jane Eyre (a.k.a. KJ) and Marcello have always been there to support my work and projects. Thank you both for all you've done!

To all the powerHouse publishing team...thank you! Special thanks to Craig Cohen.

Sincere thanks to the team at DRA and to Phil Parrotta and his company image bar for all your hard work on the MOVE FOR AIDS launch.

Special thanks to MILK Gallery in New York for supporting and launching this book and project. Rassi I admire your drive and thank you for your support of this and so many charities through MILK. We need more people like you on the planet! To Giada from MILK for all your help and energy putting this launch together.

Thank you to all the associated AIDS charities around the world that work so hard to make a difference. Special thanks to Terry and Phil at the AIDS Trust of Australia for your patience and letting me drive you mad. Mark Cavanagh I know I've driven you nuts as well...thanks for all your hard work and friendship...you've done an amazing job!

As fate and the universe works...I came in contact with the talented Mr. Hugh Jackman and stunning Elle Macpherson who became ambassadors for the **MOVE FOR AIDS** project. You're both so incredible and I can't thank you enough for helping me to be heard. Special thanks to Hugh for writing such an incredible foreword. To John Palermo and Stuart Cameron thank you for your support and for helping coordinate with Hugh and Elle... you made this happen!

Sincere thanks to Brian Walsh from Foxtel Australia for your commitment to this project and for your friendship.

Thank you to my friend Kevin Huvane for your help and support of my work and vision.

Thanks as well to my friend the talented George Epaminondas for helping me with the writing for **MOVE**.

As I work on these projects over the years I have one constant...the support and love of my friends and family...without that I wouldn't be the person I am today. I love you all so much.

When I launched my last book **ONE** in Australia last November 2005 I forgot to thank a very dear friend Michael Dimopolous. Dimi, I have shared so many incredible times with you. Thank you for an amazing friendship and for all the crazy adventures you've shared with me. I love you!

Finally I would like to thank my partner Brian McGrory for coming into my life and making me realize that reality can sometimes be as unbelievable as fantasy! I love you.

MOVE

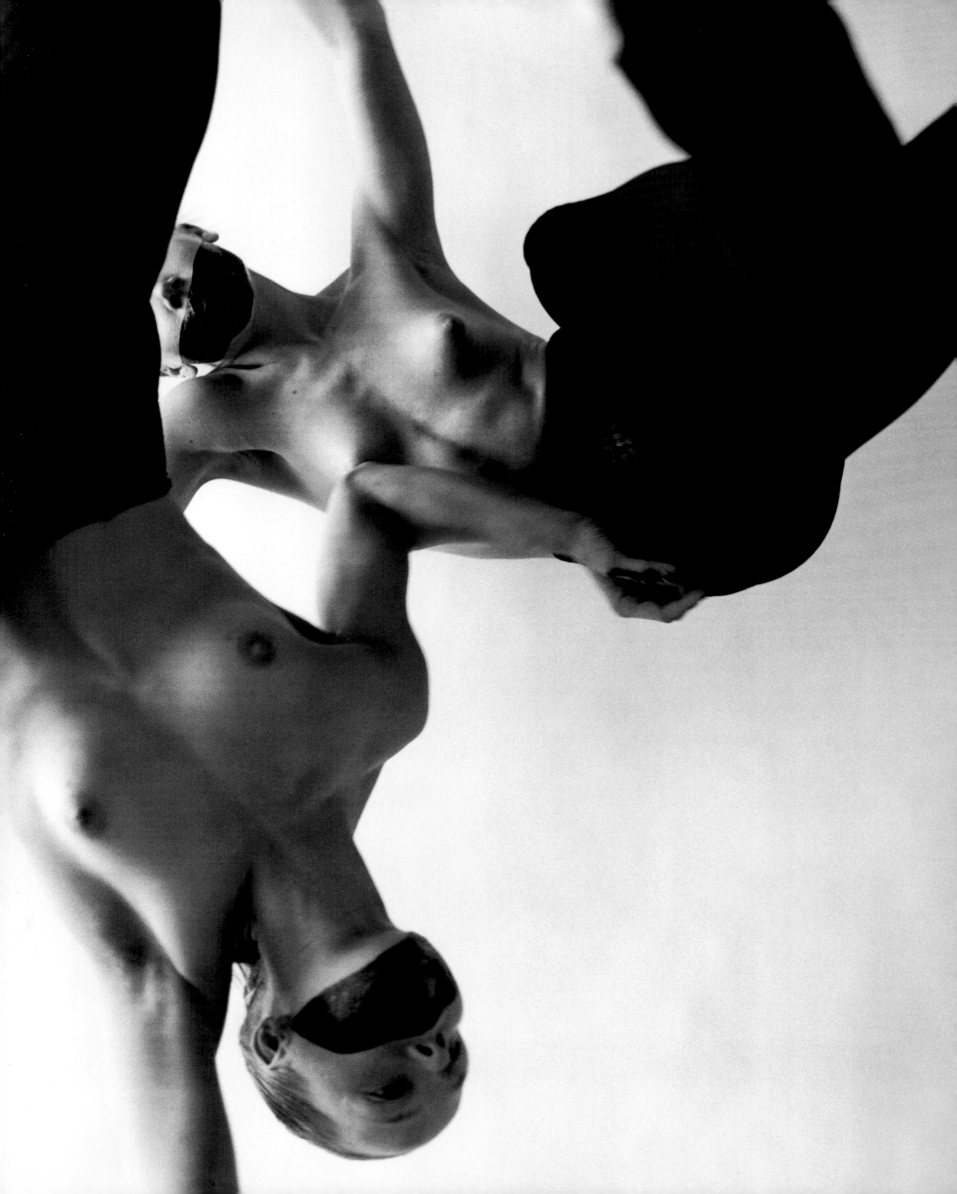

CREW

DANCERS

PRODUCER
MICHELE ARMSTRONG

MAKE-UP
LAMAR FULLILOVE
DINA GREGG
FRANCES HATHAWAY

MAKE-UP ASSISTANT
STEPHEN DIMMICK

HAIR
LEONARDO MANETTI
GERARD DECOCK

STYLISTS
MICHAEL CONTE
RANDI PACKARD

STYLIST ASSISTANT
MEGAN DELANEY

PHOTOGRAPHY ASSISTANTS
DANIEL DISCALA
BRIAN FERRARO
CHAD TENORIO
JOSHUA CLAPP
MICHAEL TEH

SHOT AT
PIER 59 STUDIOS NEW YORK

FILM DEVELOPED AT
LEXINGTON BLACK & WHITE LAB
NEW YORK

PRINTS BY
PHOTOTECHNICA AUSTRALIA

MOVE FOR AIDS
LAUNCHED AT
MILK GALLERIES NEW YORK
AS A MILK SUPPORTED PROJECT

WWW.MOVEFORAIDS.COM

FOR MORE INFORMATION ABOUT
JAMES HOUSTON'S WORK
WWW.HOUSTONPHOTO.COM

DESIGNED BY BOX COMMUNICATIONS
WWW.BOXTM.COM

DARA ADLER
MIDORI ANAMI
ALEXANDRA APJAROVA
TERRY DEAN BARTLETT
STEPHANIE C. BATTLE
MUCUY BOLLES
SHELLY BOMB
TONY BOUGIOURIS
SHEILA CARRERAS BRANDSON
TATYANA BRIKULSKAYA
JOHN BYRNE
STACEY CARLSON
SANDY CHASE
JOAN CHIANG
STEPHAN CHOINIERE
LATRISA COLEMAN
ALISON COOK
CHRISTOPER DEPERSIA
J.D. DOUGHERTY
SCOTT DUQUETTE
ALBERT PIERCE EVANS
RAMON FLOWERS
ELIZABETH FLYNN
CHRISTOPHER FREEMAN
SHANE GERAGHTY
FRANCISCO GRACIANO
SOLANGE SANDY GROVES
SHANTI GUIRAO
HEATHER HAMILTON
JULIA HOLLAND
AI IKEDA
KARA JOST
REBECCA JUNG
SHERAMY KEEGAN-TURCOTTE
GREGORY KING
CAROLINE LEPPANEN
SEAN PATRICK MAHONEY
NIKITA MAXWELL
CATHERINE MEREDITH
SHARON MILANESE
CHRISTOPHER K. MORGAN
MIHO K. MORINOUE
SHANNON MULCAHY
RANDY NEBEL
STEFANIE NELSON
JONATHAN NOSAN
WEENA PAULY
CORBIN K. POPP
DESMOND RICHARDSON
CHRISTINA SANCHEZ
MANA SMITH
YOSUKE TAKAHASHI
RAMON THIELEN
MICHAEL THOMAS
AARON VEXLER
ERIC WAGNER
JARED WOOTAN
VALENCIA YEARWOOD

"ONE OF MY CAREER HIGHLIGHTS WOULD HAVE TO BE AS A PRINCIPAL DANCER WITH AMERICAN BALLET THEATER DANCING THE LEAD ROLE TITLED *OTHELLO*, PREMIERING IT AT THE LINCOLN CENTER METROPOLITAN OPERA IN NEW YORK.

THE PROJECT **MOVE FOR AIDS** IS AN INCREDIBLE IDEA, AND I THOUGHT IT FITTING THAT THE MANY DANCE COMPANIES REPRESENTED A DIVERSE REFLECTION AND PERSPECTIVE ON OUR GLOBAL COMMUNITY.

WORKING WITH JAMES ON THE PROJECT WAS AND IS ALWAYS A PLEASURE. THE CARE AND ATTENTION TO DETAIL WITHOUT MUCH FUSS LENDS THE PROCESS A SPONTANEOUS BEAUTY. MY THOUGHTS ON THE RESULT OF HIS WORK ARE NOTHING LESS THAN *PHENOMENAL*. TO BE ABLE TO CONVEY MOVING STORIES THROUGH MOVEMENT IN A PHOTO IS HARD WORK. THE GIFT THAT HE POSSESSES ALLOWS HIM TO BRING FORTH THE MAJESTY OF THE BODY THROUGH LINE, FORM, AND CREATIVITY.

HATS OFF TO YOU BUDDY FOR THIS EXTRAORDINARY ACHIEVEMENT"

DESMOND RICHARDSON DANCER, SINGER, ACTOR, CO-ARTISTIC DIRECTOR OF COMPLEXIONS CONTEMPORARY BALLET NY

ITS

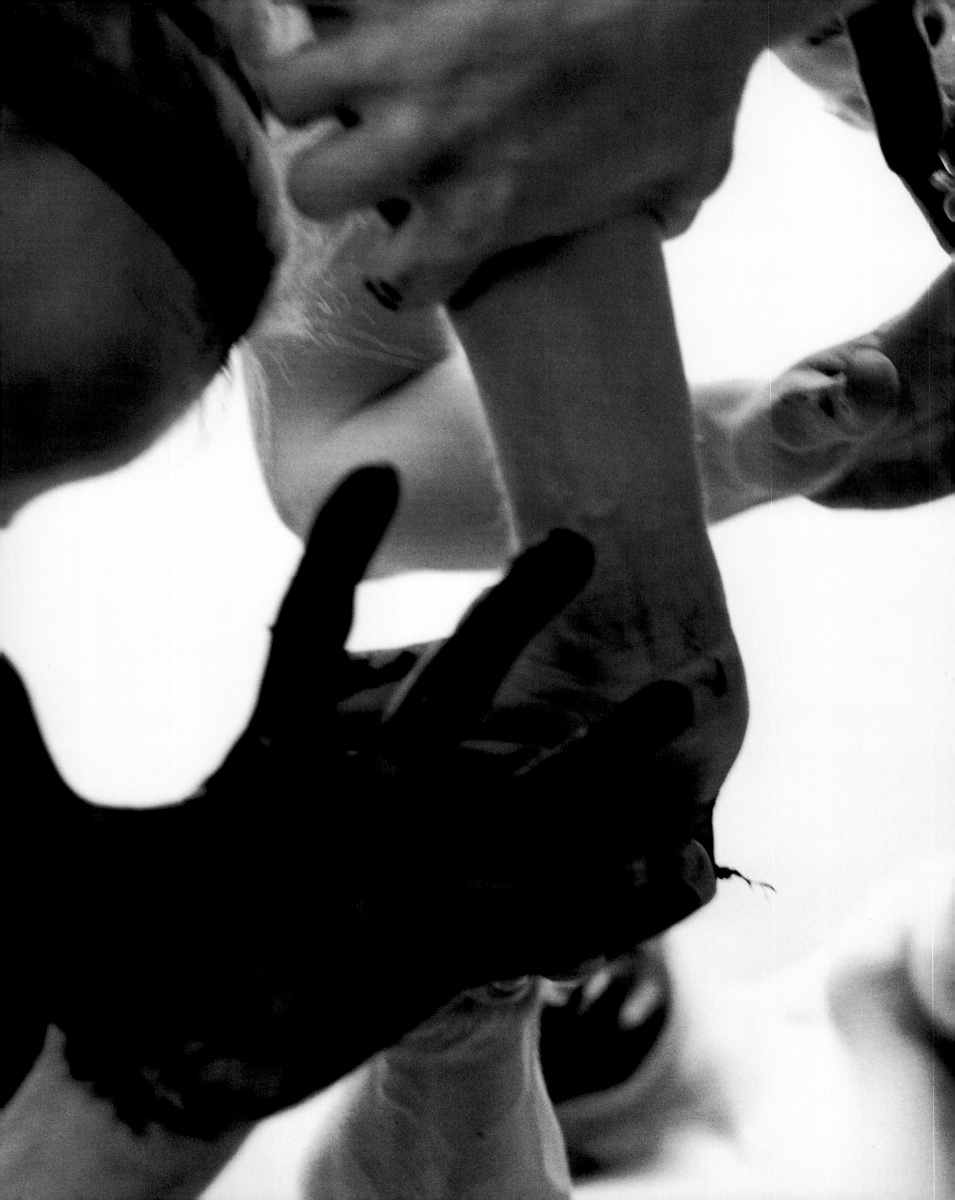

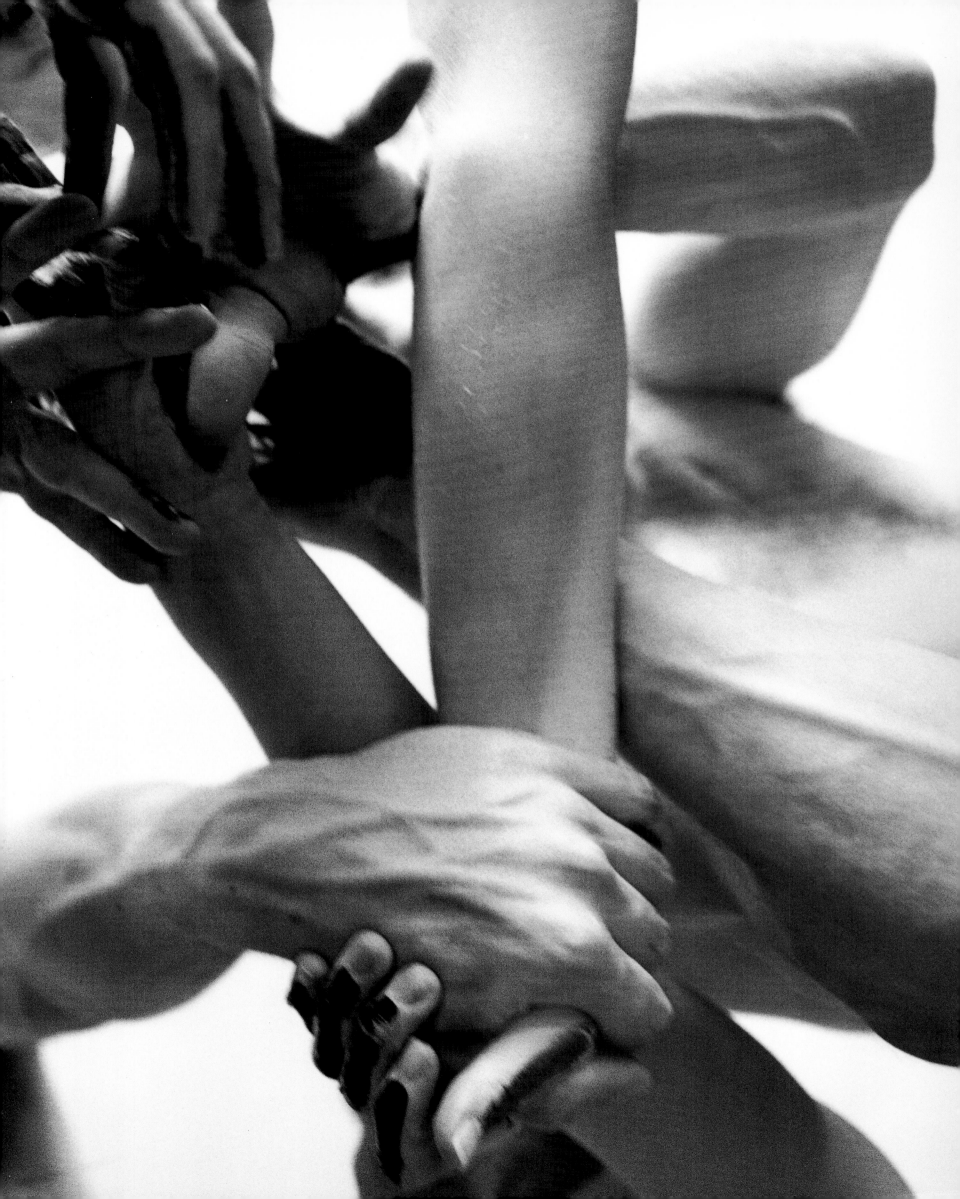

MOVE

BACK IN 2001 WHEN I HAD FIRST DECIDED I WANTED TO DO SOMETHING
TO HELP WITH THE AIDS CRISIS AND CAME UP WITH THE IDEA FOR **MOVE**,
I HAD NO IDEA THAT THE JOURNEY WOULD BE SUCH A TOUGH,
FRUSTRATING, AND EMOTIONAL ONE! AS THE YEARS PASSED,
AFTER THE BOOK WAS SHOT, I KEPT WORKING THROUGH
SO MANY REJECTIONS AND EXCUSES FROM COMPANIES, PUBLISHERS,
AND PEOPLE AS TO WHY THIS PROJECT WASN'T GOING TO WORK
AND WHY THEY DIDN'T WANT TO BE ASSOCIATED WITH IT.
I BECAME MORE AND MORE PASSIONATE AND DRIVEN TO SEE IT SUCCEED...
BY THE TIME THIS BOOK IS LAUNCHED THE JOURNEY WILL BE ALMOST
SIX YEARS.
I NEVER THOUGHT THIS BOOK WOULD TAKE THAT LONG,
BUT THAT JOURNEY MADE ME REALIZE
THAT IF YOU CONTINUE TO HAVE FAITH IN SOMETHING
AND DON'T LET ALL THE NEGATIVE ENERGY STOP YOU FROM BELIEVING
IN YOUR VISION, THEN YOU WILL ACHIEVE IT...
AFTER SO MANY HAD TOLD ME THAT DANCE BOOKS DON'T SELL
AND THAT NOBODY WAS INTERESTED IN A BOOK SUPPORTING AIDS
I BECAME MORE DRIVEN AND OBSESSED.
I EVENTUALLY CREATED THE **MOVE FOR AIDS** PROJECT
WHICH GAVE A LAUNCH FOUNDATION FOR THE BOOK WITH EVENTS
INVOLVING THE ARTS, MUSIC, AND DANCE THAT WOULD RAISE
MUCH NEEDED AWARENESS AND MONEY FOR AIDS CHARITIES.
THE CONCEPT THEN STARTED GROWING ON A GLOBAL SCALE
AS I LOOKED AT LAUNCHING IN OTHER COUNTRIES.
AS EXCITING AS THIS WAS AFTER ALL THE WORK I'D PUT IN,
IT WAS ALSO A LITTLE SCARY AS I WAS WORKING ALONE.
ITS TOUGH IF YOU'RE NOT A CELEBRITY OR PERSON WITH A LOT OF
CONNECTIONS OR MONEY TO ACTUALLY HELP THE WORLD'S SITUATION TODAY.
ITS EASIER FOR US TO TURN AWAY AND LEAVE IT UP TO THE NEXT GUY,
THE CELEBRITY OR THE BILLIONAIRE.
I WOULD HOPE THIS BOOK AND PROJECT WILL INSPIRE PEOPLE
FROM ALL WALKS OF LIFE THAT YOU CAN MAKE A DIFFERENCE
AND UTILIZE YOUR ENERGY, TALENT, AND PASSION
TO SUPPORT WHATEVER CAUSE YOU FEEL STRONGLY ABOUT.
DON'T BECOME NUMB TO WHAT'S GOING ON IN THE WORLD TODAY...
TAKE A STAND, MAKE A **MOVE**, AND MAKE A DIFFERENCE!

JAMES HOUSTON

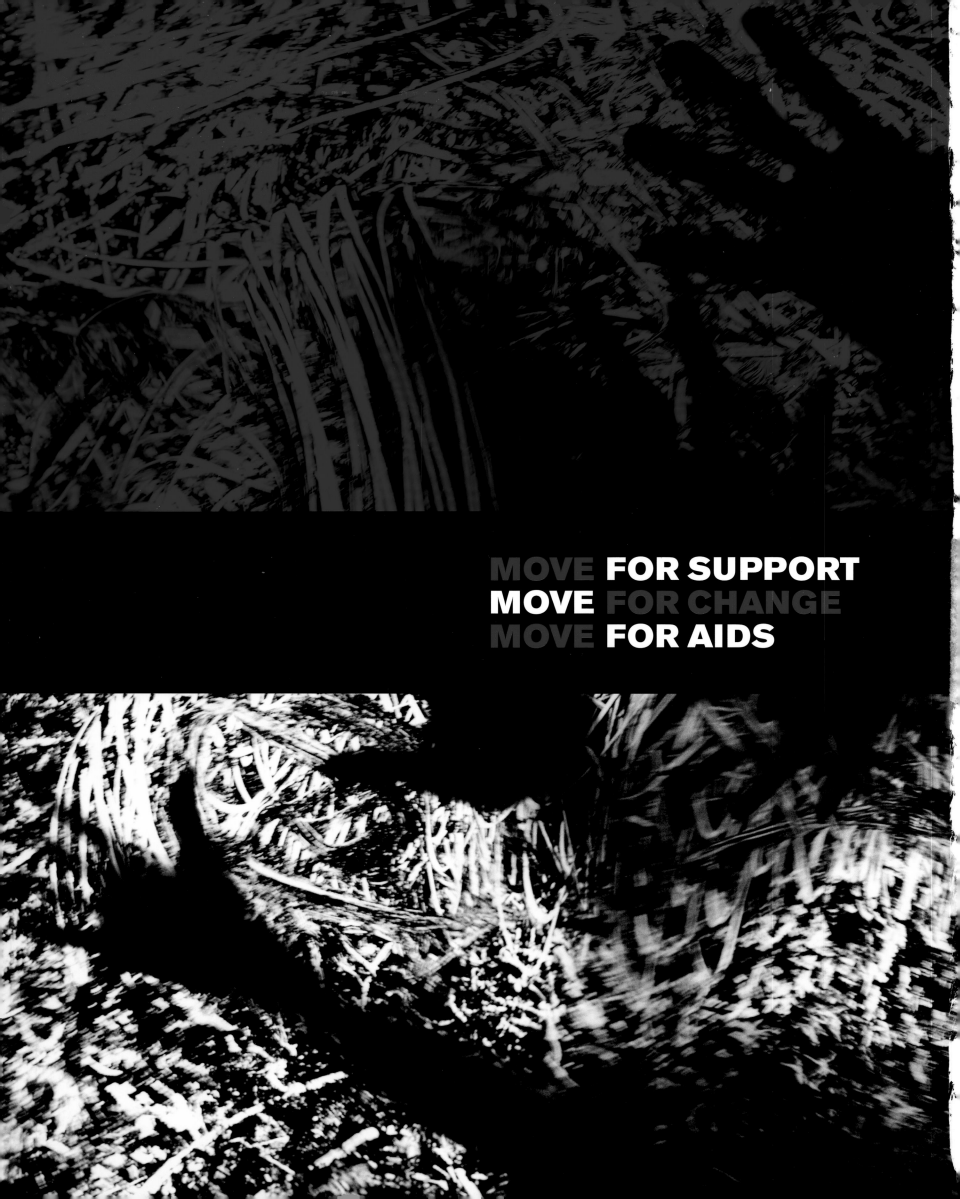

MOVE **FOR SUPPORT**
MOVE FOR CHANGE
MOVE **FOR AIDS**

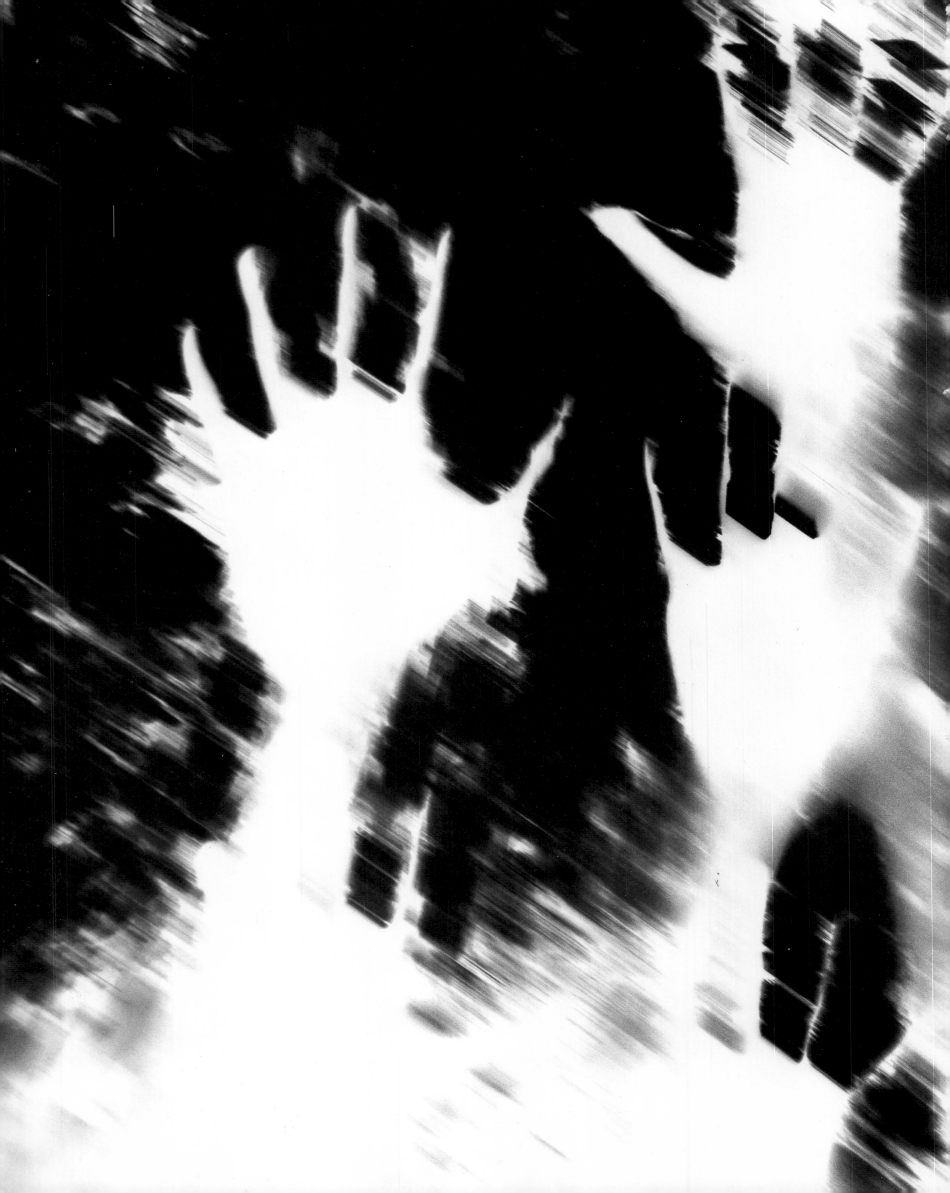